Comhairle Contae Fhine Gall

Fingal County Council

Items should be returned on or before the last date shown below. Items may be renewed by personal application, writing, telephone or by accessing the online Catalogue Service on Fingal Libraries' website. To renew give date due, borrower ticket number and PIN number if using online catalogue. Fines are charged on overdue items and will include postage incurred in recovery. Damage to, or loss of items will be charged to the borrower.

Date Due	Date Due	Date Due

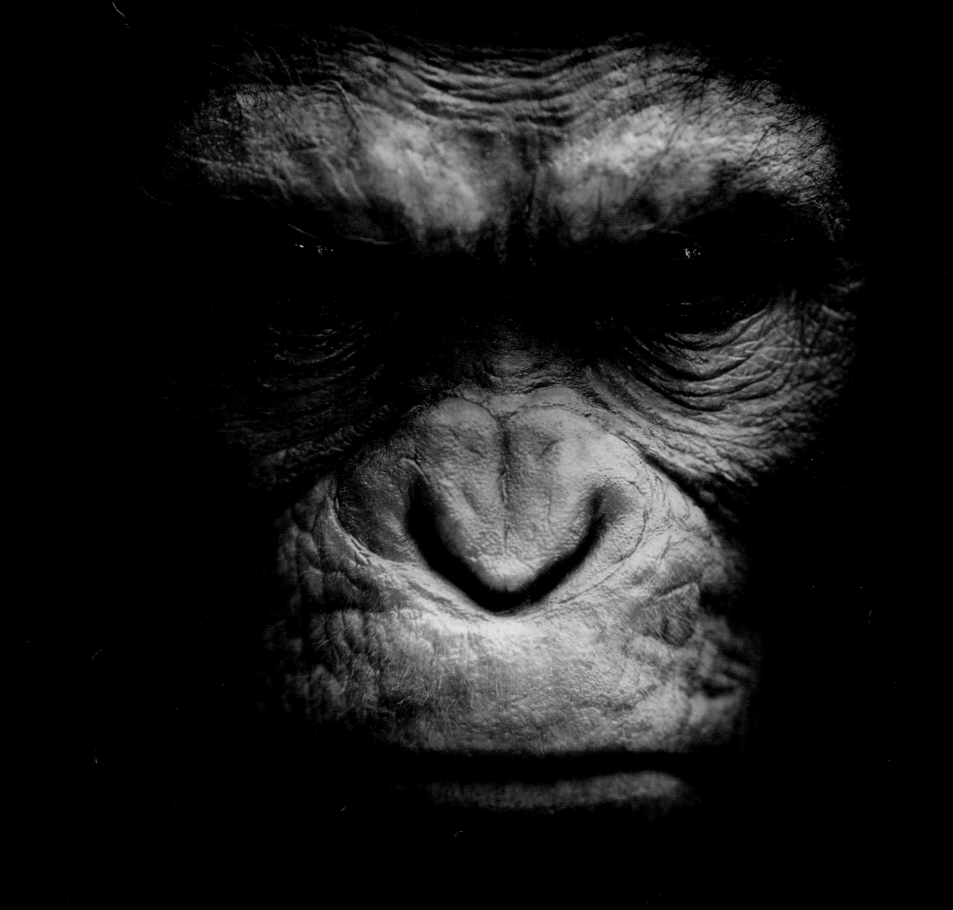

THE ART OF THE FILMS

DAWN OF THE **PLANET** OF THE **APES** AND **RISE** OF THE **PLANET** OF THE **APES**

Planet of the Apes: The Art of the Films
Dawn of the Planet of the Apes and
Rise of the Planet of the Apes

ISBN 9781783291977

Published by
Titan Books
A division of Titan Publishing Group Ltd.
144 Southwark Street
London
SE1 0UP
United Kingdom

First edition: July 2014
10 9 8 7 6 5 4 3 2 1

Did you enjoy this book? We love to hear from our readers. Please e-mail us at:
readerfeedback@titanemail.com or write to Reader Feedback at the above address.

To receive advance information, news, competitions, and exclusive offers online, please sign up for the
Titan newsletter on our website: www.titanbooks.com

A CIP catalogue record for this title is available from the British Library.

Printed and bound in China.

PLANET OF THE APES

THE ART OF THE FILMS

DAWN PLANET APES

AND RISE PLANET APES

SHARON GOSLING AND ADAM NEWELL
INTERVIEWS BY MATT HURWITZ

FOREWORD BY MATT REEVES

TITAN BOOKS

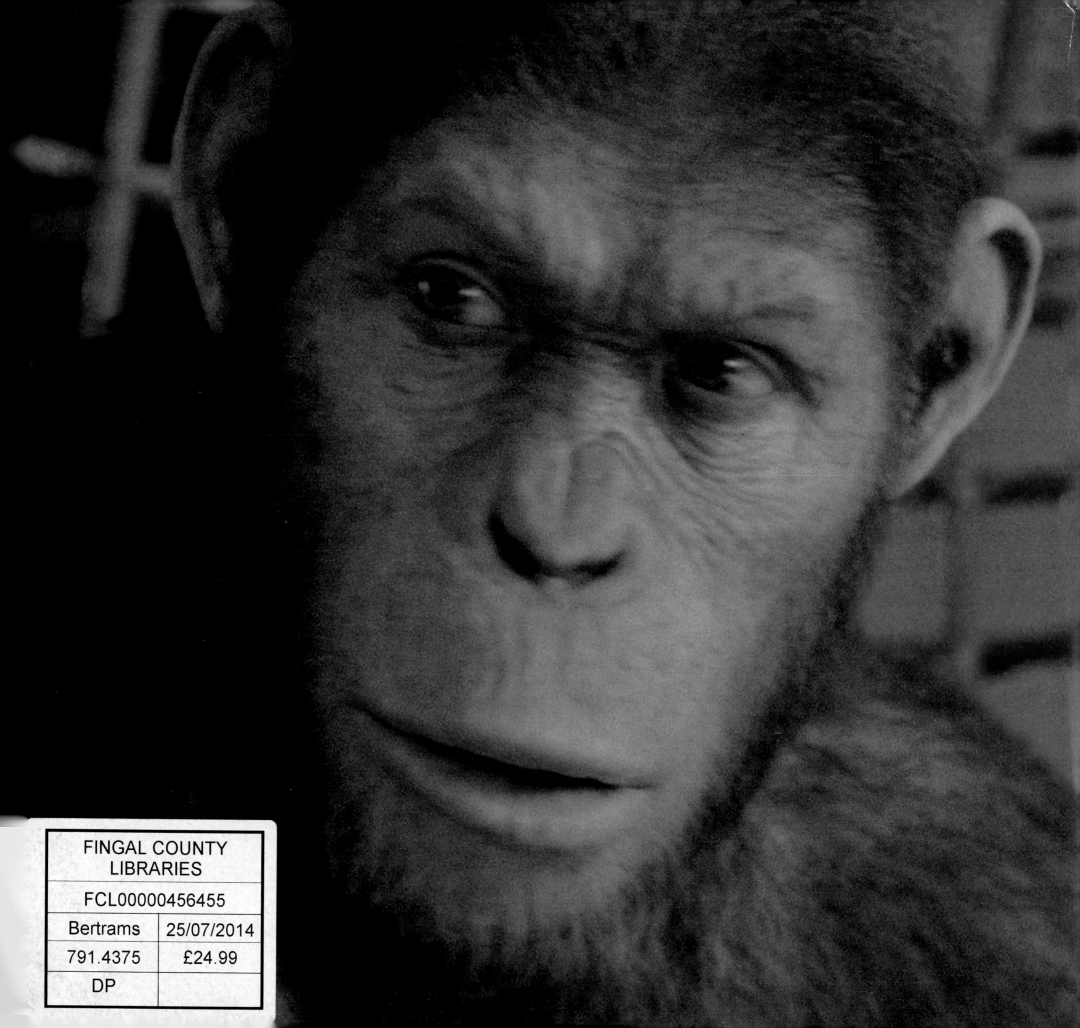

CONTENTS

FOREWORD

By Matt Reeves

When I was a kid, I wanted to be an ape. Something about the sight of armed gorillas on horseback captured my imagination profoundly. It was terrifying. And thrilling. Only much, much later did I come to realize the true depth of the story of *Planet of the Apes*, the power of its metaphors. It was about our very nature, the war against the animal in all of us. But the way into that discussion still came back to that profound and bizarre image. As with the best science fiction, it conveyed something that was completely fantastical while somehow simultaneously feeling utterly—chillingly—real.

Seeing *Rise of the Planet of the Apes* so many years later brought me back to that powerful experience from my childhood. Only this time, there was something different. Not only were the images of intelligent apes captivating, this time my sympathies were completely with them as characters. The way the story was constructed, the way the visual effects were realized through amazing advances in motion capture, I suddenly found myself in total empathy with Andy Serkis' Caesar. Finally, I was an ape. So when the producers approached me about making *Dawn*, it

was irresistible. I had to step into that primal, yet deeply emotional terrain.

Making a mocap movie is insane. The leap of imaginative faith you have to take while shooting and editing is unlike anything I have ever experienced. I can only imagine how it must have felt for Rupert Wyatt making *Rise* without knowing one hundred percent that it would even completely work—at least, I had the confidence of seeing what had been pulled off so brilliantly in his film. But nothing can truly prepare you for it.

My goal in making *Dawn* was to create a world that felt as real as possible. For me, the only element of fantasy was the growing intelligence of the apes; the rest had to feel completely grounded, so there would be no obstacles to the emotion of the story. To create that kind of illusion takes an army of artists and storytellers. And Rupert Wyatt and I were both fortunate enough to work with some of the very best. The wildly gifted Production Designer James Chinlund, and legendary Director of Photography Michael Seresin, were crucial to the visual realization of *Dawn*, just as Production Designer Claude Paré and Academy Award-winning Director of Photography Andrew Lesnie were

critical to *Rise*. Their astonishing work—and the talented work of so many others—is reflected here in this book.

A last, special note must be made about the motion capture that is the lifeblood of these films. The work that Weta does in this area is truly mind-blowing. They are the very best at what they do, and working with them has been an absolute joy. They are constantly pushing the boundaries of what is possible. And what the audience often doesn't realize—and what Weta will be the first to tell you—is that the key to the emotional engagement that we all have with their creations is the performance of the mocap actors themselves. The apes are so human because of the incredibly talented human cast that brings them to life. And in my experience, there is no actor more incredible than Andy Serkis. Andy gives his soul, his strength, his heart every minute of every day he shoots. What you are feeling when you feel Caesar is Andy. I am so lucky to have gotten to explore this rich and unusual world with him. Thank you, Andy—and thank you to all the other actors, artists, and technicians involved—for allowing me, and audiences everywhere, to become apes.

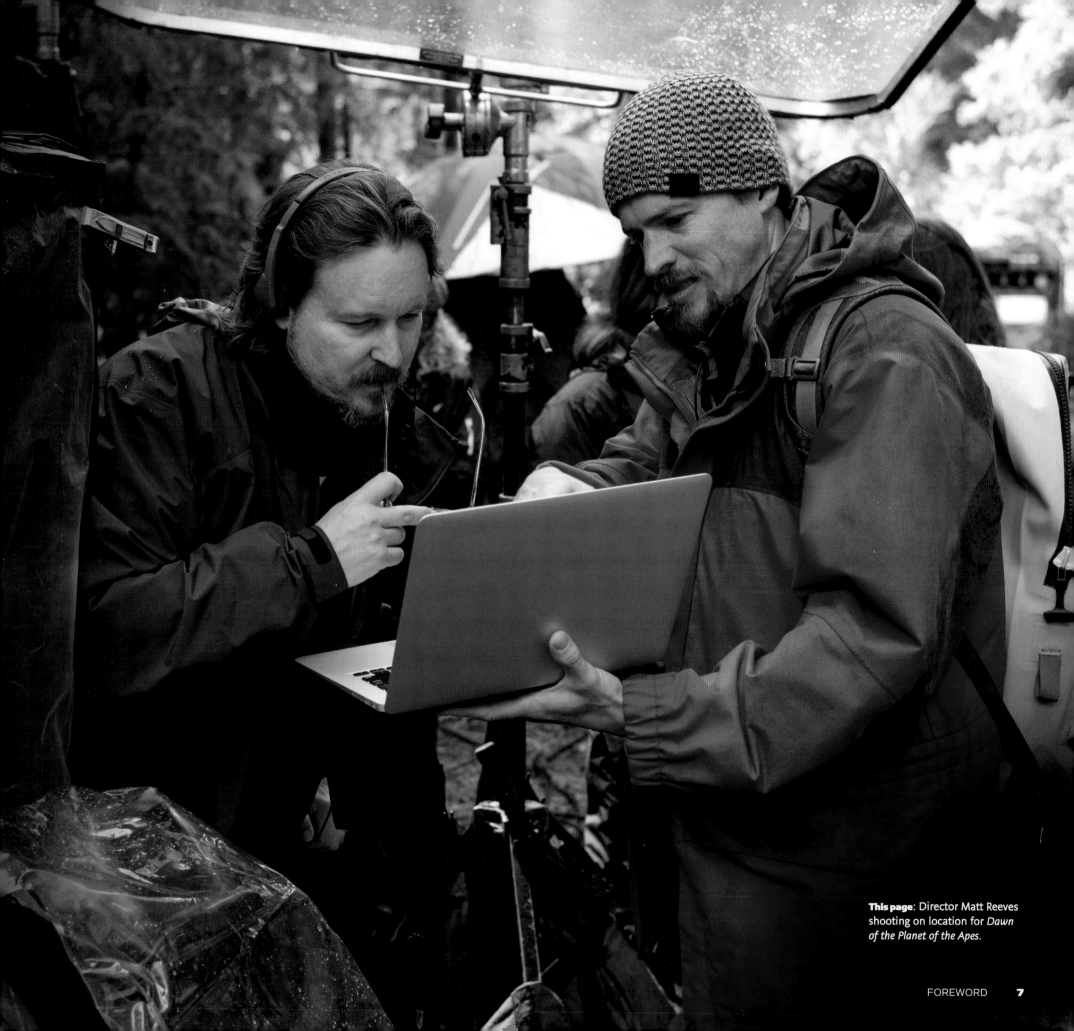

INTRODUCTION
GENESIS

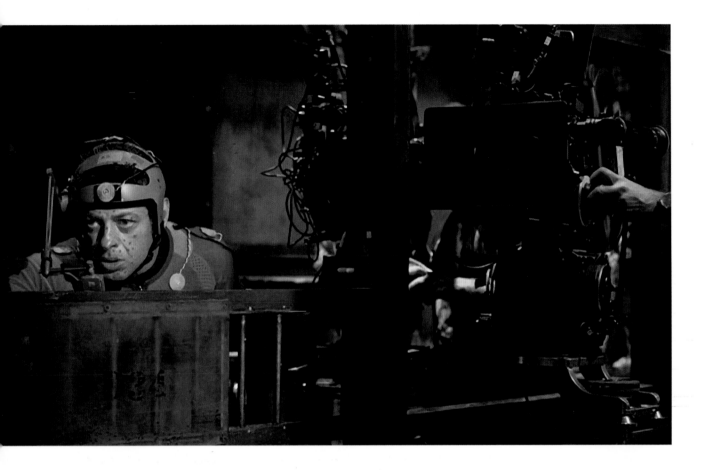

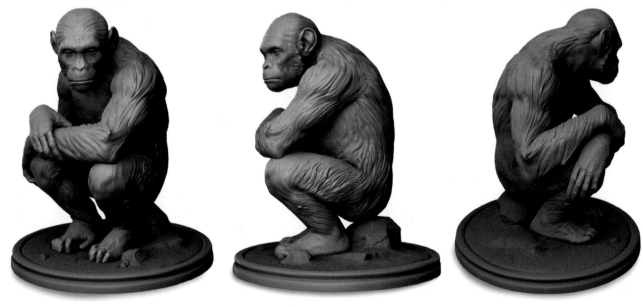

In many ways, it was the first modern film franchise. A long time before a certain galaxy far, far away came into being, the original 1968 *Planet of the Apes* movie had already become a cultural phenomenon. Based on Pierre Boulle's novel, directed by Franklin J. Schaffner and starring Charlton Heston as Taylor, an astronaut who finds himself — as only the devastating final scene makes clear — on a future Earth where apes have taken over, the film eventually led to four theatrical sequels (and a remake), two television series and, of course, countless comic books, toys, games and lunchboxes.

Yet, for all its commercial and cult success, and for all its influence on the history of the Hollywood movie business, the original *Planet of the Apes* was more than just a film franchise. Its story was somehow deeper. In 1968, at a time when civil rights were in turmoil in the U.S., and fear of nuclear warfare was rife, it offered an ugly reflection of human society. So perhaps it is no surprise that during a period when human ability to manipulate genes is more advanced than it has ever been, and interest in the uses of that knowledge is at an all-time high, *Planet of the Apes* has again found a way to mirror a controversial chapter in human history.

The journey started as far back as 2005, when husband and wife team Rick Jaffa and Amanda Silver were looking for a new project to co-write.

"For years," says Silver, "Rick had been collecting these articles about chimps that are raised in homes."

"They were being raised as if they were part of the family," Jaffa adds. "And these stories were always bad — the chimp would always eventually attack a neighbour, or attack the owner. It was just a built-in tragedy, waiting to happen. I had cut out a number of articles over the years, and I'd stared at them, trying to figure out, 'What kind of movie would you make out of that?'"

One of the obstacles, Jaffa notes, was that they wanted to stay away from "the cheesy horror movie stuff" to which these stories so readily lent themselves. Eventually he put the cuttings away, adding to them now and again over the years, but thinking no more about it for quite some time.

"Then, one day I pulled those articles back out and laid out a bunch on the floor, along with some articles about other things. I was just sitting, staring at them, trying to come up with an idea. My eyes went back to the chimpanzee articles and then to some science articles about genetic engineering. My eyes just went back and

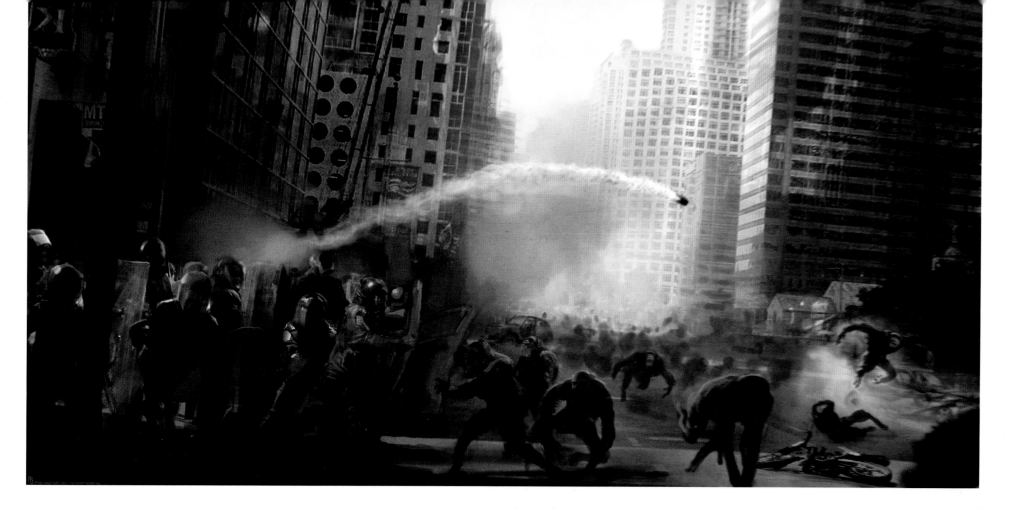

forth, back and forth, and suddenly a voice in my head said, 'It's *Planet of the Apes*.'

The pair had been working for Twentieth Century Fox, owners of the *Apes* franchise, which meant that they were able to pitch their idea quickly. As with the story itself, selling the concept to the studio seemed to come together completely naturally. "It was the cleanest, shortest, purest pitch we've ever done," recalls Jaffa. "Everyone over there got really excited."

Fox was indeed extremely excited, both about the chance to revitalise the *Apes* franchise and the ideas that Jaffa and Silver had for doing so. However, their concerns echoed exactly the writers' own early anxieties – they were worried that a movie with a hyper-intelligent ape in the lead could not help but end up being somewhat 'cheesy'.

At the time, it was a understandable concern for purely practical reasons – in 2005, the technology that we now take for granted that can create lifelike digital creatures was still in its infancy. The talented artists of the New Zealand-based special effects company Weta were in the midst of revolutionising digital character movement, but no one had yet created a blockbuster film where such a character took centre stage in the way Jaffa and Silver

had envisioned Caesar would. "The heart of the movie is Caesar," says Silver, simply.

As development of the script continued, the project took a decisive step forward with the arrival of producers Peter Chernin and Dylan Clark, of the then newly set up Chernin Entertainment. "At the time we were looking for the right property to launch our film division, and a transformed *Apes* fit the bill," explains Peter Chernin. "We saw this as an important legacy franchise that also had the potential to be re-imagined against the backdrop of modern issues and challenges. We got on board almost immediately because at its core this concept played off the origin story but also felt sophisticated and even emotional."

Chernin and Clark then brought in British-born director Rupert Wyatt, who had gained international attention with his prison break drama *The Escapist*. He joined the project with a very clear idea of how he wanted to approach the themes presented in the script, which in turn linked right back again to the original movie.

"I loved *Planet of the Apes*, the original," says Wyatt. "It was quite extraordinary in terms of the themes it was taking on and the whole notion of the civil rights

movement, nuclear disarmament and the ever-present threat of obliteration. In modern-day Hollywood, give or take the odd great exception, films don't embrace the world around us in quite the same way. We don't tackle those themes. People feel that they're an antithesis to the idea of commercial filmmaking, and I really disagree. The original *Planet of the Apes* was a really groundbreaking movie – not just the make-up effects and the concept, but what it was saying about our world. So that was always my approach – to try and hold a mirror up to us as a species and relate it, which is always my favorite form of science fiction."

The production's major decision prior to shooting was how to realize Caesar and the other ape characters. In some ways, this was where the interim years between Jaffa and Silver's first pitch and when the film went into active pre-production in 2009 really paid off. Over that time, digital technology had evolved apace. The *Lord of the Rings* films had established that it was possible to create incredibly believable digital characters that had their basis in an actor's physical skill – not least through Andy Serkis's remarkable performance as Gollum. *King Kong*, again with Serkis, and then James Cameron's *Avatar* had developed

the technology still further, so that by the time *Rise of the Planet of the Apes* was ready to take center stage, the options available had opened up considerably.

"We had a choice of how we were going to achieve what we needed for the story," recalls Wyatt. "Obviously, what choice we made was then going to dictate the tone of the film. I remember sitting in a room with the key people involved and we really talked it through. Very quickly we got rid of the option of using actors in suits, because we're dealing with real apes in this world, in a contemporary context. And you may get an actor to play a gorilla in a suit, but it's physically impossible for a human actor to play a chimpanzee in a suit, because they have a very different anatomical structure to us — they have short legs and a long torso. The use of live apes in film for me is totally contrary to how we should treat apes, and it would have been highly ironic to tell a story about ape emancipation and then basically imprison a whole bunch of apes to tell it! So we were left with the option of performance capture, which from a creative point of view was far and away the most exciting. Fox, of course, had had the experience of making James Cameron's *Avatar* and their relationship with Weta is such that it's a very easy call to make."

Wyatt's first contact with Weta was to talk with Joe Letteri, who joined the production as senior visual effects supervisor.

"The first thing Joe said was, 'You need Andy Serkis'," Wyatt recalls. "We hadn't actually cast Caesar at that point, but Joe said immediately, 'You need an actor who is going to play this role in the way they would play a human character, rather than try to emulate a chimpanzee.' So we were really lucky because we had a very easy access to Andy because of Weta, and I think Andy felt confide nt because of their involvement, and he responded well to the script."

"Honestly, I read the script and I was blown away by it," says Serkis. "It had the most amazing arc. It had this journey of a character who was an outsider. He was brought up believing he was one thing, and reached a certain point in his youth where he's suddenly told he's something else. He's cast out, he's forced to live with supposedly his own kind, who turn on him and he then turns them around and leads them. And, oh, by the way – he's a chimpanzee. Regardless of the fact that Caesar was a chimpanzee, you read it on the page and it read like any human character. It was as complex, as beautifully charted, and emotionally centered as any role and I just immediately thought, 'God, I'd love to play this part'. That was my entry point to it, and luckily that was exactly how Rupert wanted to approach it, and everyone at Fox. People said to me, 'Andy, you spent a long time researching and playing King Kong, why are you playing another ape character?' And I said, 'Look, I don't see this as anything to do with King Kong. He's a completely different character, this is a completely different story.' It's like saying, 'Well, I'm playing this human being in this movie' and people are like, 'Why are you playing another human being?' What I had discovered with Kong was that all gorillas have their own very individual, idiosyncratic personalities, They're 97% the same as us genetically. This was a vastly different journey."

In fact, it was during his intensive research for *King Kong* that Serkis found what would become the foundation for Caesar's character. For that earlier role, the actor had spent months studying the great apes, even going as far as visiting Rwanda to see the gorillas in their natural environment. He had also come across some fascinating footage from the 1970s, of a chimpanzee named Oliver who had been raised in a way very similar to those described in Rick Jaffa's collection of cuttings.

"Oliver was extraordinary in the sense that he was very unlike any other chimpanzee," explains Serkis. "He walked totally bipedally, he had very human facial expressions. He became a celebrity, he wore clothes, he flew in planes. They even began to question the possibility of whether Oliver was the missing link – did he have any human DNA in him? Was he possibly a 'human-zee'? Then he reached adolescence, and became quite aggressive. He was put into a sanctuary and left, really, for 30 years, and slowly went mad. Then he was discovered by his original owners, as a sad and broken character. So I based a lot of Caesar on Oliver."

Serkis was joined by a troupe of other talented actors playing the apes. "One of the keys who came in very early on was Terry Notary, who played Rocket," Wyatt notes. Notary, a stunt coordinator and movement coach with a circus background, would go on to play a vital role on and off screen. "He ultimately became our ape movement expert," Wyatt explains. "He put all of our actors through 'ape camp'. I leaned on Terry a lot to advise me on casting the supporting roles. He said, 'Don't go with people who can just do a good ape impression, because that doesn't mean anything.' We all have these preconceived notions of how we would play a chimpanzee, and he said, 'In some ways those guys are harder to break and re-educate, because invariably they get it wrong.' So we just looked for the best actor. Karin Konoval is a good example – the actress who plays Maurice. She had a stillness about her when she auditioned. She didn't try to play an orangutan, she just played the character of Maurice."

While casting was going on, the characters were also coming together elsewhere. Concept artist Aaron Sims was charged with illustrating what the chimps would look like in *Rise of the Planet of the Apes*. This was a key aspect of pre-production, as Sims' imagery would provide a visual guide for Weta's animators to work to later, as well as establishing a tone for the overall ape community. One of the initial questions that Sim had to address was whether Caesar, as an evolved, intelligent ape born to a chimp that had been given the ALZ112 virus, should look at all human.

"We explored some really creepy looking stuff," Sims recalls. "It was creepy because we look at apes and we accept them for what they are, and we look at humans and do the same, but when you cross them, there's this uncomfortable look." One early attempt featured a chimp with a more human nose, which Sims recalls as being particularly disturbing. "Once you start changing the cartilage and making it human there, it's just wrong. We realized early on that part of the process was to make the ape look intelligent, more so than a regular ape – he was evolving. We probably did 100 iterations until we got from creepy to something that felt like a chimpanzee, but there was a human element. What we found was that the human element came from the eyes. Everything else was almost maintained, except that we also brought the muzzle further in, it wasn't as far out as in a chimp. Ultimately we came up with something very cool. Weta did a great job of bringing it to life and Andy Serkis was such a great choice.

I really felt like it came together on every level."

In fact, *Rise of the Planet of the Apes* ended up as an excellent example of every aspect of filmmaking coming together to make an impressive whole. It successfully relaunched a beloved franchise for a new generation, a franchise that Fox and Chernin Entertainment would build on and expand with director Matt Reeves in *Dawn of the Planet of the Apes*. But as the crew gathered in Vancouver to start principal photography back in summer 2010, they faced a daunting prospect. For the first time in film history, digital characters finalized in a post-production process would be initially brought to life by means of total performance capture of actors, not on a separate green screen soundstage, but alongside live-action characters on a standard movie set, and even out on location... Was this going to turn into a madhouse?

THE ART OF

RISE OF THE PLANET OF THE APES

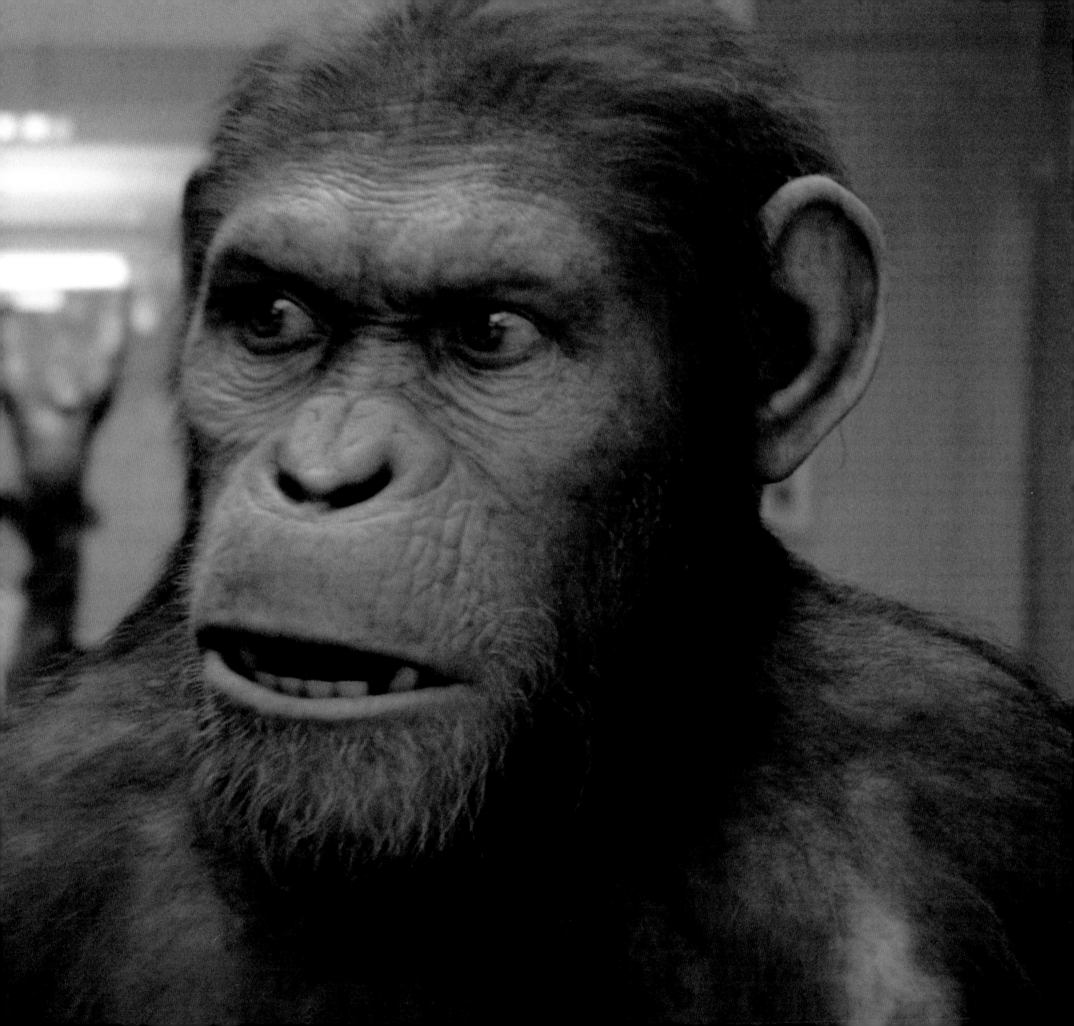

THE RISE BEGINS

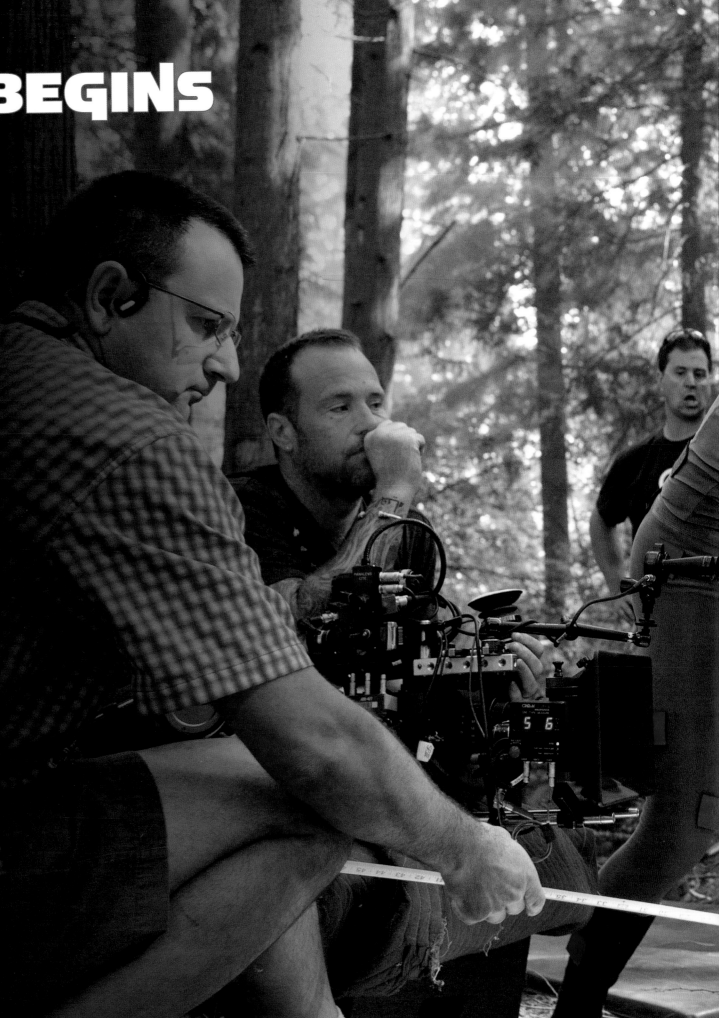

The key to bringing *Rise of the Planet of the Apes* to the screen was the development of performance capture. Motion capture had been around for several years, a mechanism that records an actor's movements by means of markers placed at strategic points on the performer's body, which can then be transferred to a computer environment and digitally built upon. Only two films before *Rise*, *King Kong* and *James Cameron's Avatar*, had applied this to facial muscles too, dubbing this all-encompassing method 'performance capture'. Neither of those films had taken this technology on location, or used it to record performances alongside live action.

"That was the big step forward for this film and for Weta," says Rupert Wyatt. "We were taking performance capture technology and placing it into actual on-set locations. So we didn't go away and work with the chimps on a green screen stage and then shoot the human characters on location and then put them together. We were always interacting."

The advantages of this method were immediately clear. "When Andy Serkis and James Franco [Will] got together, there was a lot of discussion about how we were going to play the scenes from the point of view of the technology," recalls Wyatt. "Very quickly, it became clear that we didn't have to worry about that hampering us. We just approached and shot the scene as we would any other. It just so happened that Andy was using chimp noises instead of human words."

Right: Rupert Wyatt works with Andy Serkis and James Franco on location. "James Franco was extraordinary," says Serkis. "He totally got it, that we were just two actors playing opposite each other. I think [the performance capture suit] only worried him for literally about an hour on the first day."

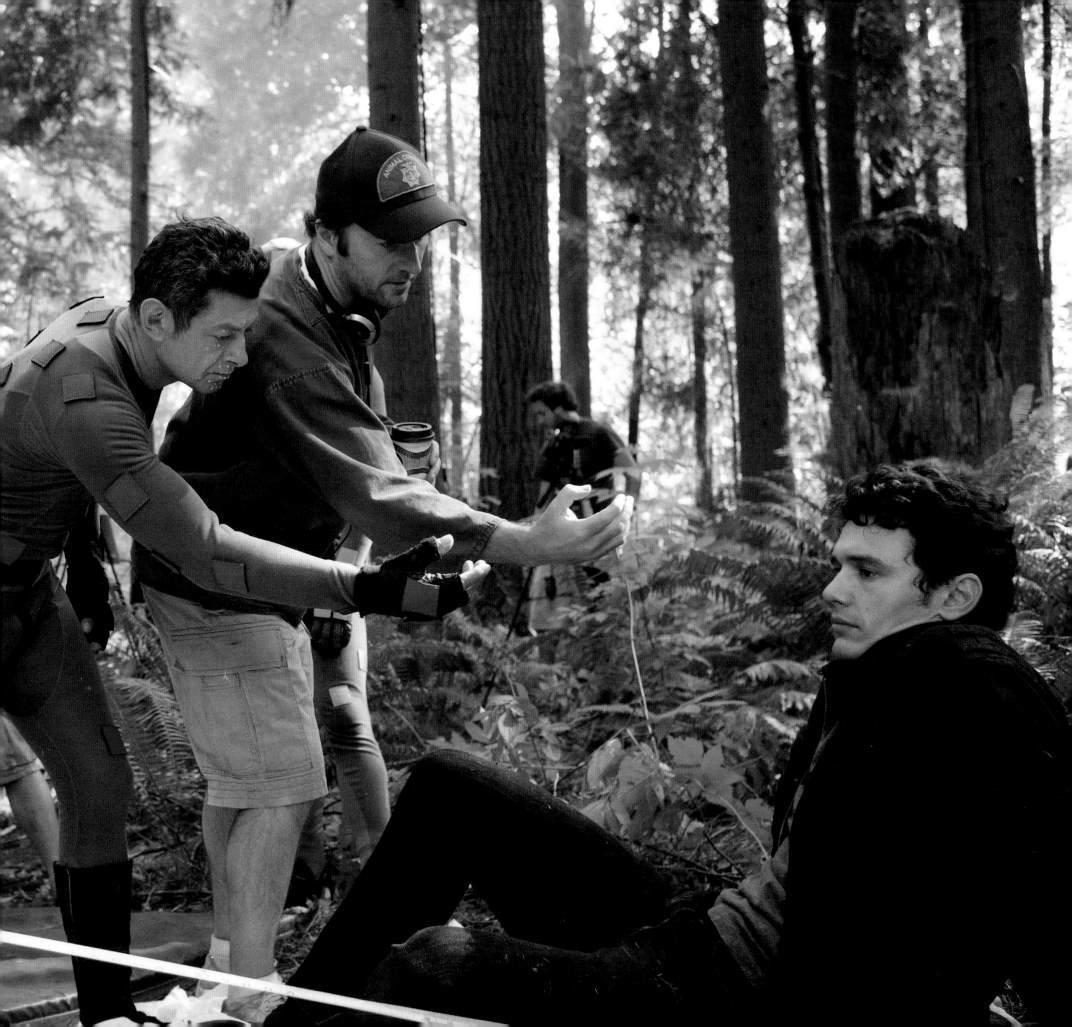

GEN SYS

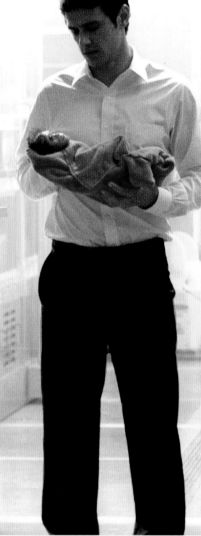

Claude Paré was brought on board as production designer, tasked with developing a distinct look for each scene. Some of the first images he worked on were the setting for Gen Sys, the laboratory complex where Will creates the ALZ-112 virus. It was an important starting point, from both a story and a production point of view, because so much of the film was set to develop within it. Although the exterior was a location—the British

Columbia Institute of Technology building in Vancouver—the interior lab was created from scratch.

"It was a single, large set," says Wyatt, "that covered the holding cages for the apes, the corridor, and the key scan room."

"Basically, I poured a giant concrete slab on the stage for this," Paré explains. "Everything is inset—all the trims that you see going across the set, it's all hiding cables for the crew and even our devices for lighting and so on."

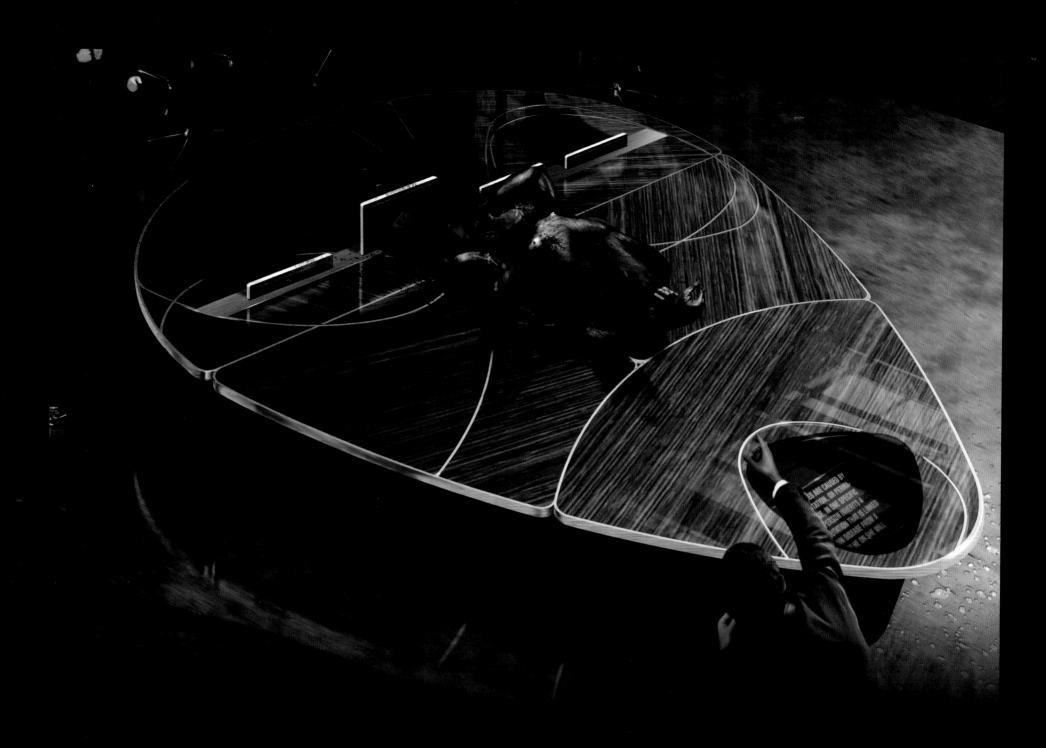

To make shooting as easy as possible, Paré came up with ingenious ways of making sections of the set moveable at a moment's notice. For the conference scene where Caesar's mother, Bright Eyes, goes berserk, the production designer created an elegant yet highly functional set.

"The table we built, it's like a guitar pick shape," explains Paré, "but it's in five sections so that we could move the camera around it and nearer to what was going on. It's the exact opposite shape of the room, so that the room was also a shaped like a guitar pick, but it was oriented a different way. All the screens you see were visual effects."

Images like this also helped the director to show the studio what his plans for shooting were, a technique called 'pre-visualization'. Pre-vis helps to map out exactly what's going to happen in a scene prior to filming, and can consist of art such as this, storyboards, and also simple animation.

"Pretty much every set piece that I can think of in the movie was very carefully pre-vis'd, which is something that Fox, traditionally, has always liked to do." Wyatt recalls. "It's a very good tool when used correctly, for getting everybody on the same page."

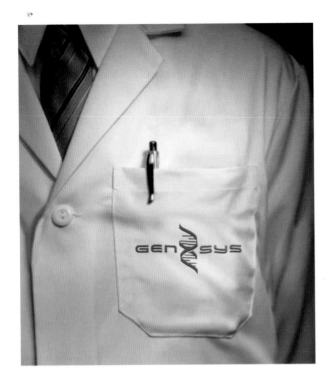

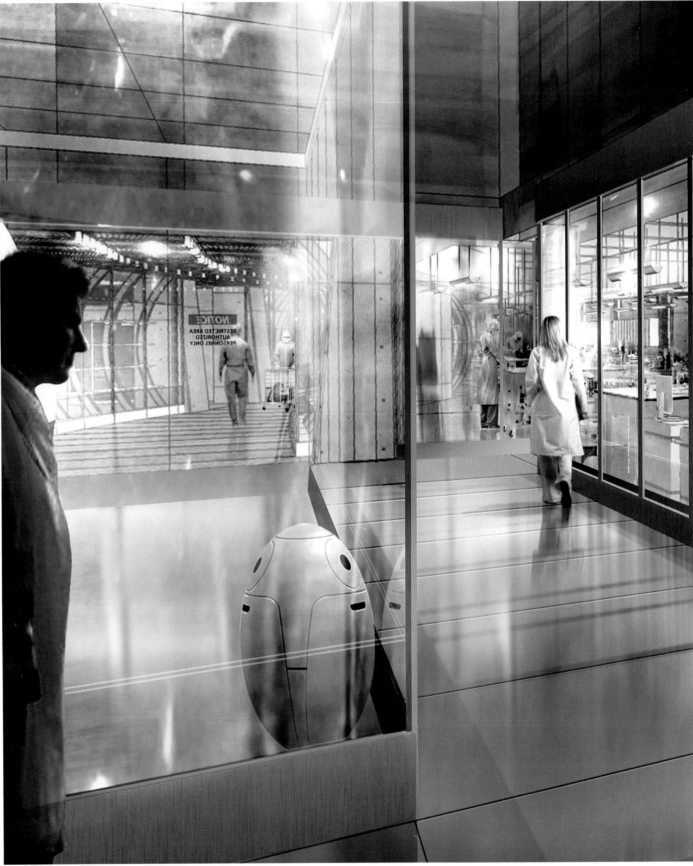

GEN SYS

Wyatt specifically asked for the Gen Sys set to be as open as possible. "I wanted lots of sight lines," he says, "so that we could be in one room and see into another. There was one particular sequence when Will comes back to the lab and realizes that they're testing on apes again, and he and Jacobs (David Oyelowo) walk and talk throughout the laboratory. That was one shot, so I needed the set in one."

Claude Paré took this idea and ran with it. "Every wall is a piece of glass, because I wanted to add lots of depth," he explains. "I only used really cool colors like blue, because I really wanted it to feel cold and inhuman for the apes."

Above: An early piece of concept art detailing the inside of the Gen Sys offices.

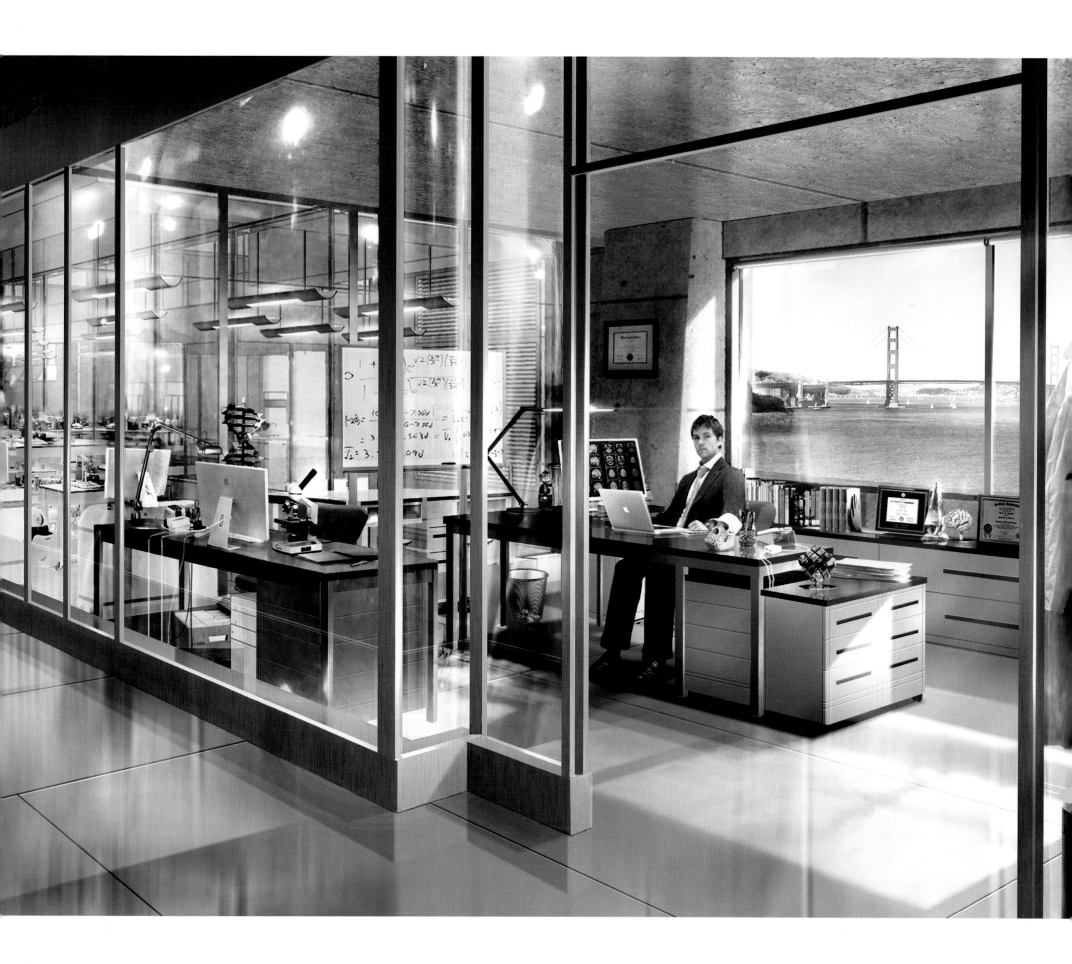

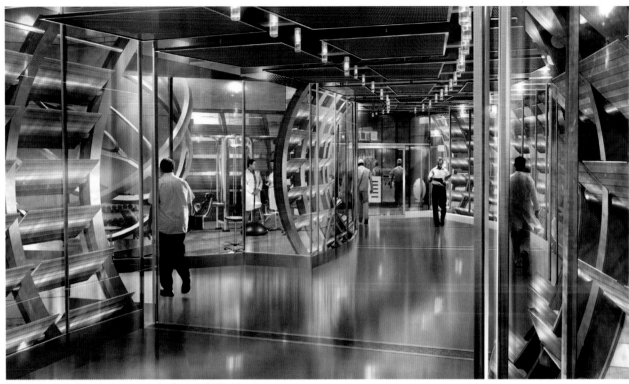

Above: Claude Paré's original concept design for part of Will's laboratory.
Below: Shooting in the finished set.

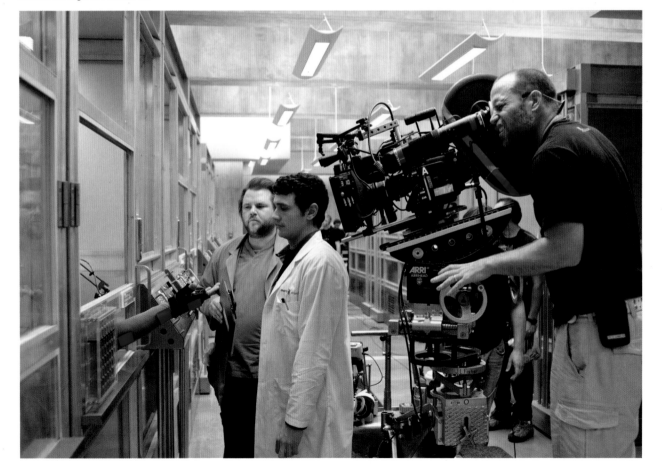

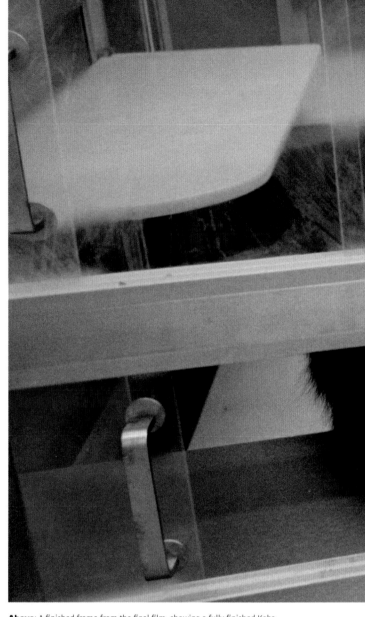

Above: A finished frame from the final film, showing a fully finished Koba.

Below: Christopher Gordon as Koba in his performance capture suit for the take.

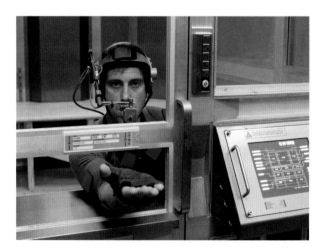

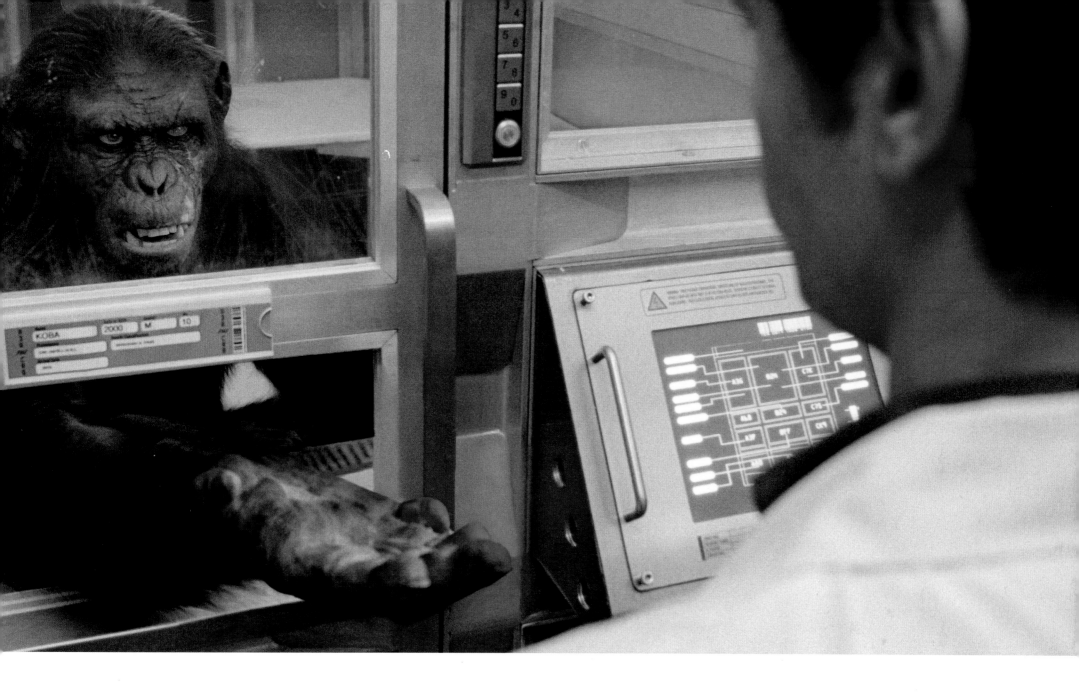

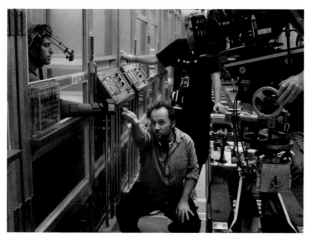

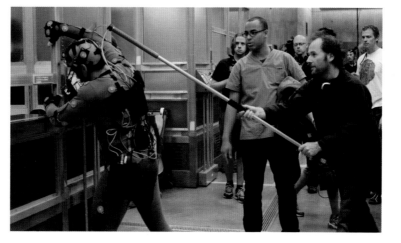

"All these cages were built individually and all the control panels would function. You could depress a button and a light would come on."

Claude Paré, *production designer*

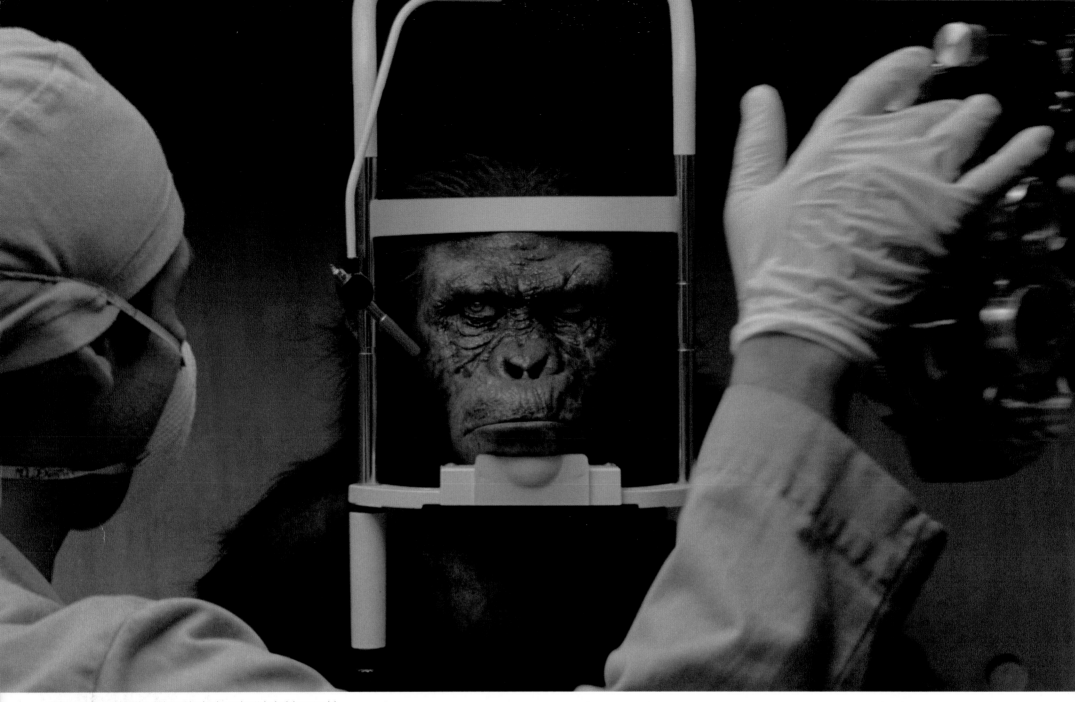

This page: Even this early on, the production knew that Koba had the potential to be more than just a foil for Caesar as the franchise progressed.

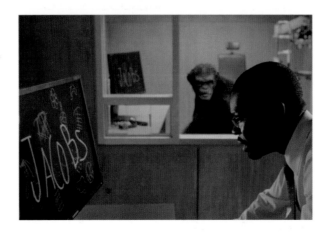

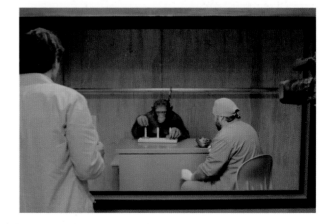

Above: Concept art of Koba caged.

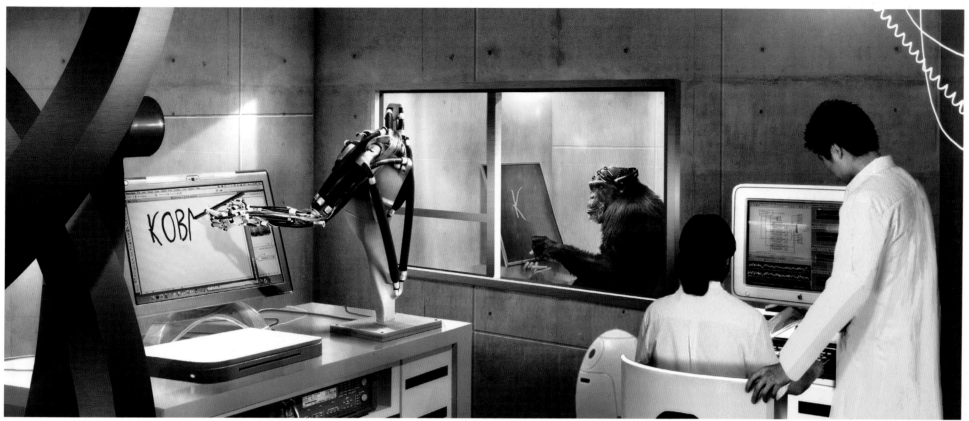

Above: Early concept art showing the intelligence testing performed on Koba.

Gen Sys is where we meet Koba for the first time. Concept artist Aaron Sims had to find a way of showing how Koba's experience with humans contrasted to that of Caesar's through his physical appearance.

"Koba was a character that we knew was damaged from the process of what the humans were doing," he explains. "That was something they wanted to convey in his look—that he'd had a hard life, that he'd probably had a hard life before they even captured him. A lot of it was in creating an imperfect character, an asymmetry to his face. Caesar looks symmetrical—symmetry we identify with as balance, and asymmetry we feel is off-putting."

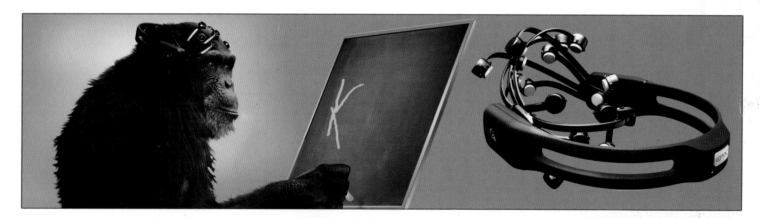

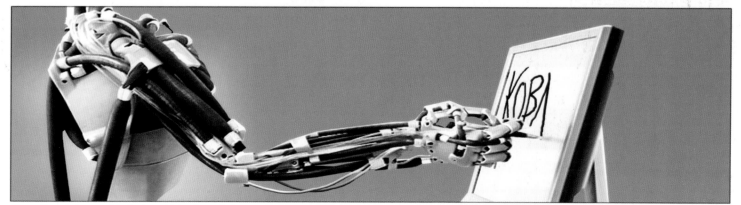

Above: These tests were originally planned to involve a robotic arm.

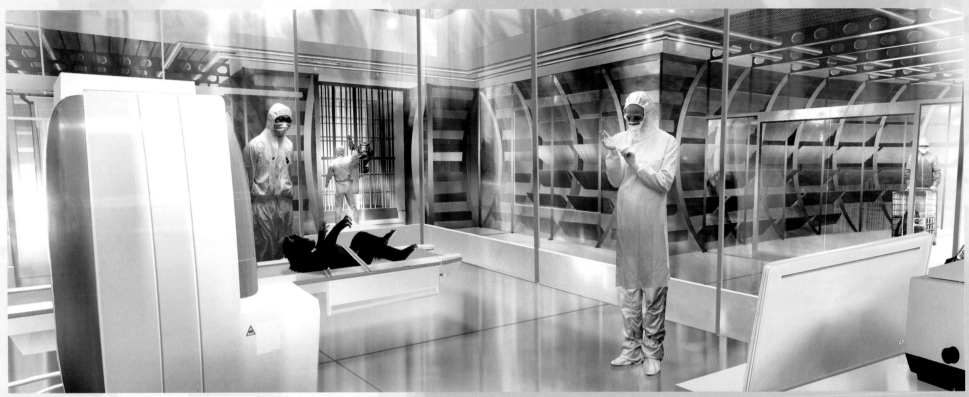

Above: Concept art for the CAT scanner room.

Opposite: Early concept art of Caesar's mother Bright Eyes escaping.

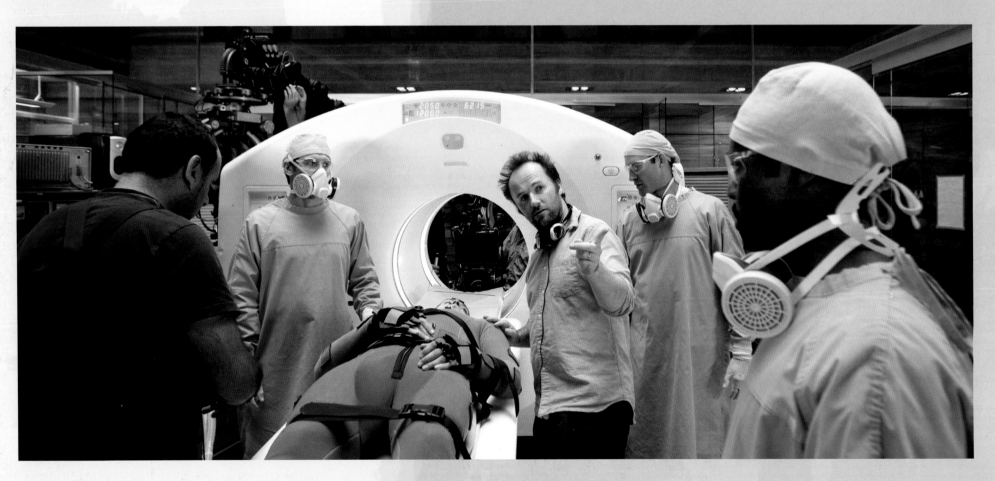

CAESAR GROWS UP

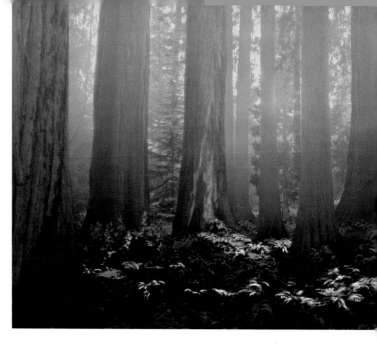

For the writers, some of the most significant parts of the film's structure were those scenes in which Caesar and Will spend time together as Caesar grows up. It was important for them to show that Caesar really had become part of the Rodman family.

"There was always a balance between Will enjoying him and genuinely loving him, and also being fascinated by his intelligence and recording it," explains Amanda Silver. "It was clear that Caesar was not just a scientific experiment that Will is running in his house. I think that's one of the things we pulled off—not just us, obviously, but Rupert, James, and Andy—there was that real bond there, as a motor for the whole movie."

"At first we got feedback saying, 'Get to the ape facility fast—we want to be there by the end of the first act'," Jaffa recalls. "We kept saying that we need to spend some time with him in the home to build this bond, because that's what fuels Caesar's emotional journey—his [sense of] betrayal and the other things that happen in the script don't work unless you have that strong bond created."

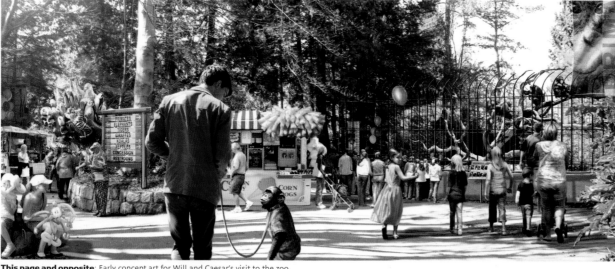

This page and opposite: Early concept art for Will and Caesar's visit to the zoo.

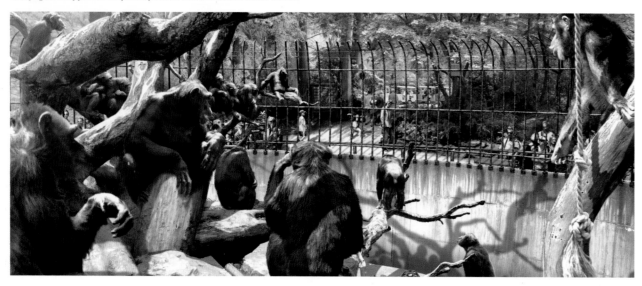

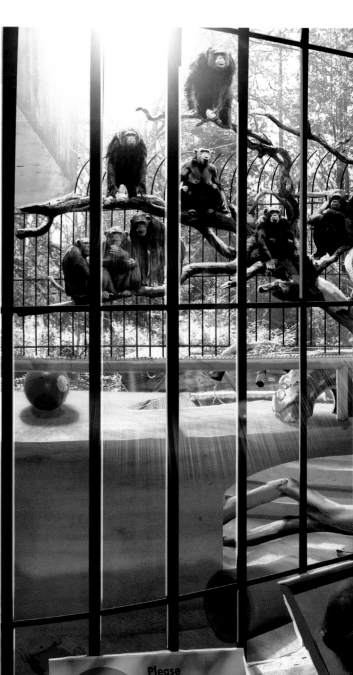

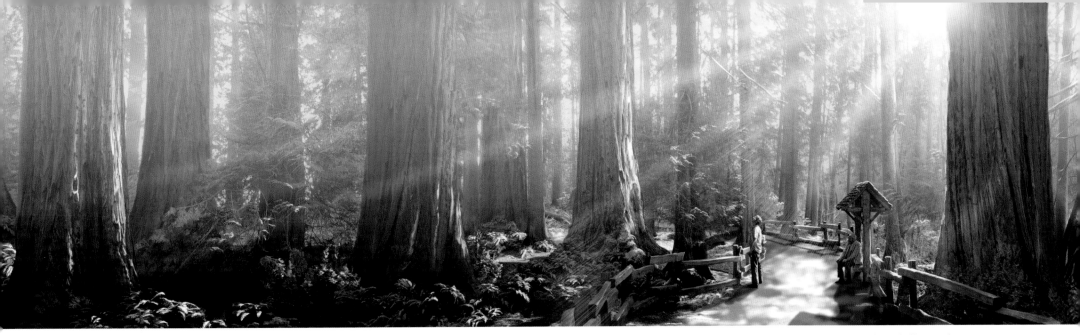

Above: Muir Woods would be a significant setting throughout Caesar's story.

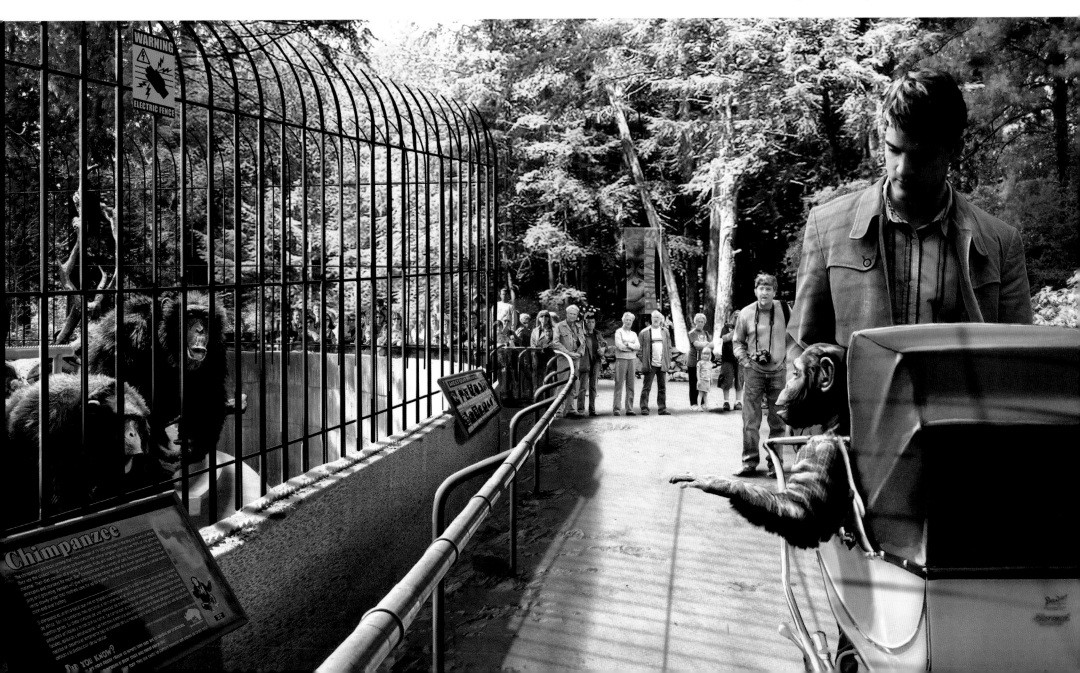

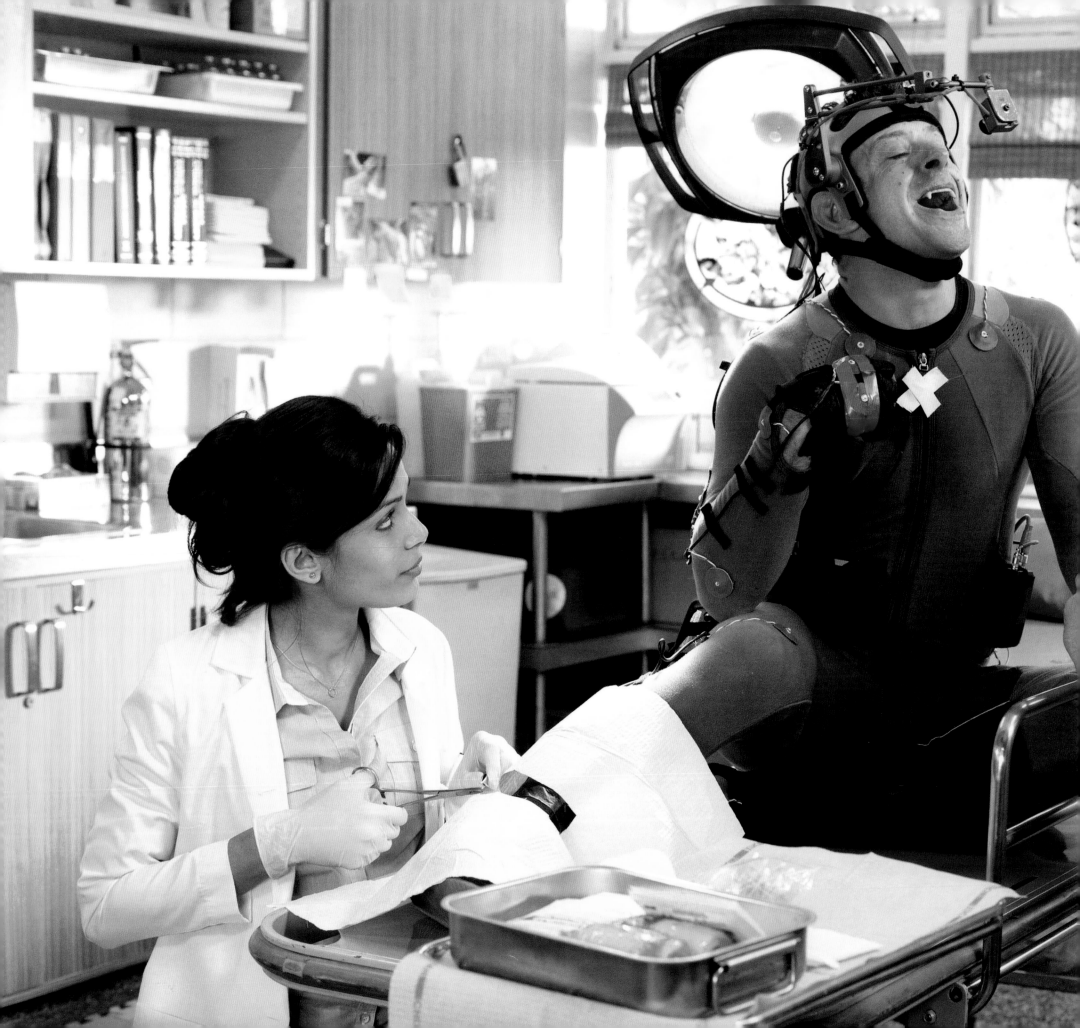

As that bond between Will and Caesar strengthens, Will meets primatologist Caroline (Frieda Pinto). "She loves the fact that Will cares for a chimpanzee so much that he treats him almost like a son, a human," says Pinto. "As the movie progresses, I think the father/son relationship takes over," agrees Franco. "Will becomes even more humane and less of a scientist, and starts to care about Caesar more than the success of his drug."

Franco admits that from the first scene, he found acting opposite Serkis "easy, because Andy is so good at the behavior, he's so connected to what he's doing, and to the other actors, that he allows my imagination to take over, and I really can treat him as if he were a chimpanzee."

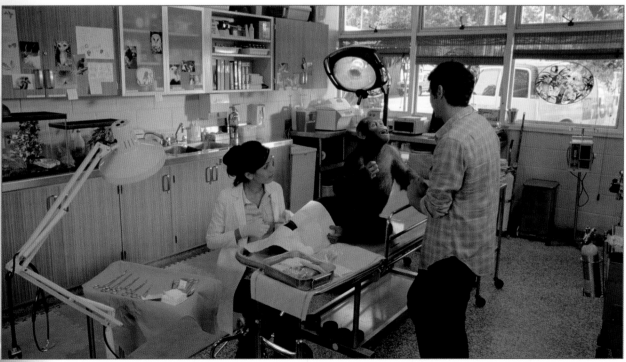

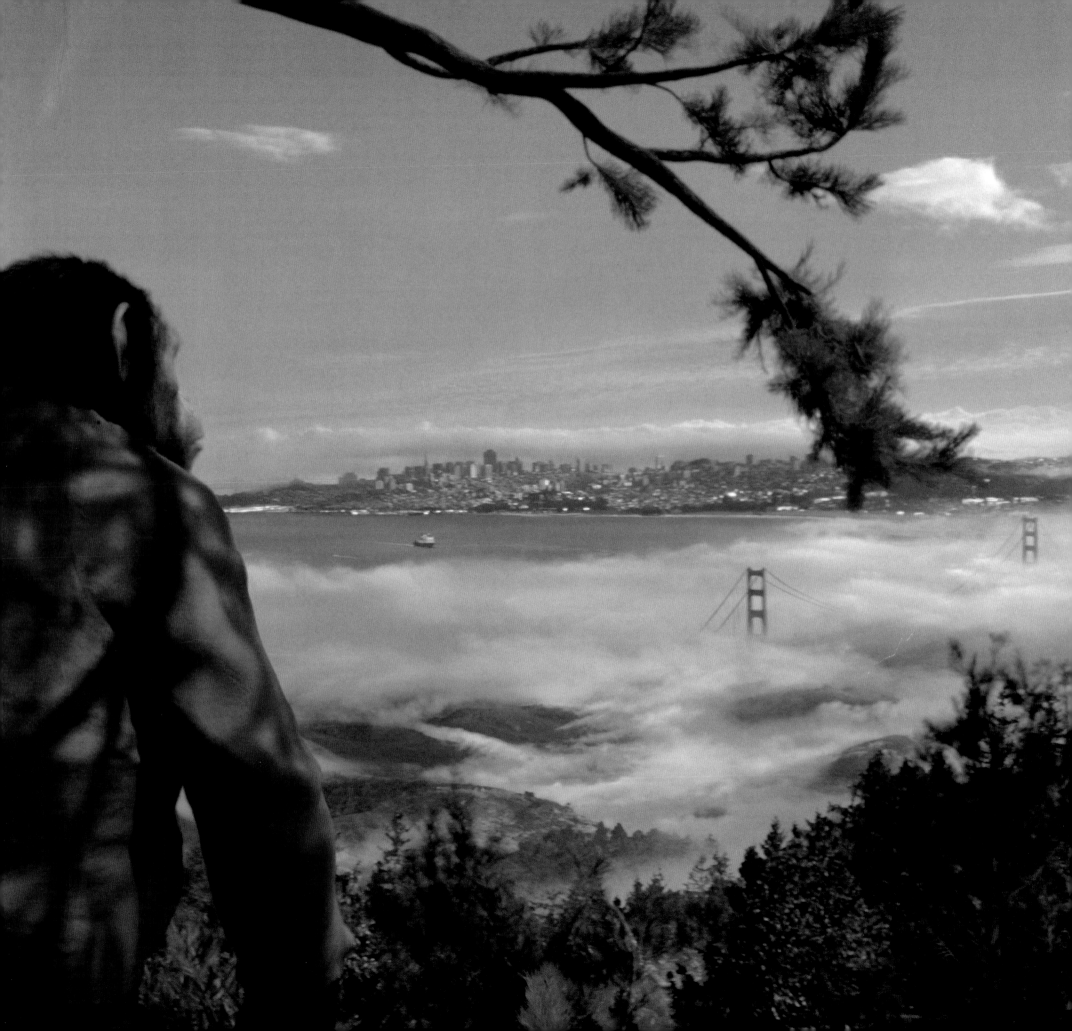

Muir Woods would be an extremely significant setting throughout both *Rise* and *Dawn of the Planet of the Apes*. Fittingly, it's where Caesar first begins to question his place in Will's world when he sees a large German Shepherd dog wearing a leash similar to his own.

"That was a significant moment for me," recalls Andy Serkis. "If you remember, what it cuts to after that is Caesar being led by Will back to the car. He's been used to jumping into the trunk like a dog, and he chooses to sit in the back seat. That was an improvised moment. That was a moment of, hold on—this does not feel right that Caesar would jump into the trunk again. He would stop and question it, given the thing that he's just experienced. I think that was a real turning point for me playing the character and also for Rupert, actually. We realized we'd hit on something there—it represented a big character transformation."

"It's character though," adds Amanda Silver. "That's the deal—it's a total character choice. Andy's a genius."

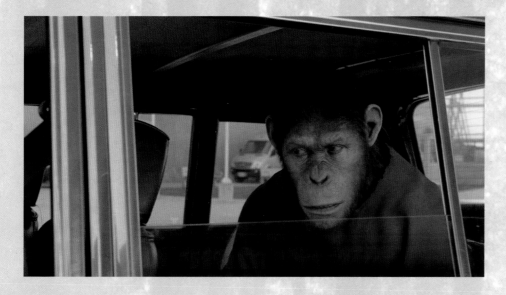

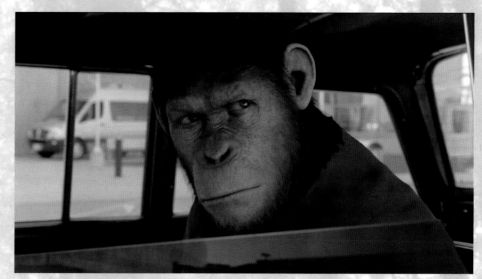

WILL'S HOME

Most of the exteriors and locations in *Rise* were shot in and around Vancouver, British Columbia, as was the location picked for Will's home. "We chose it primarily because it had a façade, and also, obviously, the street for the chase sequence," explains Wyatt. "The interior was all on set."

Shooting a location in Vancouver, Canada, and making it look as if it's actually in San Francisco, California, presented some issues for production designer Claude Paré and his team. The street and its houses were perfect, but the foliage surrounding it was not. "It's that kind of neighborhood where all the great Victorian houses are,"

says Paré. "The big difference is the greens. It's like rainforest in Vancouver, whereas San Francisco is more like desert, so we had permission from the municipality to pressure wash the moss off the trees so that they were not as green as they are most of the time."

For the interiors and also the scenes shot in Will and his neighbor Hunsiker's back yards, Paré constructed several large sets at Mammoth Studios in Burnaby, B.C. "You could go through the house, all the way to the back and exit into the courtyard," he says. "The second floor was built on another stage and the attic was built on another stage, as well."

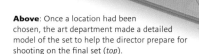

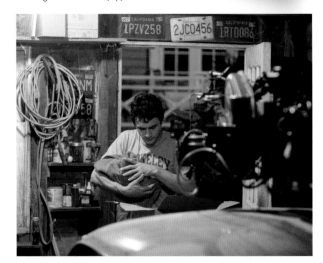

Above: Once a location had been chosen, the art department made a detailed model of the set to help the director prepare for shooting on the final set (*top*).

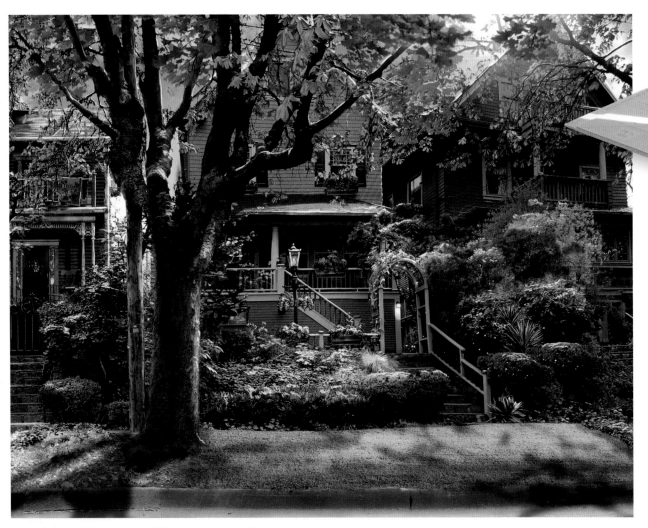

Above: Concept art for the exterior of Will's home. The design for the soon-to-become iconic attic window had not been finalized at this point.

Above: Will brings the infant Caesar home.

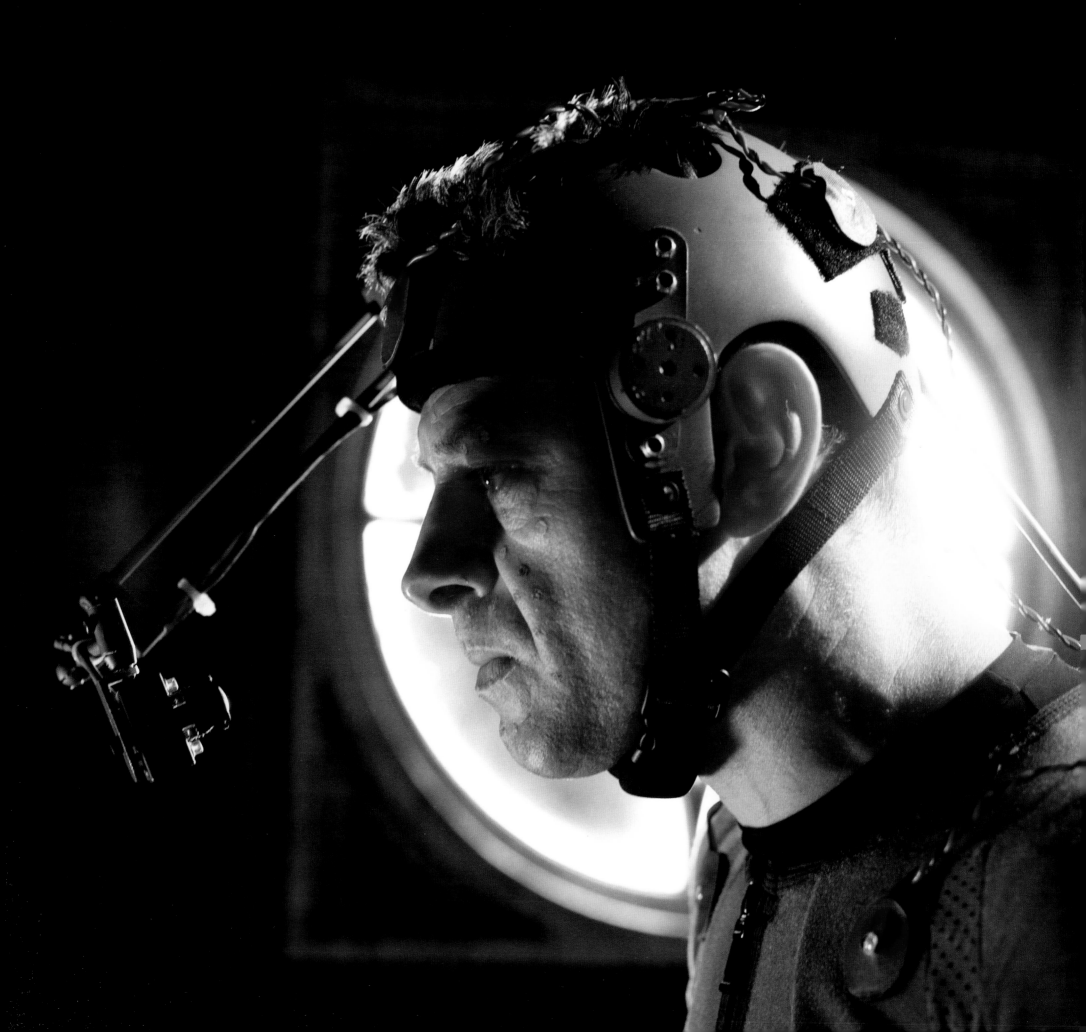

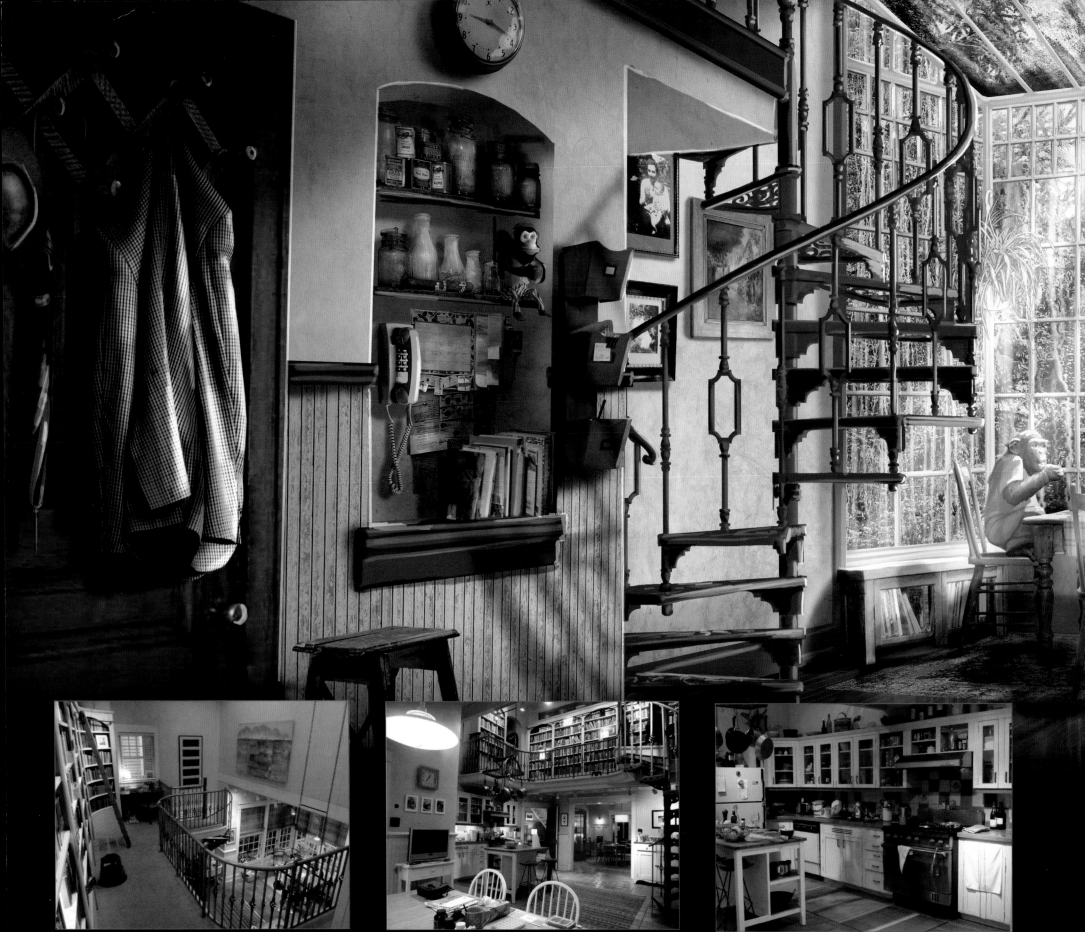

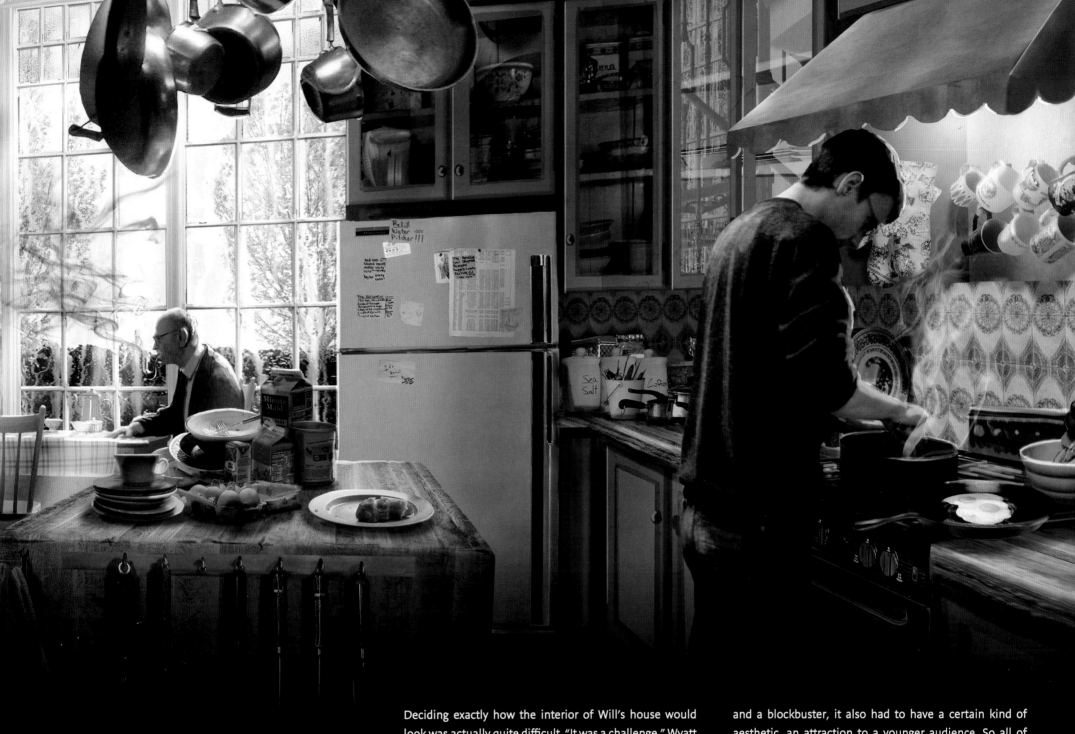

Deciding exactly how the interior of Will's house would look was actually quite difficult. "It was a challenge," Wyatt admits. "You're talking about a slightly unusual living situation, with an older man and his younger but very adult, grown-up son. I needed to design it from the point of view of giving it a certain reality, but at the same time masculinity. It had to be in keeping with what represented John Lithgow's character, but because it's a modern film

and a blockbuster, it also had to have a certain kind of aesthetic, an attraction to a younger audience. So all of those considerations were taken into account, but for me it was very much on the page in Rick and Amanda's script, which was wonderful."

"The layout was really made for accommodating the script," agrees Paré, "because the whole dining room becomes a giant lab for Will."

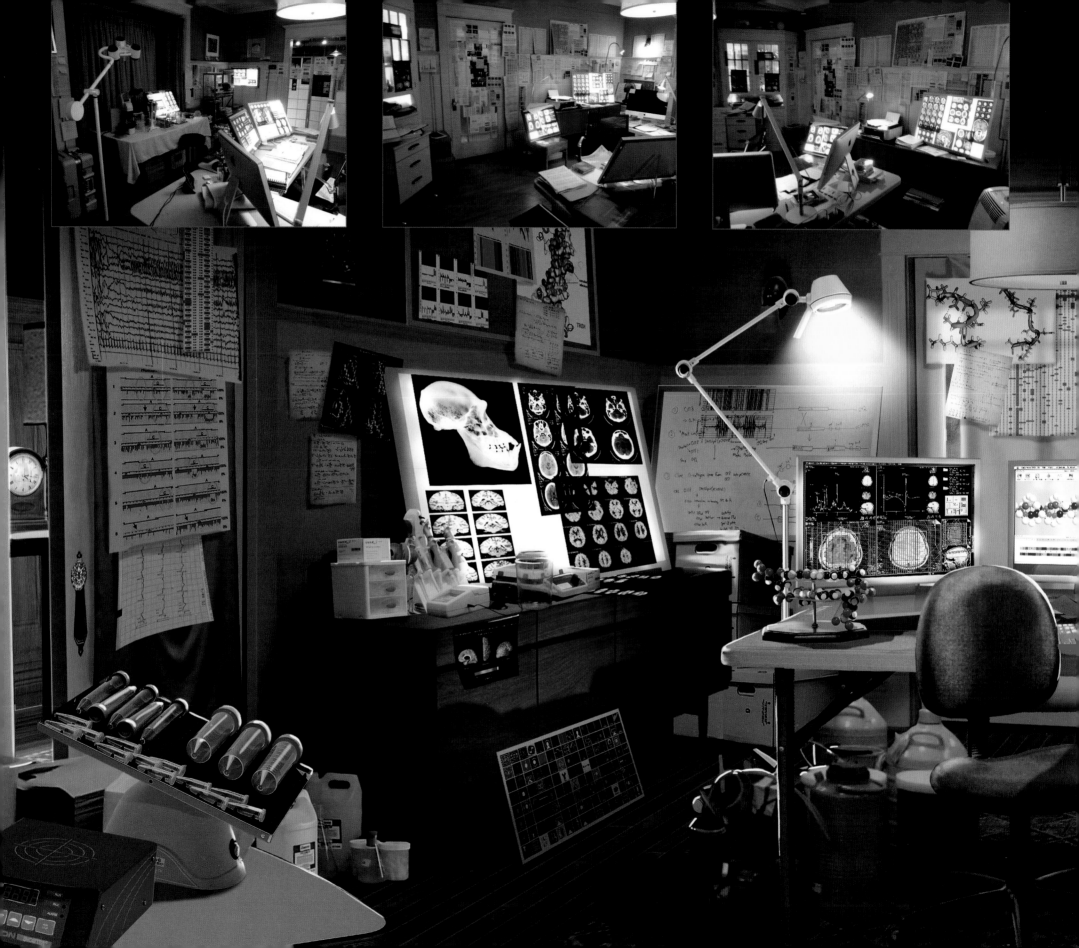

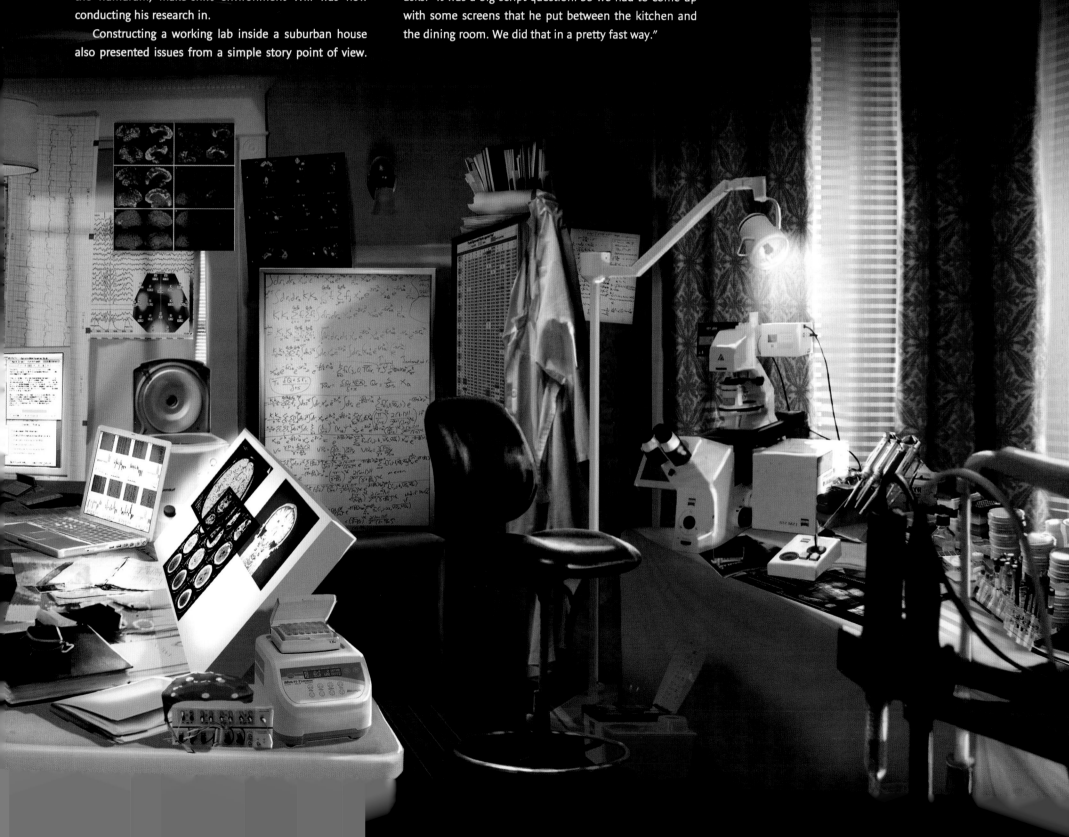

When Will's experiments are closed down by Gen Sys, his home has to become his primary work space. Paré's designs for what this space would look like deliberately played on the contrast between the pristine, sterile working environment at the laboratory complex and the humdrum, make-shift environment Will was now conducting his research in.

Constructing a working lab inside a suburban house also presented issues from a simple story point of view.

After all, it's one thing hiding a room full of scientific equipment if people rarely visit your house, but it's another if you have, as Will had with Caroline, a developing romantic relationship.

"How could he hide this from her in this house?" Paré asks. "It was a big script question. So we had to come up with some screens that he put between the kitchen and the dining room. We did that in a pretty fast way."

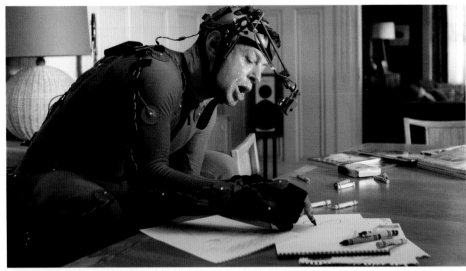

Above and right: Andy Serkis in full performance capture gear, and how the finished scene turned out.
Below: Early concept art. Caesar becomes part of the family.

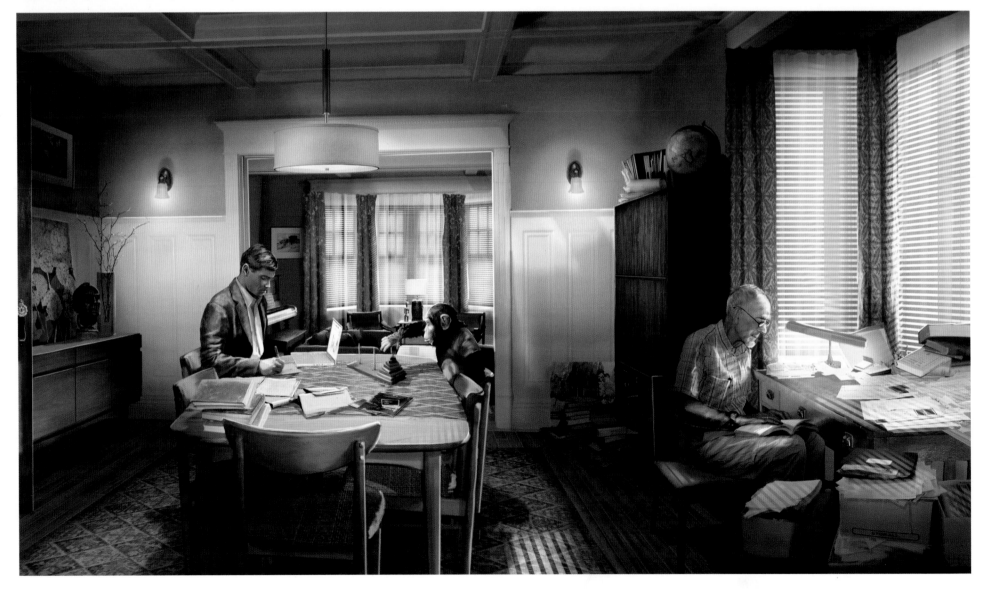

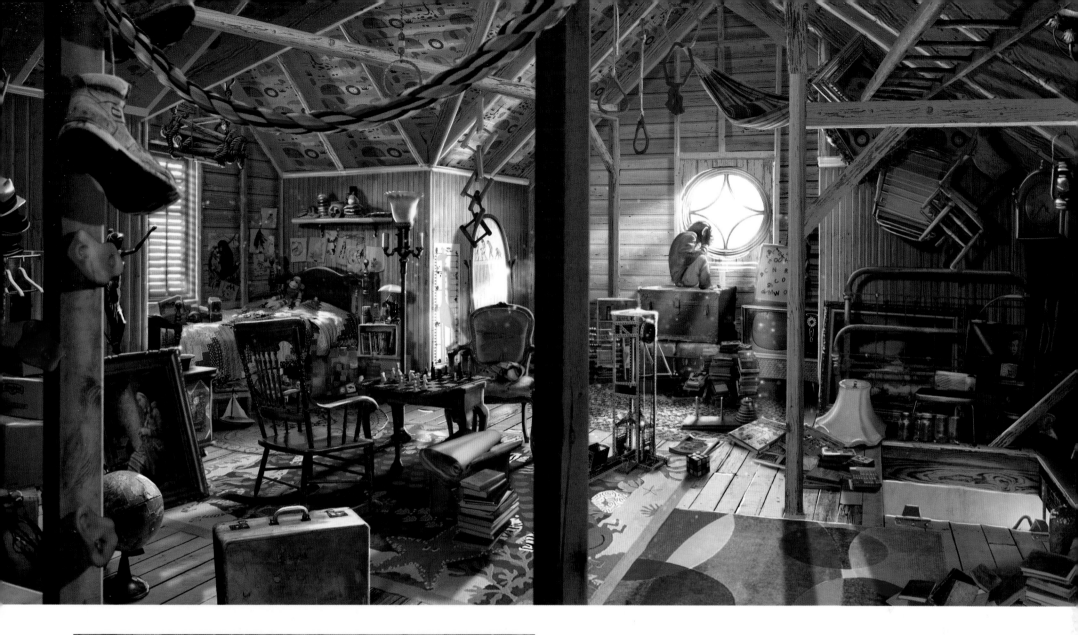

"It was really appealing to be able to design an idealized child's bedroom," recalls Wyatt, of discussions surrounding the attic set. Paré and his team really went to town on the design, filling the space with color and fun. "The director and the script were saying to make it like his bedroom," the designer recalls. "So it had to be convivial, it had to have tons of games and stuff to play with. You want to keep him training his brain, because he's very smart, so he has all these IQ games in there. We created our own wallpaper based on paper we liked. But we had to move quickly—all of this was pre-paneled, because we had just a night to change it from the bare attic set to this nice environment."

Above: The design for Caesar's attic bedroom was faithfully transferred to the final set (left).

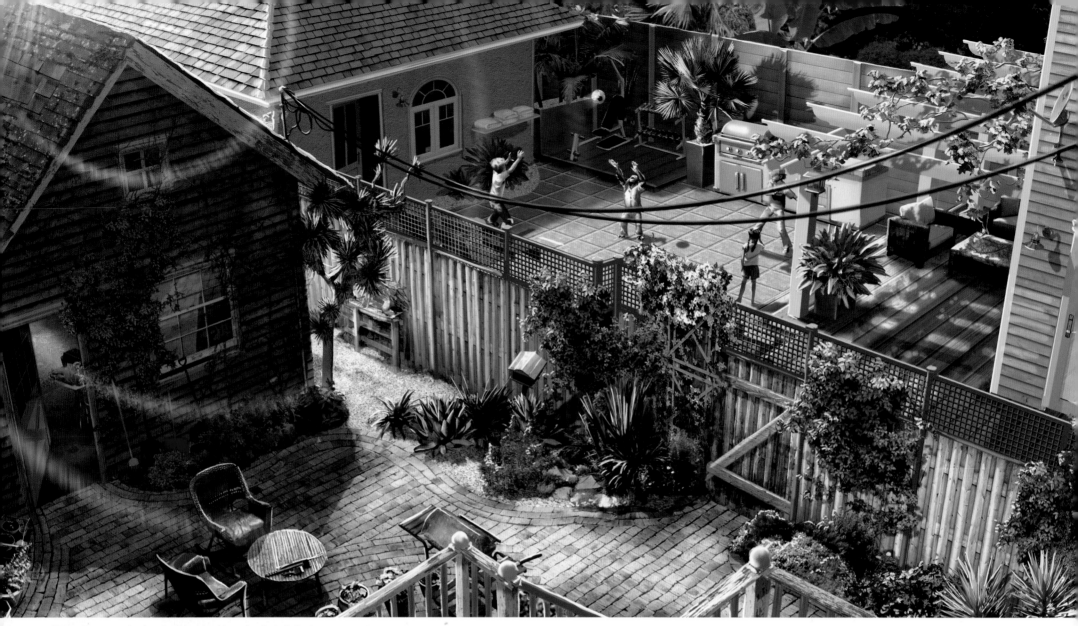

Above: Concept art showing what Caesar would see when he looked out of his attic bedroom, and the final set (below).

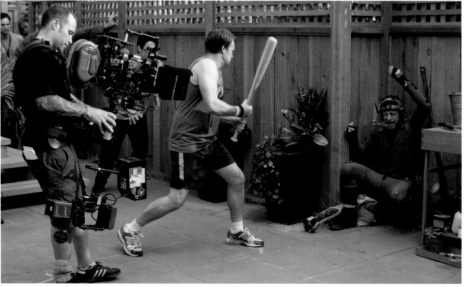

Above: Filming Caesar's first confrontation with next door neighbor Hunsiker, played by David Hewlett.

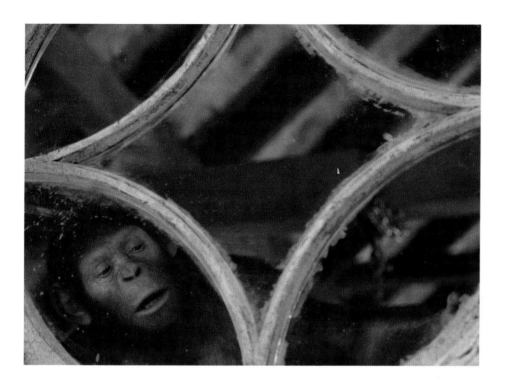

The Caesar's attic set was important, not only in terms of showing the care Will and his father had taken over the raising of this chimp, but also because one specific aspect of it would become a significant motif.

"The window came about, really, from just trying to identify his place," says Wyatt. "Then, out of that, when we were shooting the primate facility scenes, we were trying to figure out how to give a sense of what he was yearning for."

For Paré, this meant creating a shape distinctive enough that the audience would both remember and instantly identify it. "Once we came up with the nice diamond shape, they decided OK, that's what he will draw on the wall once he is in his cage, to remind himself of how nice it was," says the production designer. "He dreams that he can go back there to his attic and look outside at the kids playing. And we built the reverse of that, the exterior house roofline with the window, so that we could shoot it on the stage, coming into the actual set that had Caesar looking out."

Below: Filming for the attic window scenes also took place on a performance capture stage, known as a 'volume'.

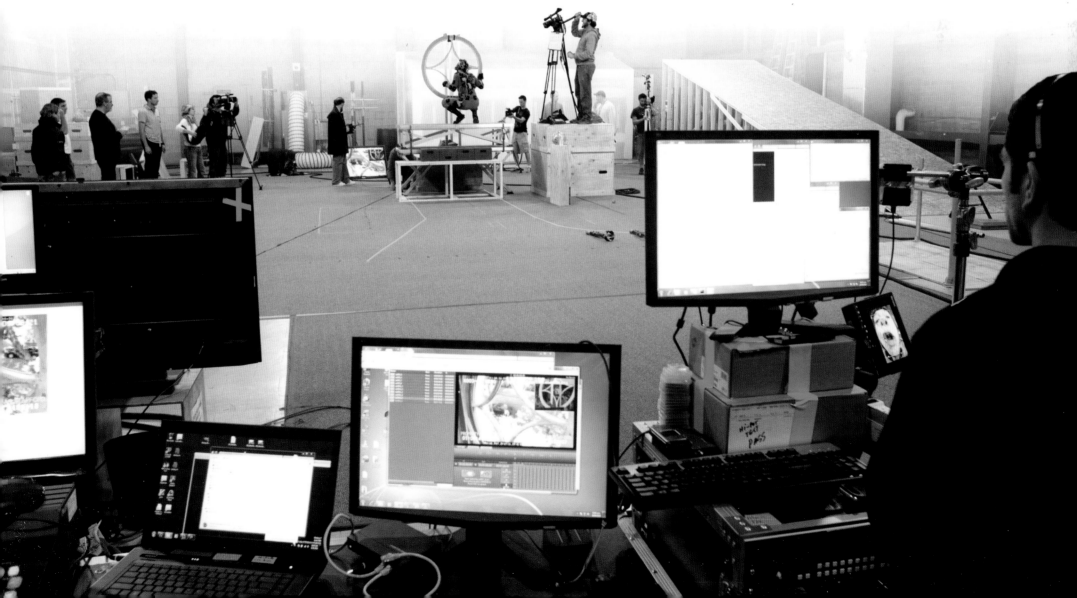

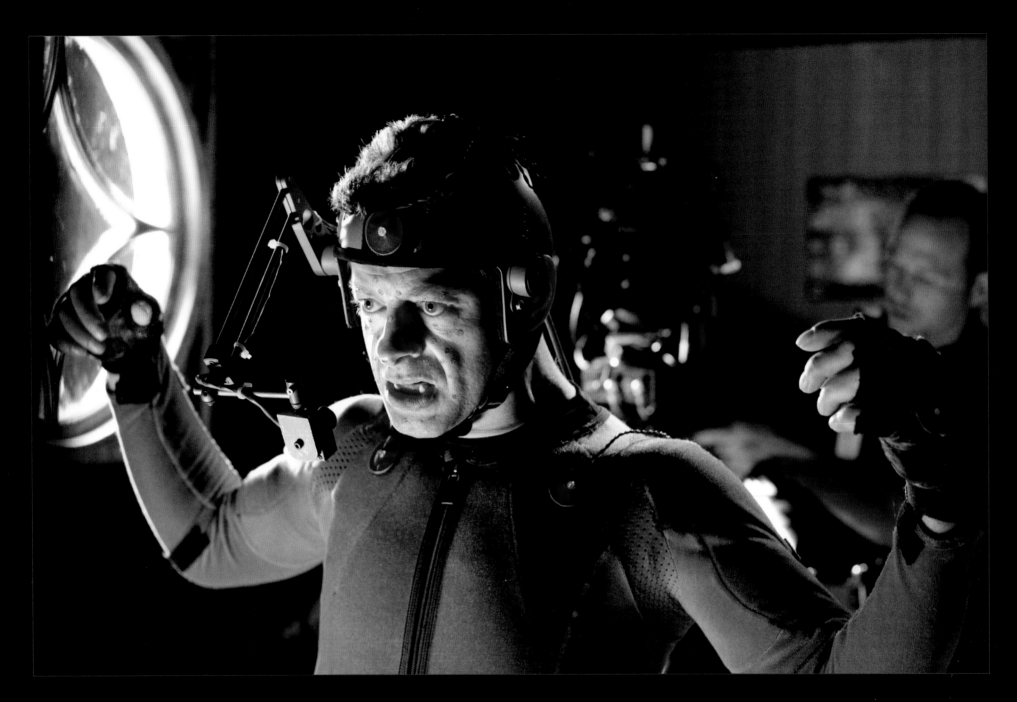

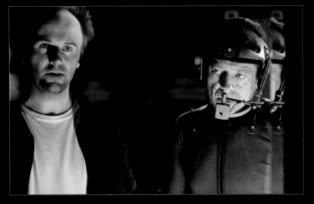

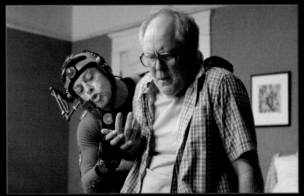

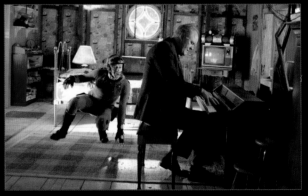

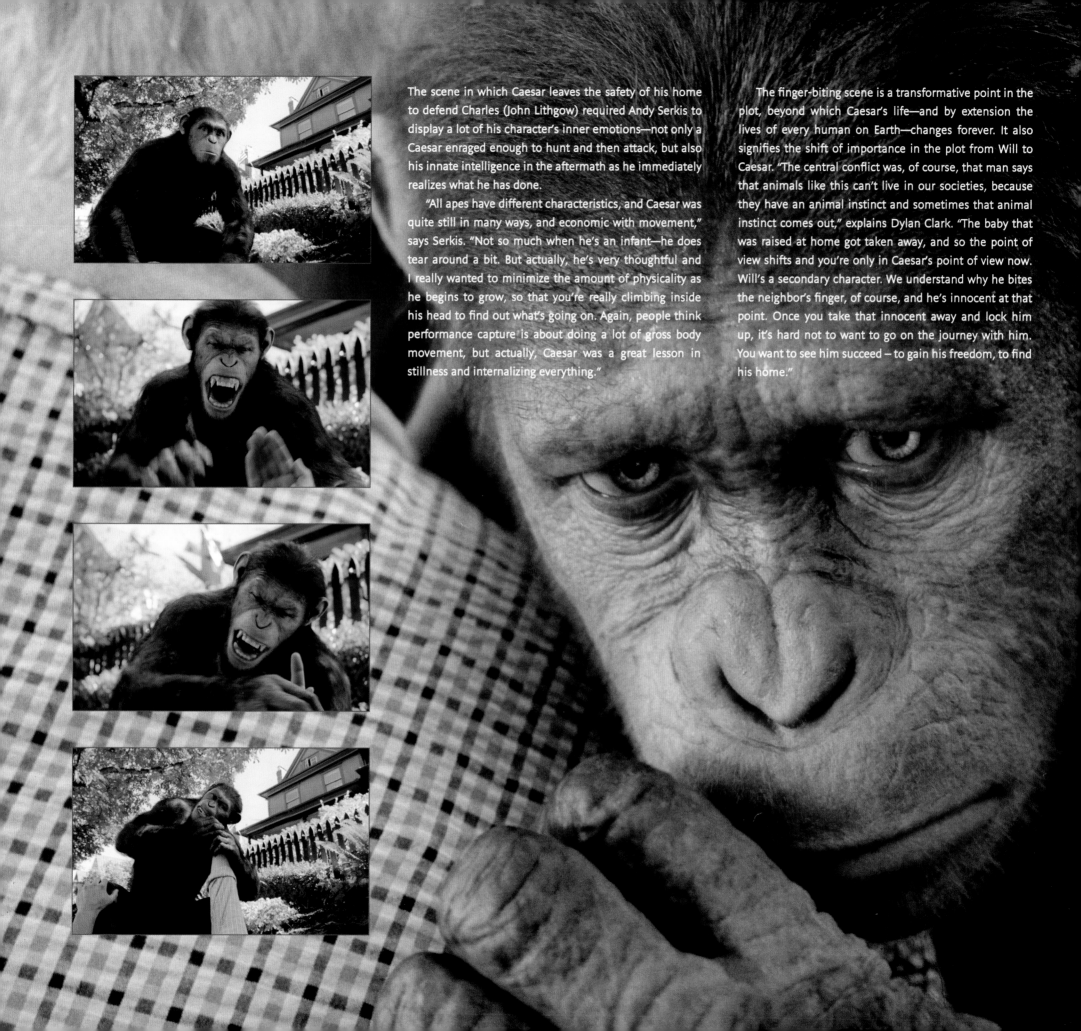

The scene in which Caesar leaves the safety of his home to defend Charles (John Lithgow) required Andy Serkis to display a lot of his character's inner emotions—not only a Caesar enraged enough to hunt and then attack, but also his innate intelligence in the aftermath as he immediately realizes what he has done.

"All apes have different characteristics, and Caesar was quite still in many ways, and economic with movement," says Serkis. "Not so much when he's an infant—he does tear around a bit. But actually, he's very thoughtful and I really wanted to minimize the amount of physicality as he begins to grow, so that you're really climbing inside his head to find out what's going on. Again, people think performance capture is about doing a lot of gross body movement, but actually, Caesar was a great lesson in stillness and internalizing everything."

The finger-biting scene is a transformative point in the plot, beyond which Caesar's life—and by extension the lives of every human on Earth—changes forever. It also signifies the shift of importance in the plot from Will to Caesar. "The central conflict was, of course, that man says that animals like this can't live in our societies, because they have an animal instinct and sometimes that animal instinct comes out," explains Dylan Clark. "The baby that was raised at home got taken away, and so the point of view shifts and you're only in Caesar's point of view now. Will's a secondary character. We understand why he bites the neighbor's finger, of course, and he's innocent at that point. Once you take that innocent away and lock him up, it's hard not to want to go on the journey with him. You want to see him succeed – to gain his freedom, to find his home."

PRIMATE SHELTER

The narrative of *Rise* takes a dark turn following the events in which Hunsiker is attacked. Will is forced to place Caesar in a government-run primate shelter, kicking off the tumult that eventually leads to the apes' revolution.

This spread: The Agrodome, an events center in Hastings Park, Vancouver was used as the exterior. As with Will's home, the interior was built on a sound stage.

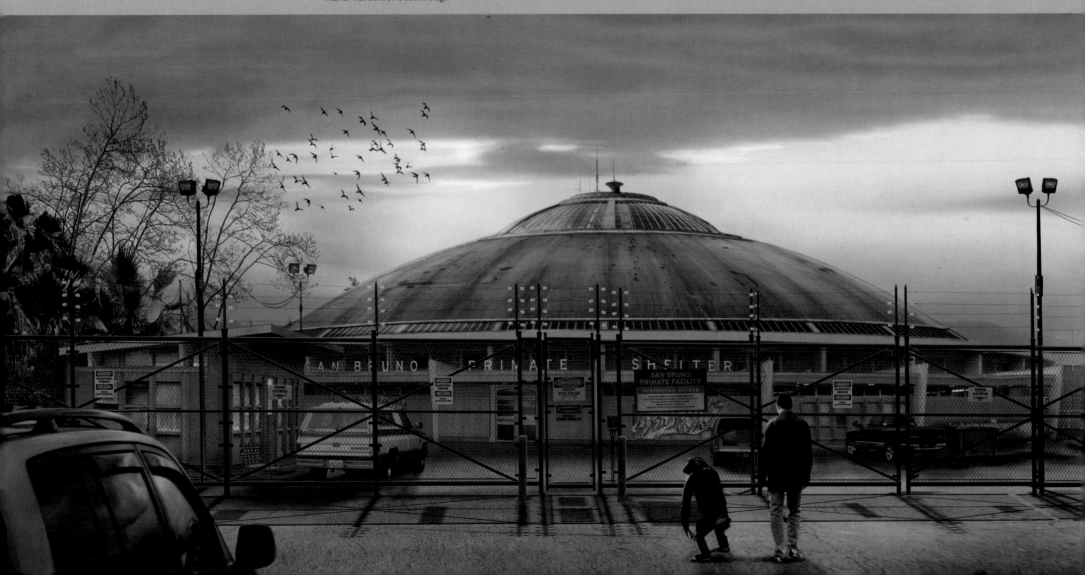

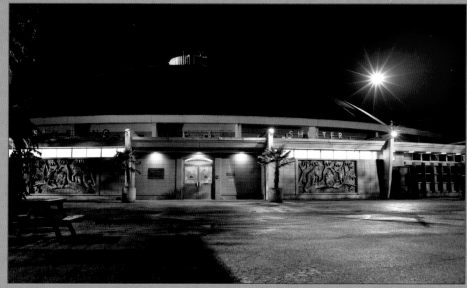

Above and right: Claude Paré created large concrete bas-relief pieces depicting apes to cleverly conceal most of the location's existing doors.

"The aesthetic of the primate facility was an interesting ongoing discussion with the studio from a creative point of view," recalls Wyatt. "I always wanted it to look like a Turkish prison, and give a sense of a real hell that he's going into. While they totally respected the fact that we needed to tell the story and we needed to show that it's no picnic for Caesar, there were concerns about going a little dark. What was interesting that came out of our conversations was the decision to create this atrium-like environment. I had this idea with Claude that, OK, maybe what we can do is make it look like it's fun—there's a waterfall and rocks and there's a mural around the atrium. But in being there and finding his way around, Caesar realizes that it's fake. It's a prison. So in a way, that's even more torture than the place looking like hell—it's supposed to make you feel happy, but actually it's just as bad as the metal bars of a cage. That's where the atrium came from. The holding pens stayed closer to my original idea, which was to put them in what was similar to a human prison."

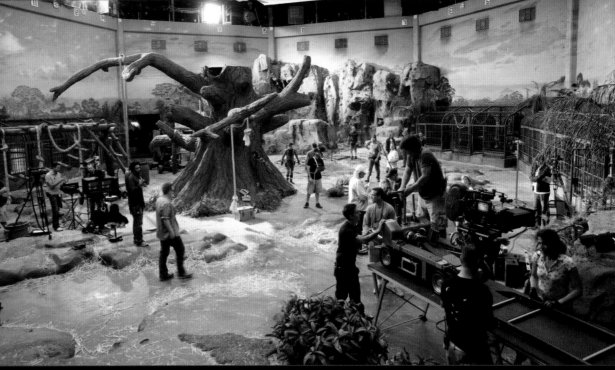

Above: For the mural surrounding the apes' atrium habitat, Paré sourced an existing product and then aged it to suggest a neglected facility.

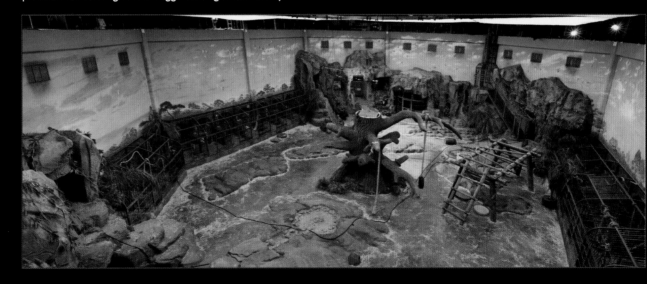

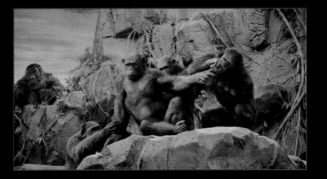

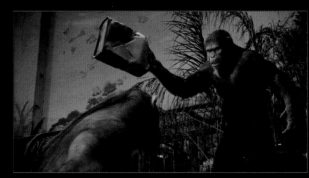

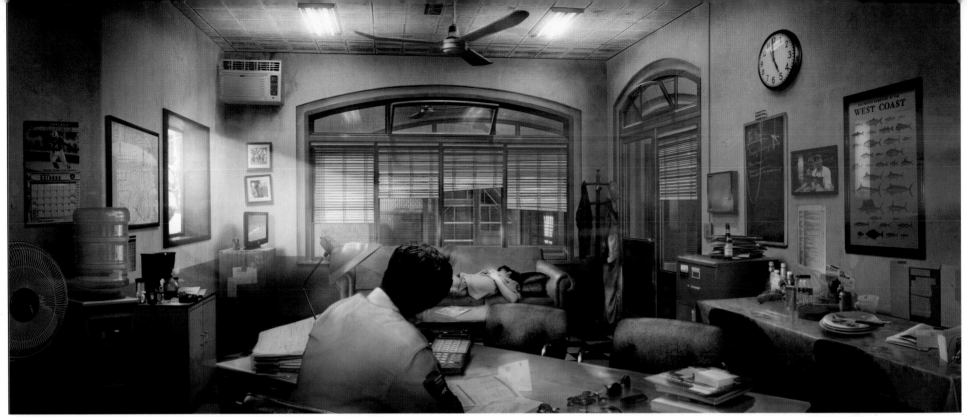

This page: Paré was keen to make the dingy décor inside the facility really feel as if it had been designed and then run down by municipal employees who weren't bothered by their surroundings.

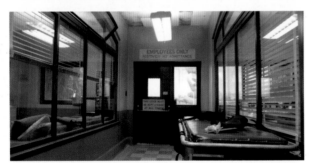

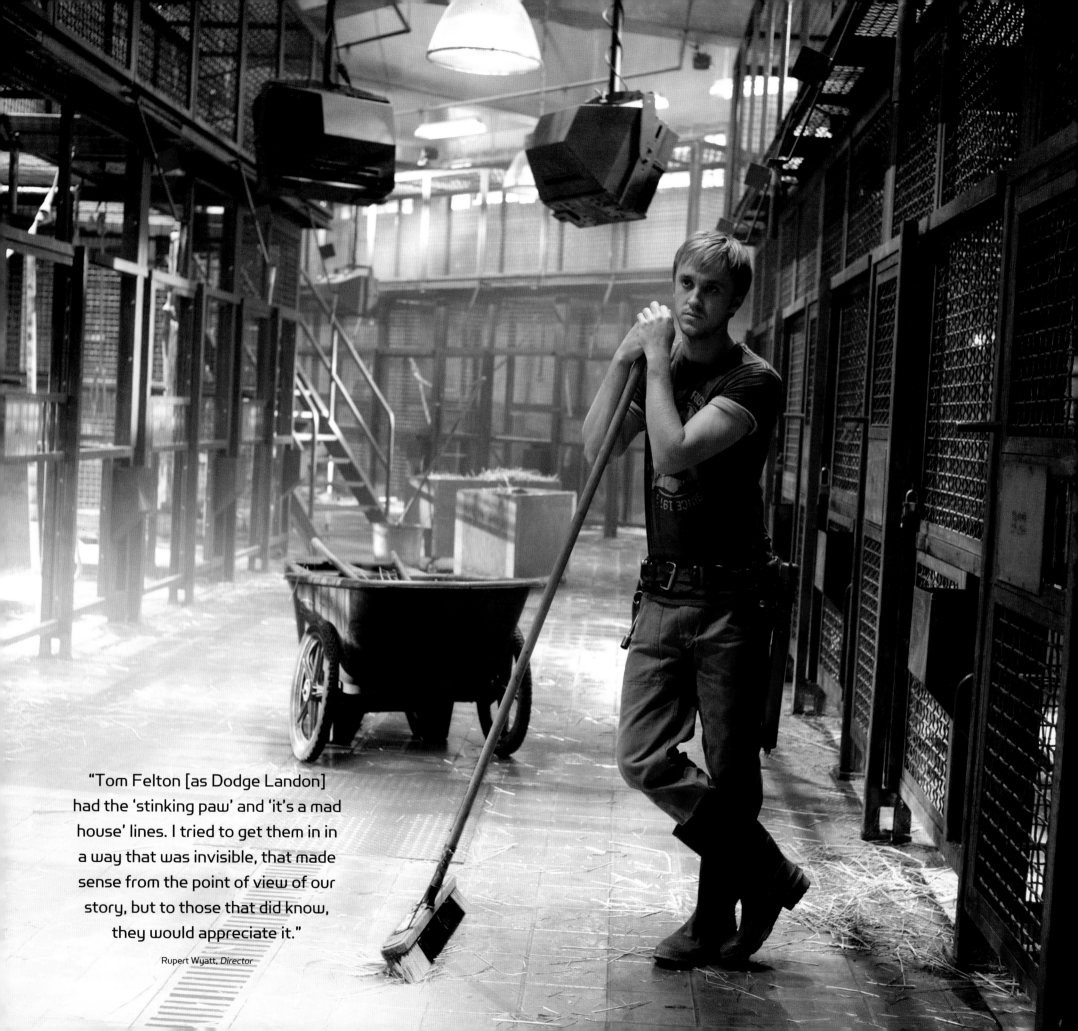

"Tom Felton [as Dodge Landon] had the 'stinking paw' and 'it's a mad house' lines. I tried to get them in in a way that was invisible, that made sense from the point of view of our story, but to those that did know, they would appreciate it."

Rupert Wyatt, *Director*

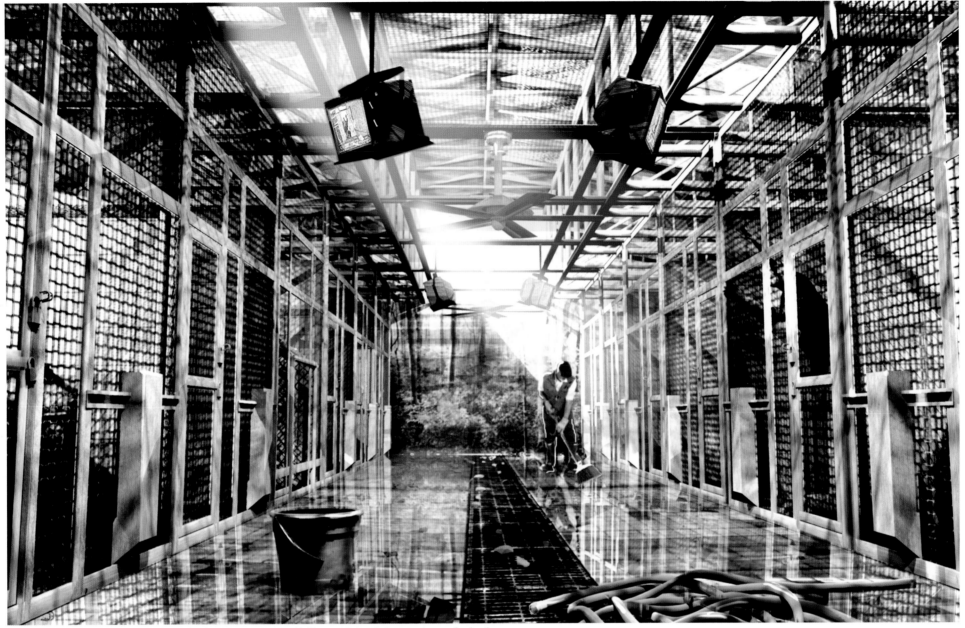

Above: As with the Gen Sys sets, Paré made sure that the ape cages were assembled in a way that made them easy to move for shooting.

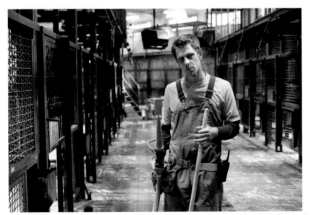 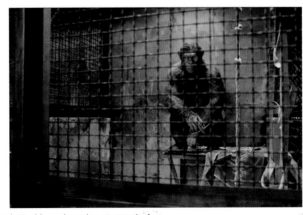 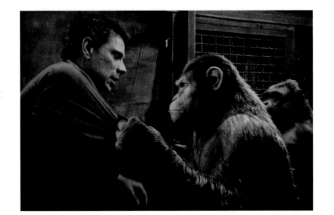

Above: The bleak surroundings and jaded employees of the shelter—including Rodney (Jamie Harris)—are in stark contrast to the fun and color of Caesar's attic room and the warm family atmosphere of Will's house.

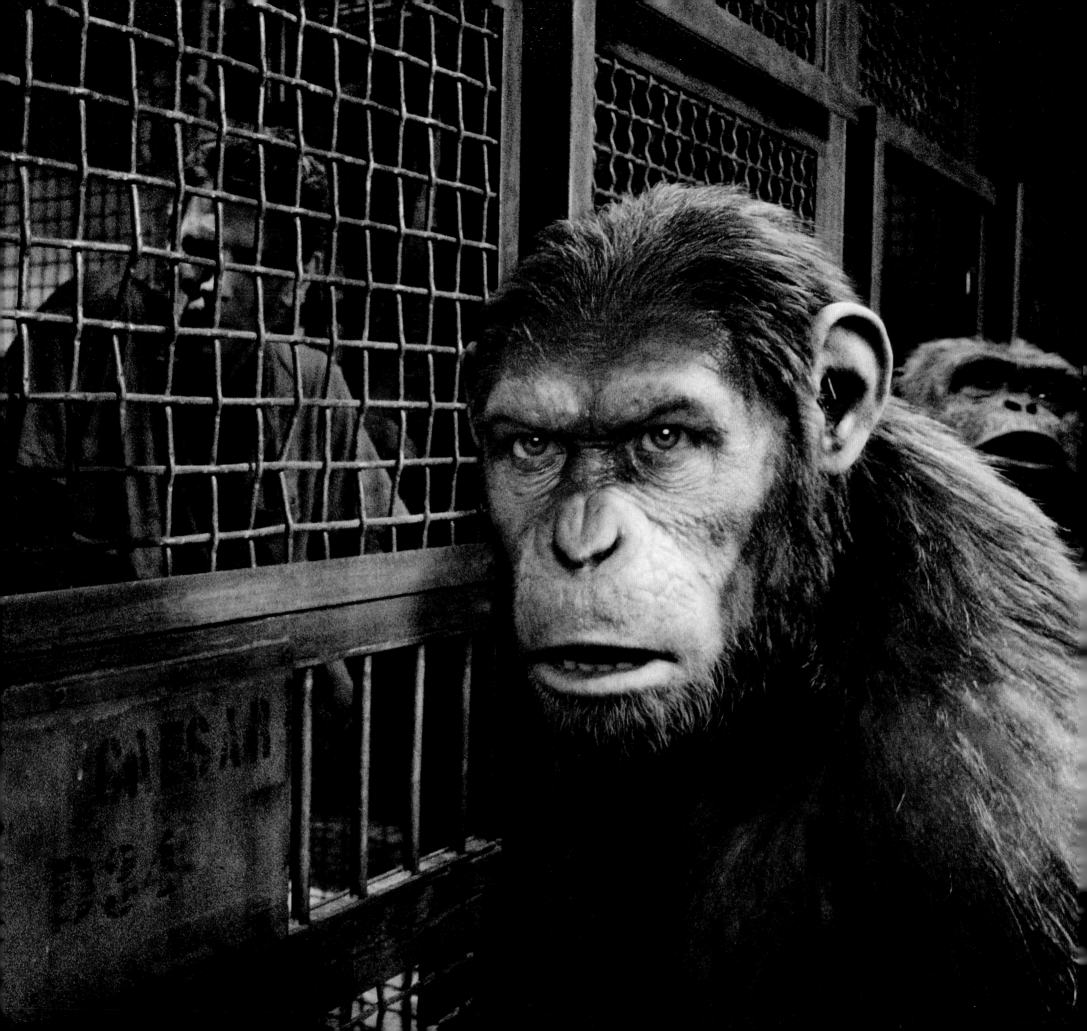

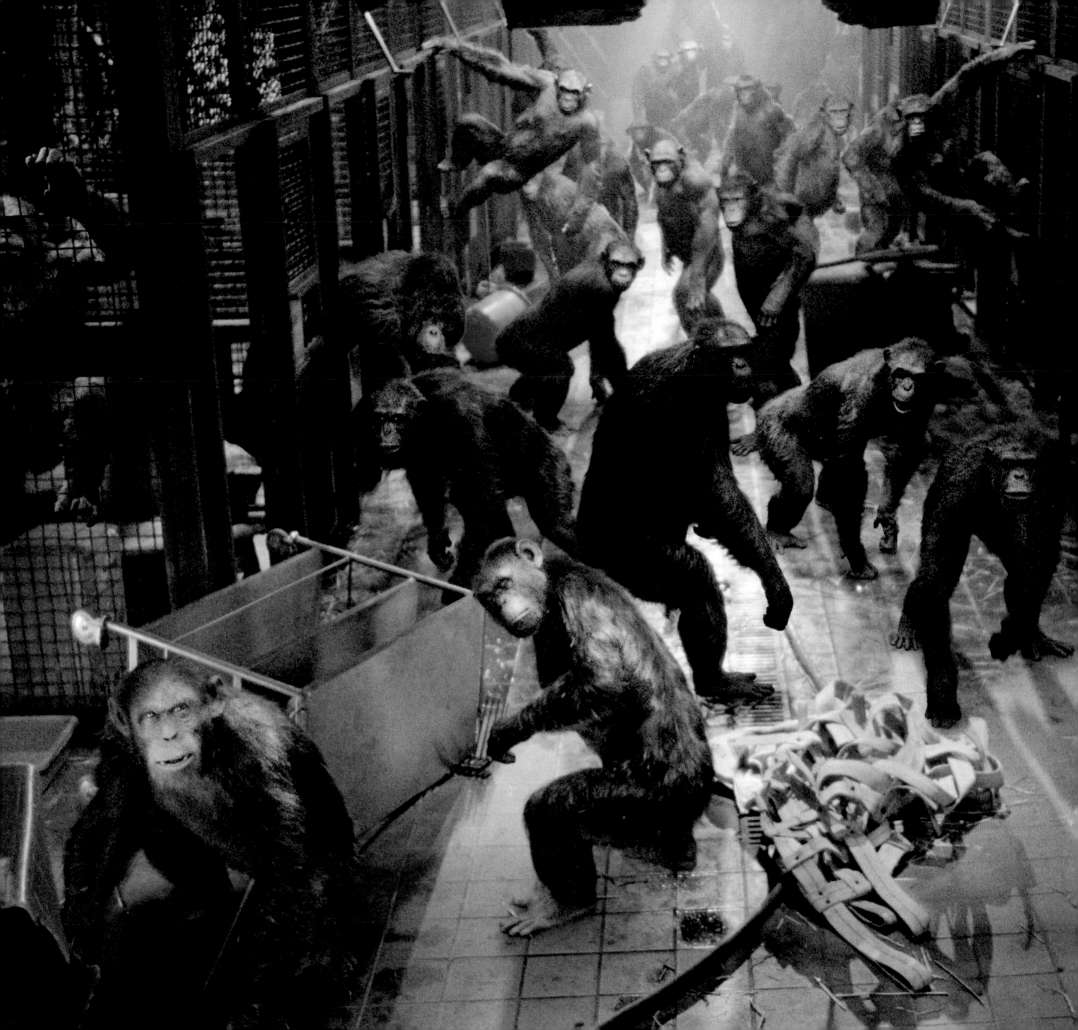

The scenes set inside the primate facility serve not only to fuel the coming rebellion, but also a transformation in Caesar. "I always played Caesar as almost a human trapped inside an ape's skin," says Serkis. "He had to find his inner ape when he went to the sanctuary. I think he realizes that he's different. He's an outsider, and whether that's a good or bad thing, it's a realization that he is not like the others. He is like a Dickensian character, in a way, this young child that is thrown into a gang of people who doubt him and want to put him down, led by Rocket, of course. Because he has the intelligence, he finds a way of communicating through his connection with Maurice and sign language, eventually bringing them round. He finds himself at the center of this revolution which leads them to freedom."

ESCAPE

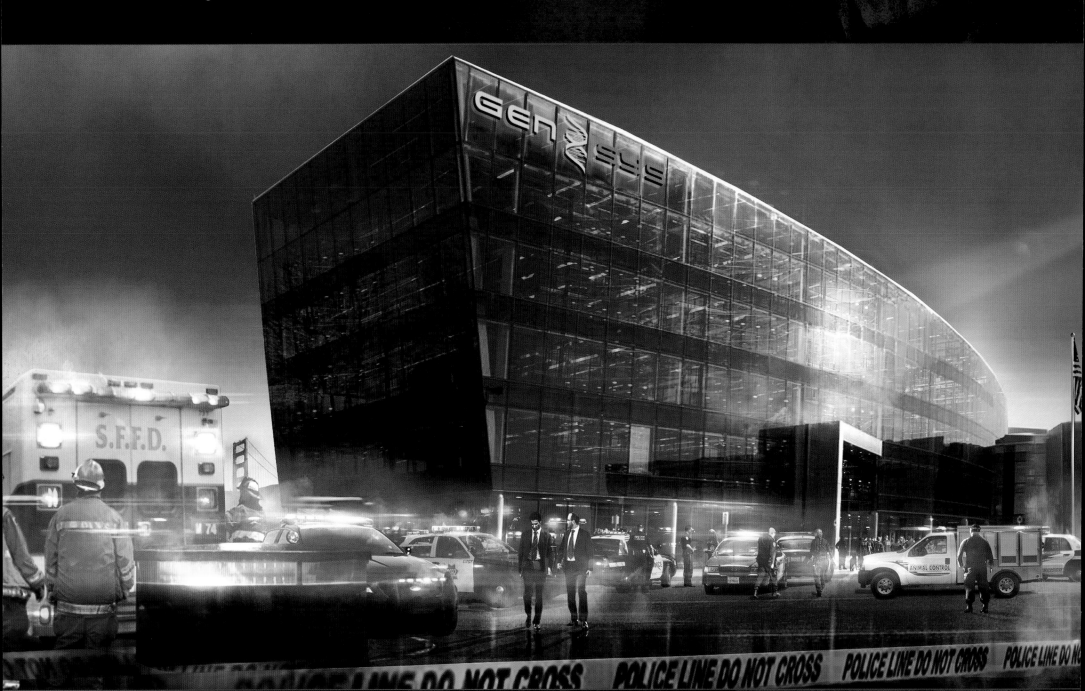

T he ape attack on the Gen Sys building was another opportunity to use the location's somewhat science fiction looking exterior.

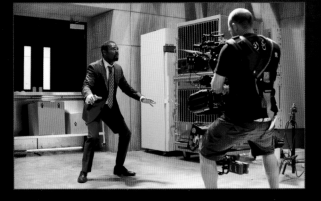

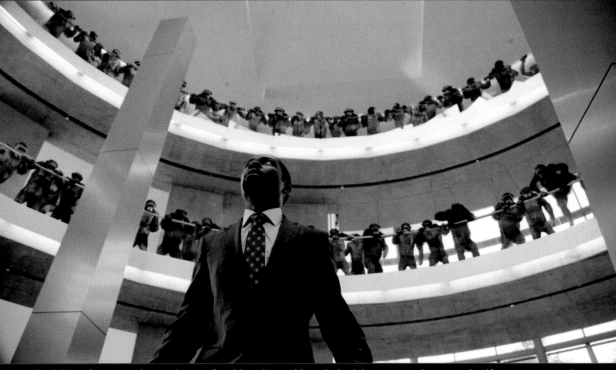

Above: The lobby of Gen Sys also made use of real locations, although the laboratory environment itself was constructed as a set.

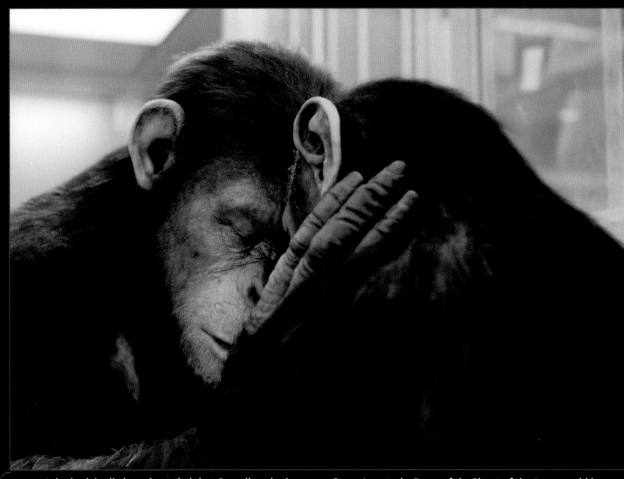

Above: It had originally been intended that Cornelia, who becomes Caesar's mate in *Dawn of the Planet of the Apes*, would have more of a role in *Rise*. This is a frame from a deleted scene of their reunion post-escape.

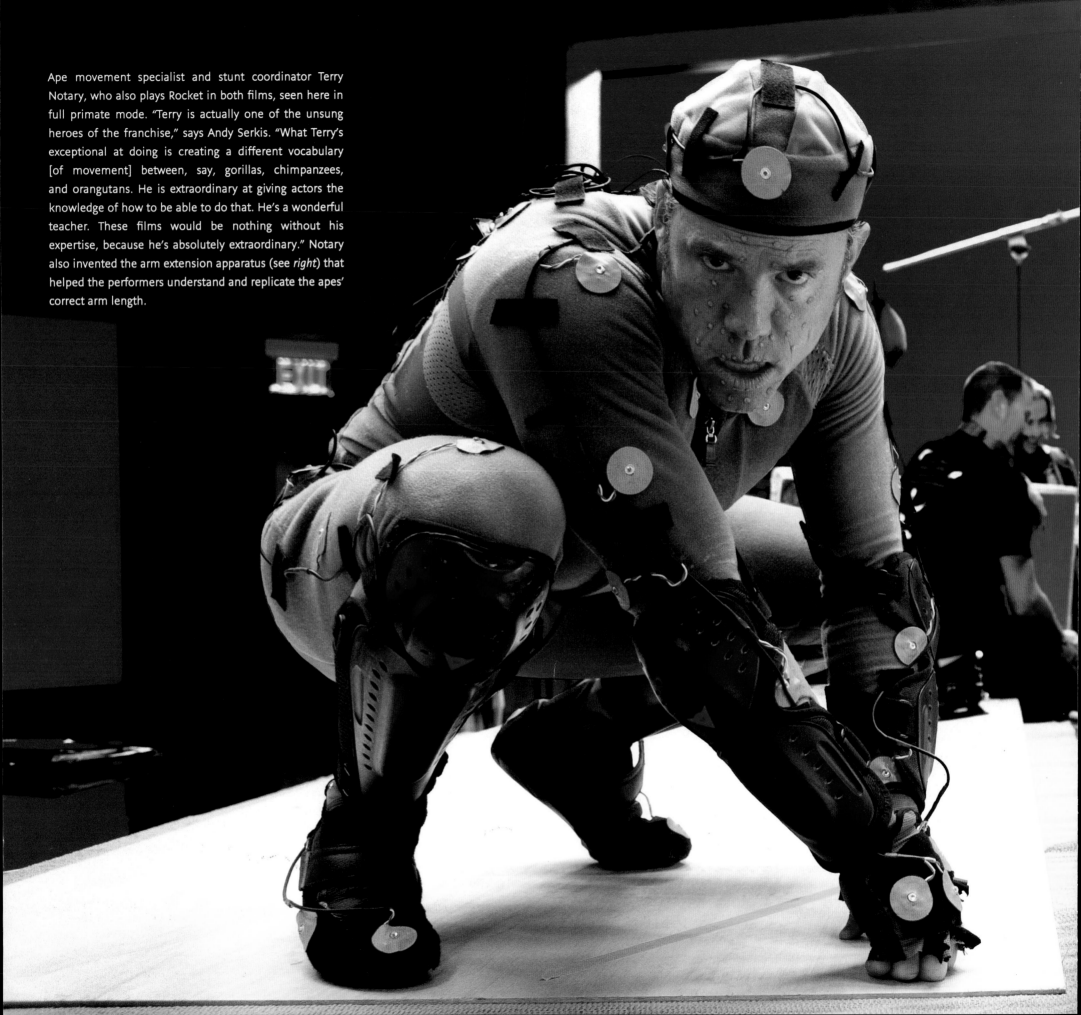

Ape movement specialist and stunt coordinator Terry Notary, who also plays Rocket in both films, seen here in full primate mode. "Terry is actually one of the unsung heroes of the franchise," says Andy Serkis. "What Terry's exceptional at doing is creating a different vocabulary [of movement] between, say, gorillas, chimpanzees, and orangutans. He is extraordinary at giving actors the knowledge of how to be able to do that. He's a wonderful teacher. These films would be nothing without his expertise, because he's absolutely extraordinary." Notary also invented the arm extension apparatus (see *right*) that helped the performers understand and replicate the apes' correct arm length.

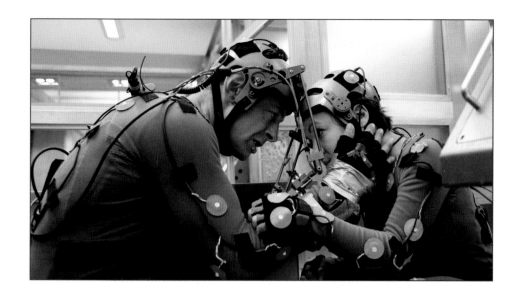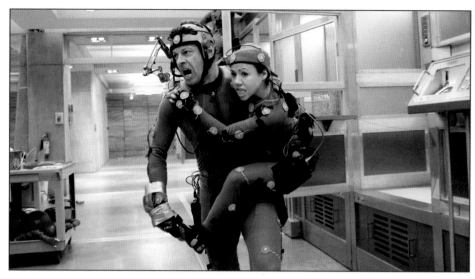

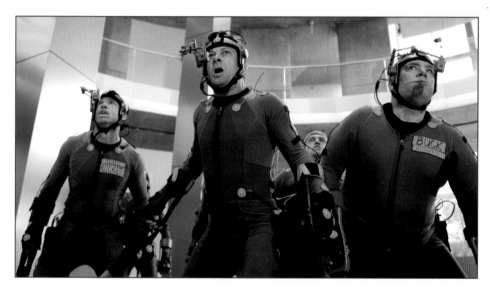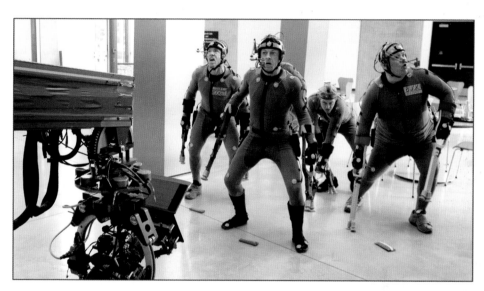

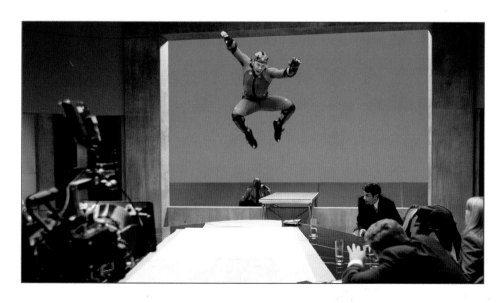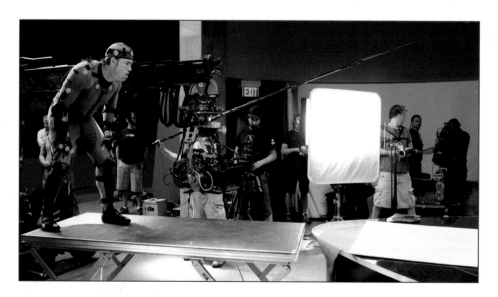

The location chosen as the Gen Sys lobby—and the setting for our first glimpse of just how terrifying a mass ape attack can be—provided an excellent blank canvas for the production designer to work with. "The appearance of the circular mezzanine inspired me," Paré explains. "I built all these tall, rectangular 'trunks'—I first got that idea from looking at pictures of the Chinese Summer Games Stadium, where you've got all kinds of columns that are crooked, not straight. I thought, 'Well, if the apes are up there when the bad guy shows up, they could use these as if they're coming down trees in the jungle.' That was the idea behind using all these tall columns."

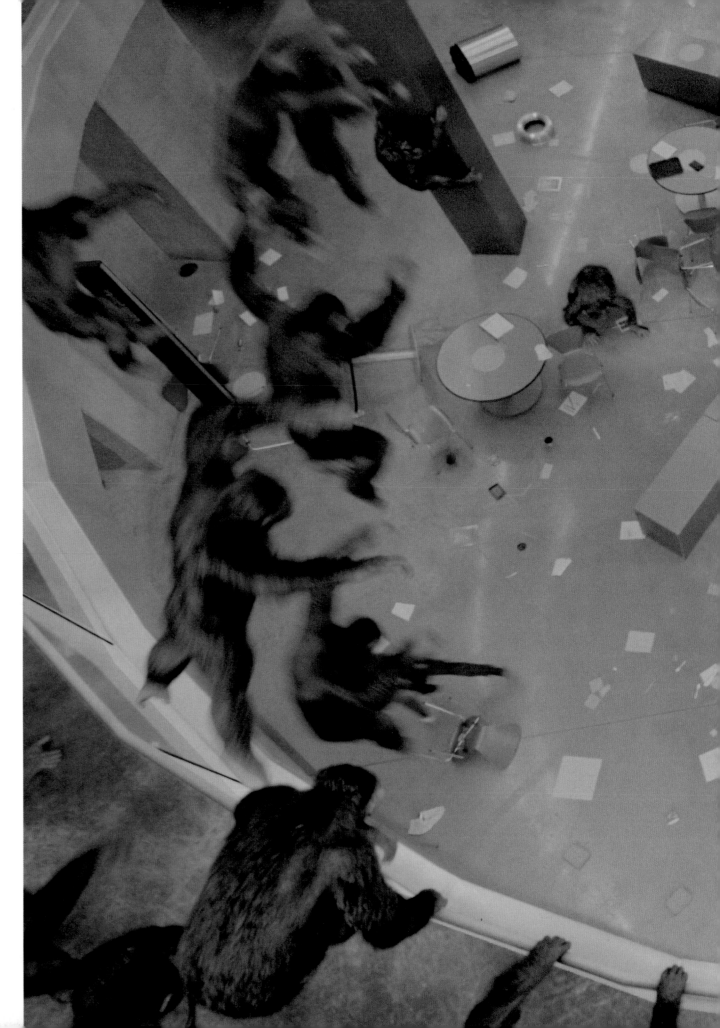

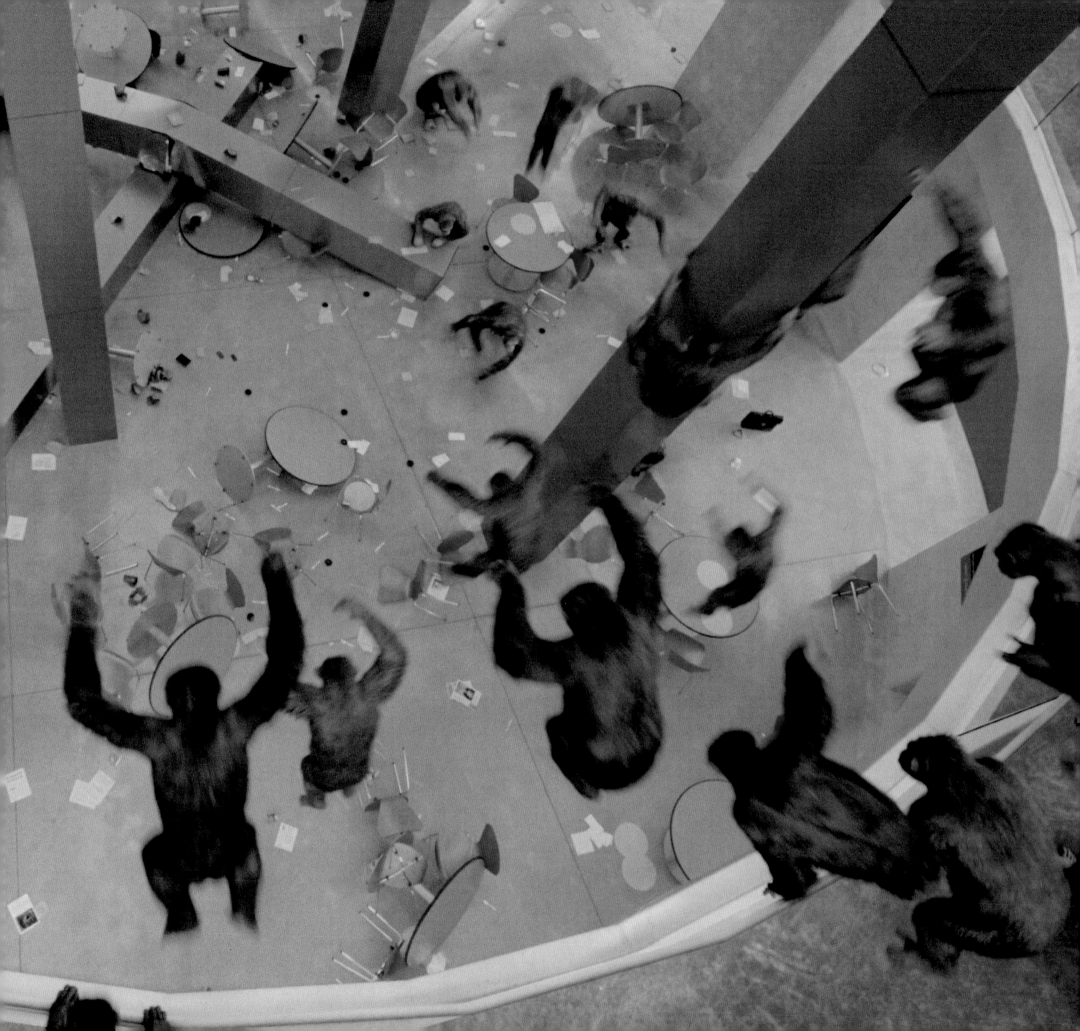

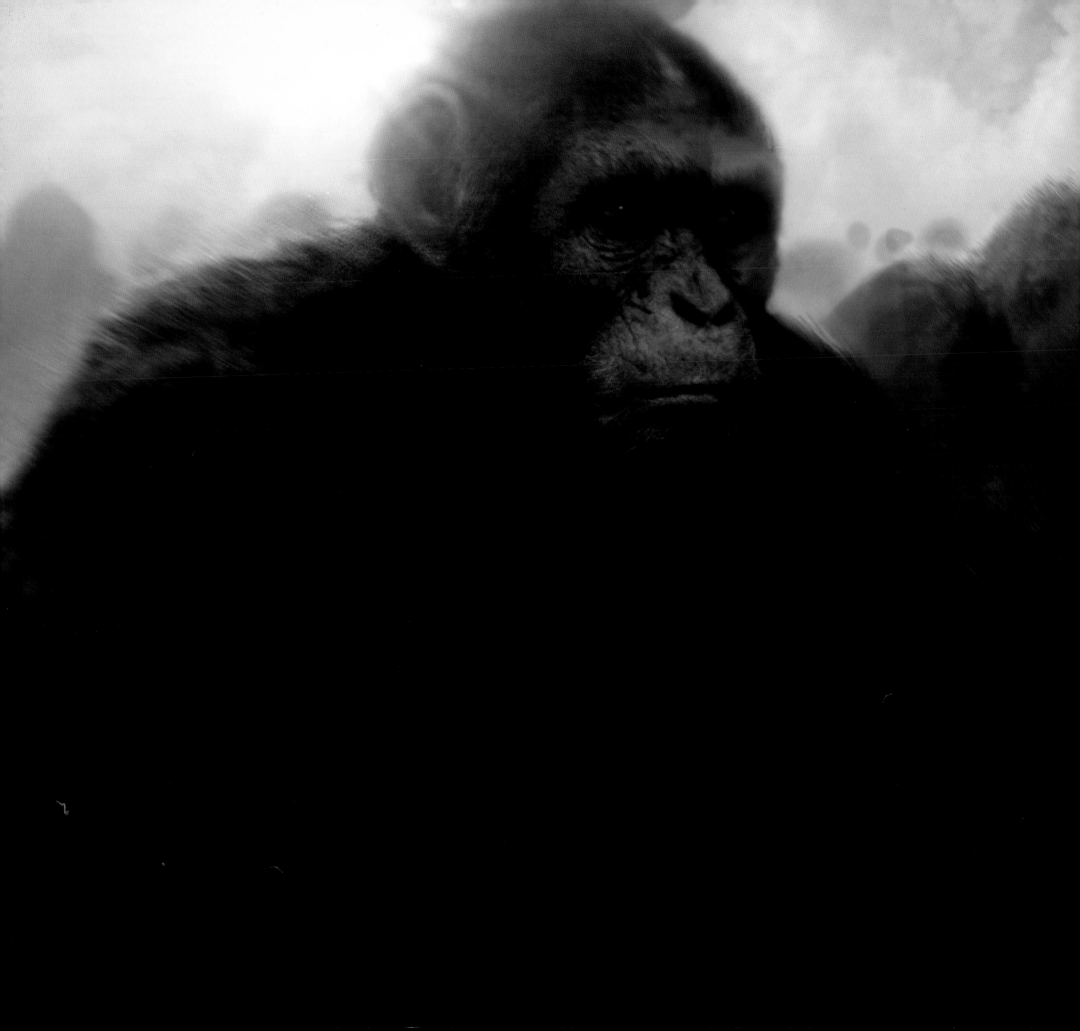

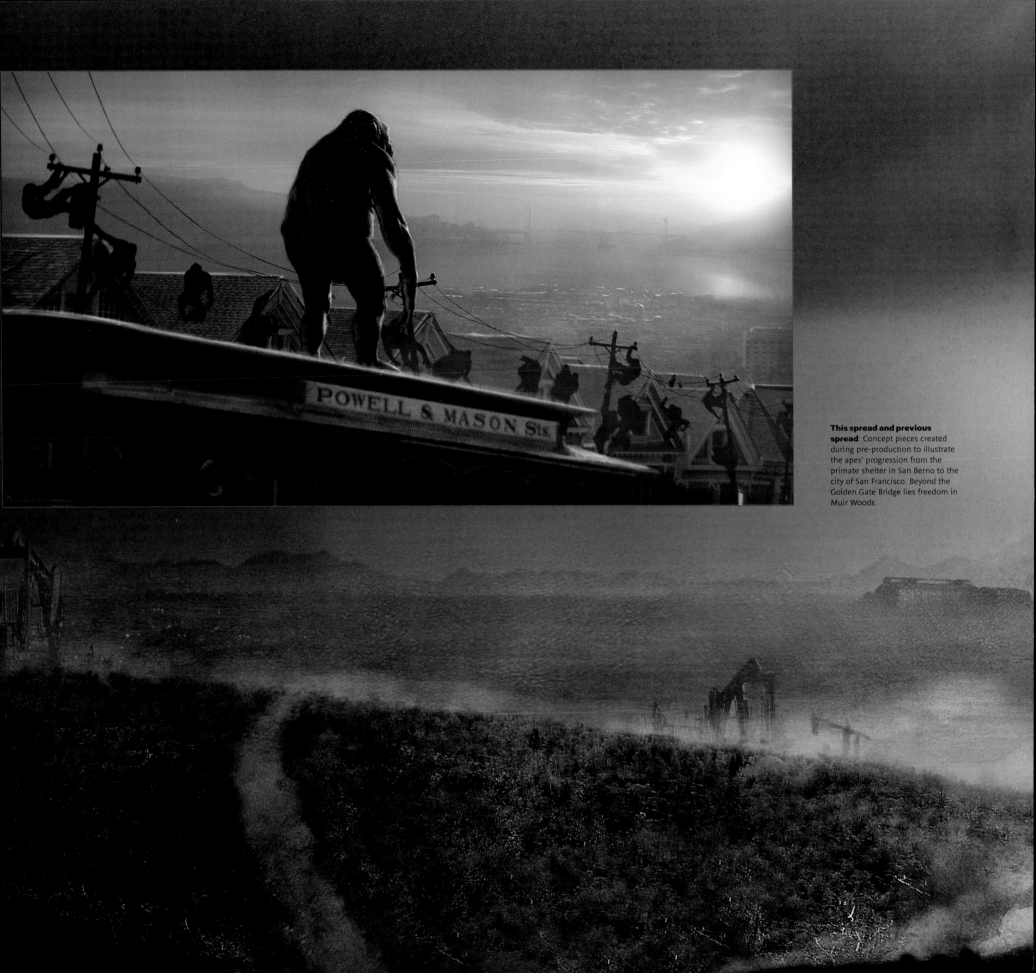

This spread and previous spread: Concept pieces created during pre-production to illustrate the apes' progression from the primate shelter in San Berno to the city of San Francisco. Beyond the Golden Gate Bridge lies freedom in Muir Woods.

POWELL & MASON Sts.

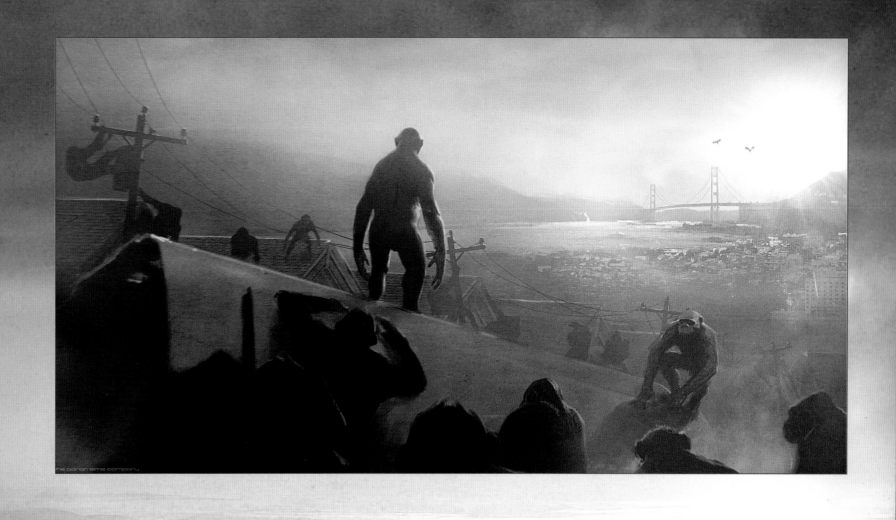
the aaron sims company

BRIDGE TO FREEDOM

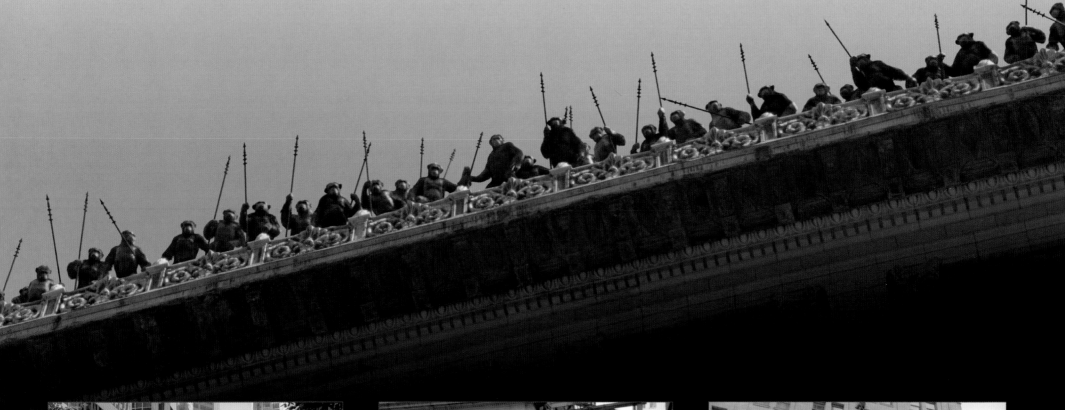

he final act is a headlong rush towards the climactic confrontation played out across the iconic backdrop of the Golden Gate Bridge. Wyatt had a clear picture of the way in which he wanted to tackle the apes' behavior as they made their way toward Muir Woods. "The revolution is not about rampages through the city," says the director. "It's about escape, it's about getting them across the bridge with as little loss of life as possible. There are specific moments on that bridge where Caesar prevents some of the other apes from killing humans, because he realizes the repercussions of that. I think that is where the greatness in his leadership lies, as a character."

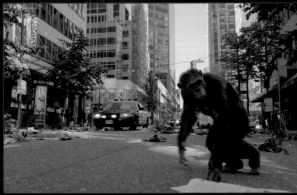

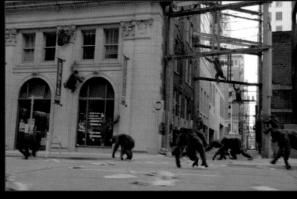

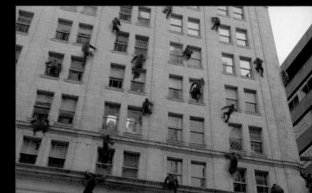

Above: Although some establishing plates were filmed in San Francisco itself, most of the sequence was shot in Vancouver.

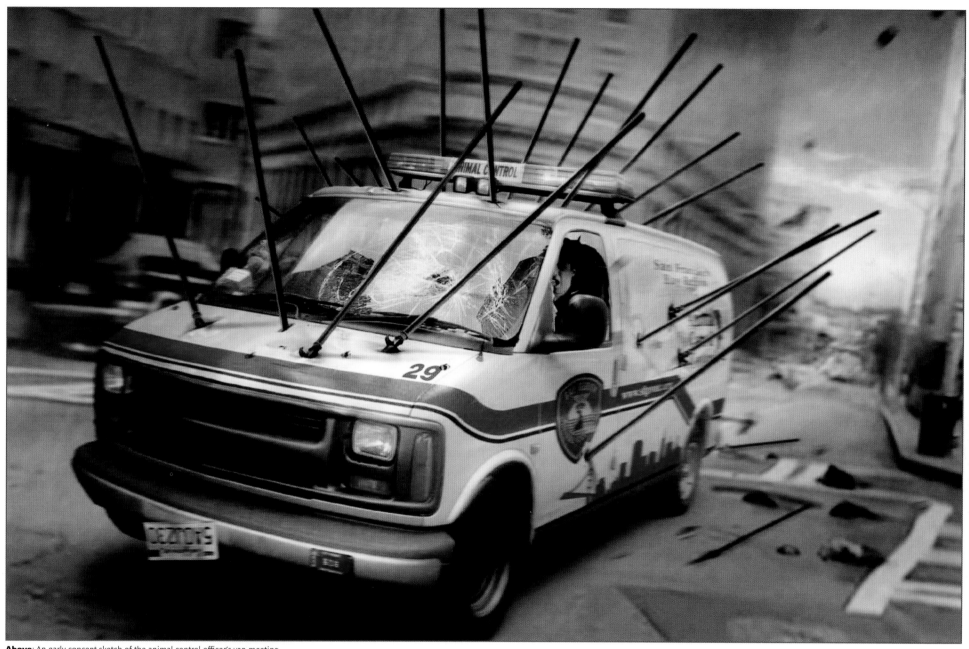

Above: An early concept sketch of the animal control officer's van meeting an untimely end.

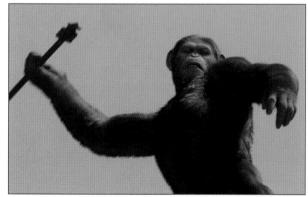

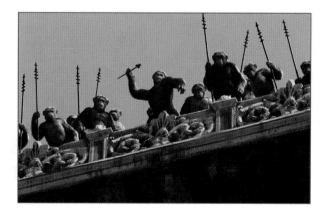

Above: The scene in which the apes wield spears to free one of their own was an early foreshadowing of the opening action of the sequel.

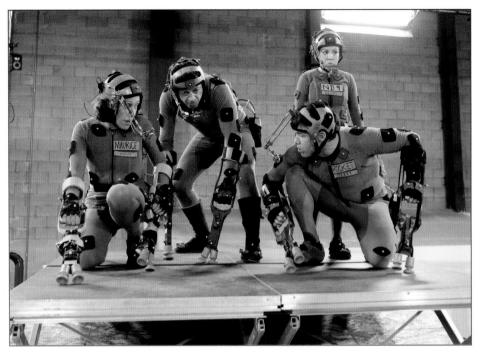

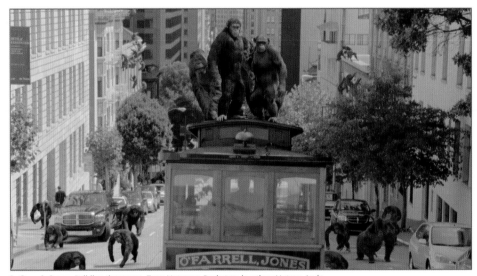

Left and above: Building the scene—Terry Notary as Rocket on location; Notary, Andy Serkis, Karin Konoval (Maurice) and Devyn Dalton (Cornelia) on the performance capture stage; and a finished frame with all of Weta's digital work completed.

"The last act is not a rampage of apes destroying San Francisco. It's Caesar trying to get them to freedom and running into resistance."

Andy Serkis, *Caesar*

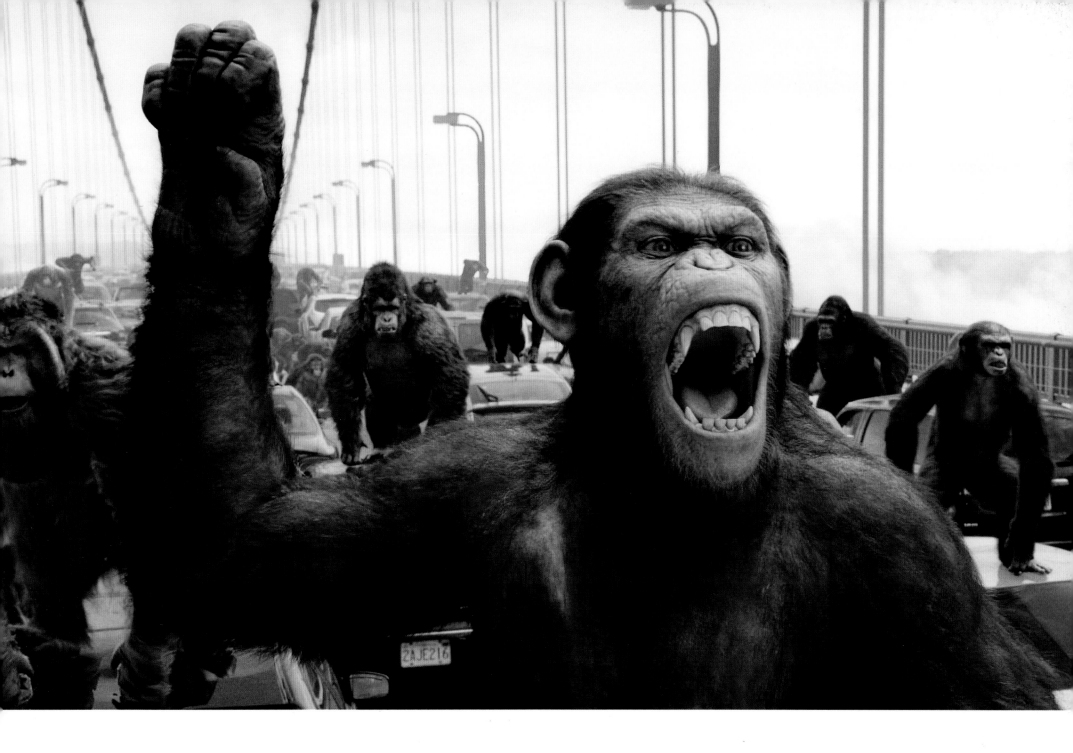

Shooting on the real Golden Gate Bridge was always going to be impossible, and so the production did the next best thing. They built their own.

"It was on a parking lot," says Claude Paré. "There was some existing asphalt, a runway built for the movie *2012*, and we were planning on using that. But then Andrew Lesnie [the director of photography] came and looked at it, and said, 'I think it's in the wrong direction. We're going to have too many days to shoot here, and the shadows will

move with the direction of the sun.' So we built our own asphalt and installed all the railings, the sidewalk, and all of the lampposts."

"We built, I think, three or four hundred feet of bridge," adds Wyatt. "Originally it was second unit—we had a separate unit shooting for ten to twelve days. They were shooting a lot of the action stuff. Then we did additional shooting, which was six or seven months into post. We went back, because there were certain aspects of the story

that we wanted to tell. Caesar's benevolence, his desire not to hurt humans, the fact that they had a set agenda to get to Muir Woods—those things we wanted to make clear. So we went back and did three or four days of shooting back at the same place."

Though the bridge set was slightly narrower than the real thing, the production did everything they could to make sure the rest of their version matched reality. This presented a problem when it came to making sure certain aspects were safe to shoot around. This was particularly the case for the in-set median markers that show the bridge's traffic lanes.

"I went to the real bridge myself to get the correct color matching samples, but we couldn't have those big metal studs, because we were using horses on our bridge," recalls Paré. "The horses could not run on them because they could break an ankle. So we had to cheat the eye and paint them in trompe l'oeil, which is a scenic painting effect that looks as if it's in relief, but it's actually just painted."

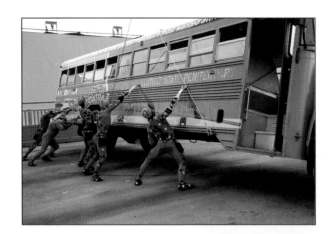

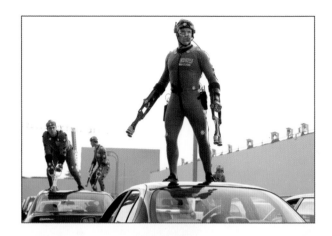

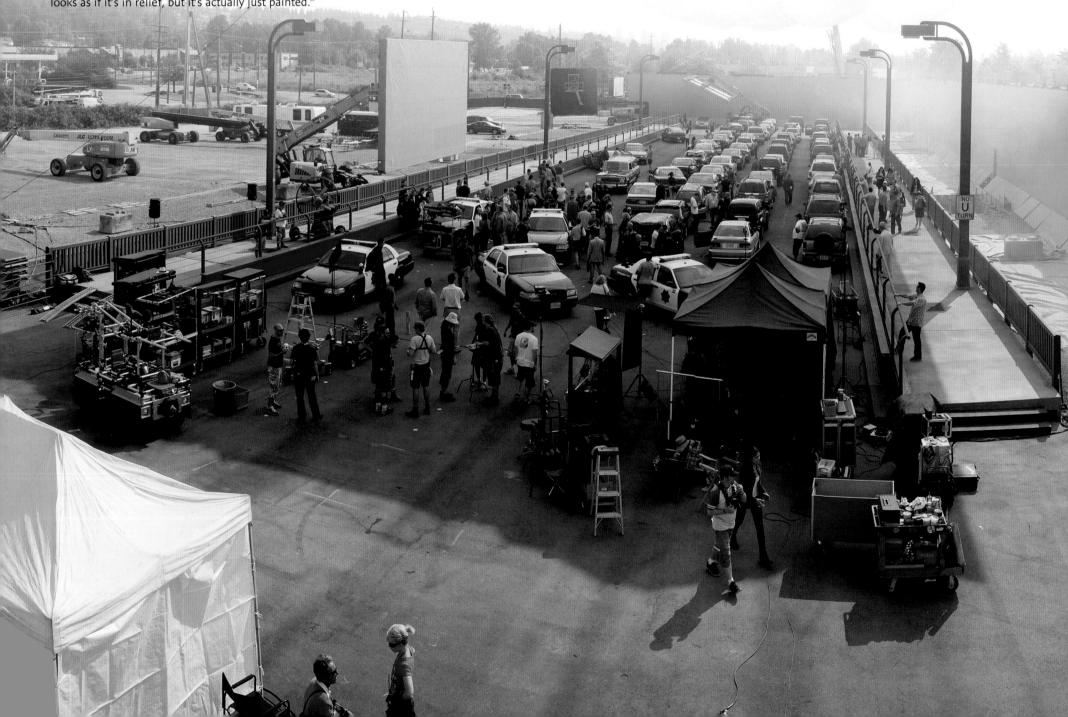

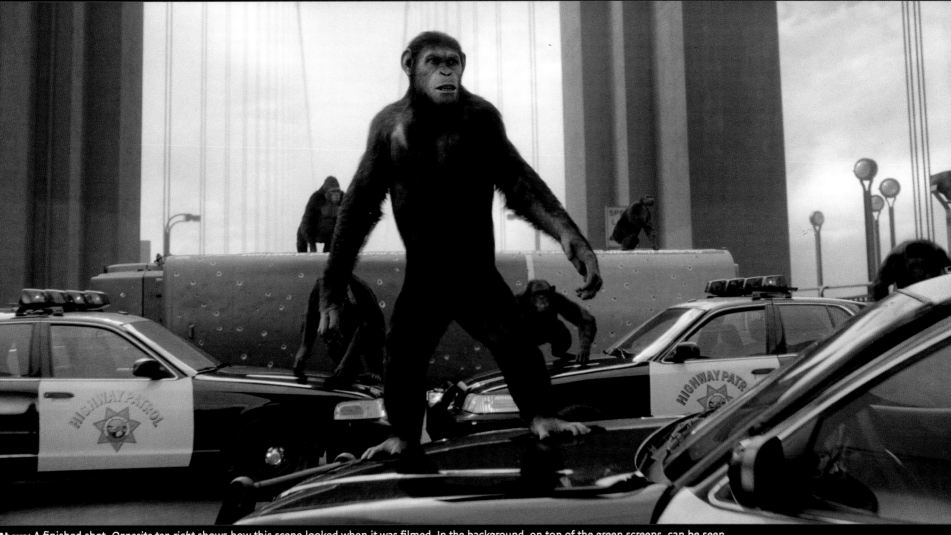

Above: A finished shot. *Opposite top right* shows how this scene looked when it was filmed. In the background, on top of the green screens, can be seen the performance capture cameras in situ. The set became the largest motion capture volume ever built.

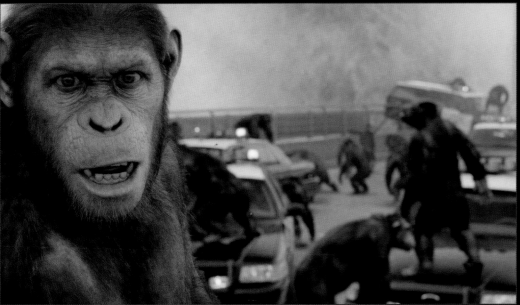

Above: The sequence with Buck roaring into an officer's face was completed by Weta in post-production and shot with Terry Notary on a volume stage in New Zealand.

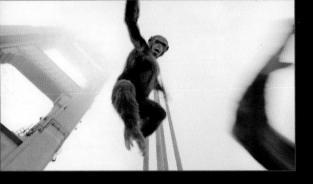

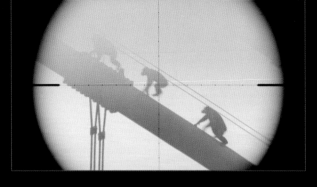

Despite the size of the bridge set, Weta Digital still needed to work some CGI magic to finish the shots. "We built the ground level aspect, and then it was digitally extended and the environment around it was digitally added," explains Wyatt. "We did some plate shots where we went to Golden Gate with a Canon 5D camera, and we just took stills that we then piled into the environments."

To create the illusion of Koba's team scaling the bridge towers, Weta first captured the performance of the ape actors on a "motion capture volume" set—a green screen sound stage used to gather motion data from the actors' movements. The actors perform on specific set pieces, such as a metal cylinder for the bridge's suspension cable, which are later replaced digitally with a matte painting.

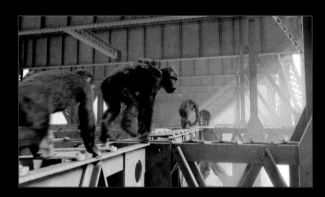

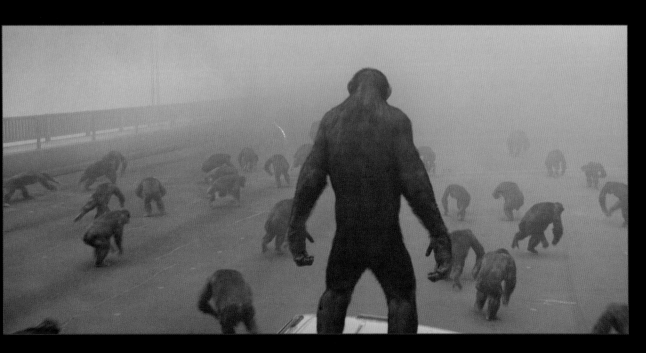

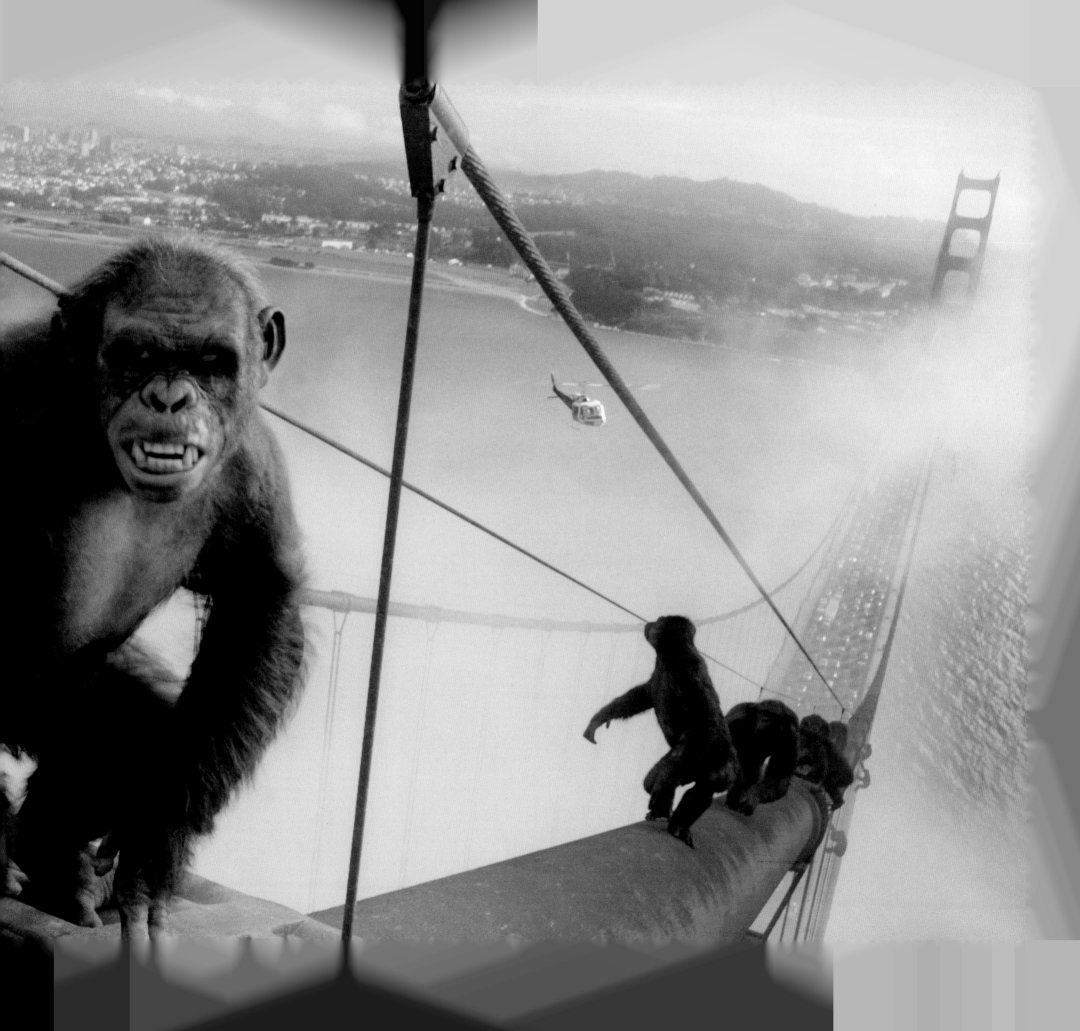

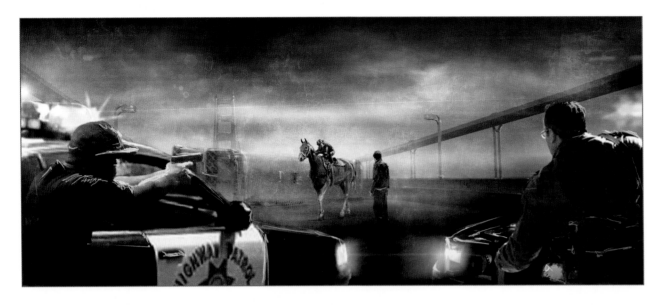

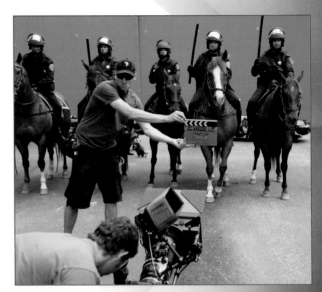

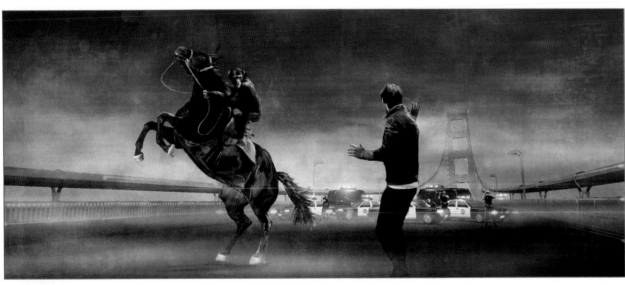

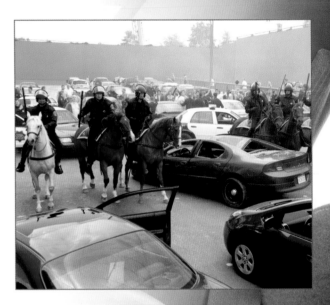

One of the biggest challenges throughout the Golden Gate Bridge scene (which includes the helicopter crash sequence pre-vis'ed *bottom left*) was ensuring the success of the performance capture. There was a good reason that *Rise of the Planet of the Apes* was the first film that had ever taken the technology on location—using the performance capture cameras alongside standard film cameras, let alone outside, was a difficult proposition.

"Technically you have two competing needs here," explains Joe Letteri, senior visual effects supervisor on *Rise*. "You have the film camera and the lights that go with it, and you have the motion capture cameras and their lights, and they both want to see different things."

Typically, motion capture cameras capture only infrared light projected onto the actors and reflected off of reflective markers at key points on the body. In a motion capture volume, the infrared cameras are only collecting data of the motion of these points as the actor moves, not the images of the actors themselves. In *Rise*, there were also film cameras at work, capturing the on-set images of actors and settings, which all needed to be lit with movie lights, not infrared lights. To address this, Weta devised an ingenious system, using LED lights giving off their own infrared light, instead of markers reflecting infrared light being shined on them, as would be the case in a motion capture volume. "We had those LED lights out of phase with the film camera, so our motion capture cameras were only seeing this infrared light whenever the shutter was closed on the film camera, allowing us to track the motion separately."

 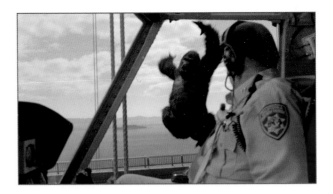

The culmination of the apes' successful traversing of the Golden Gate Bridge is Buck's bringing down Jacobs' helicopter. It's a signal to the apes that despite the humans' access to technology, they can still be bested.

"We bought a helicopter that was already trashed—you can buy them from the aircraft 'graveyards' in the desert in Nevada," Paré explains. "The way we did that shot is that we mounted [the helicopter] on a motion base and the camera was on a Technocrane."

"That was a fun one," recalls visual effects supervisor Dan Lemmon. "We put it on a model-mover base, which was a big, six-axis, computer-controlled motion base that moved the helicopter around. We had a camera on a crane at the same time that the helicopter was moving, and that got us the first half of the shot. Then we handed over to a digital version of the helicopter with Jacobs and the other guys inside."

The destruction of the helicopter also features a significant character moment, as Caesar allows Koba to kill the begging Jacobs by tipping the chopper carcass from the bridge. "There was a real division about which one of those guys should push him over the edge," recalls Rick Jaffa. "Some of us thought it should be Caesar, because it's his movie, but Amanda and I felt that it's still his moment—he rises above it. He's not going to kill the guy in cold blood. It's just not his character. So we really fought to hand it to Koba."

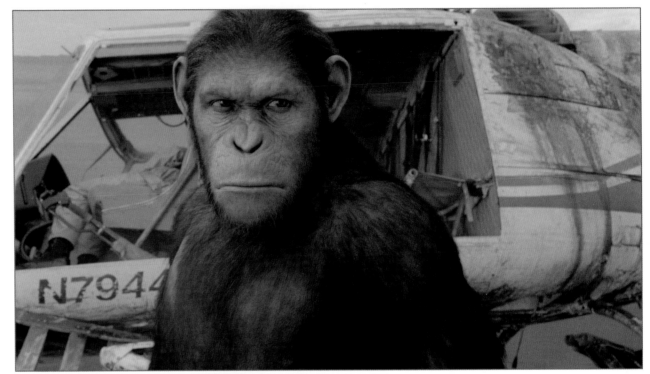

Above and below: Caesar allowing Koba to push Jacobs to his death is a significant character moment for both apes, and paved the way for the development of their relationship in the sequel.

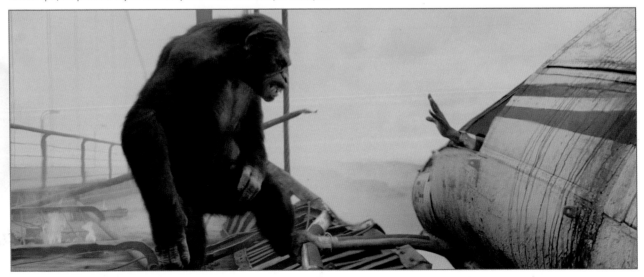

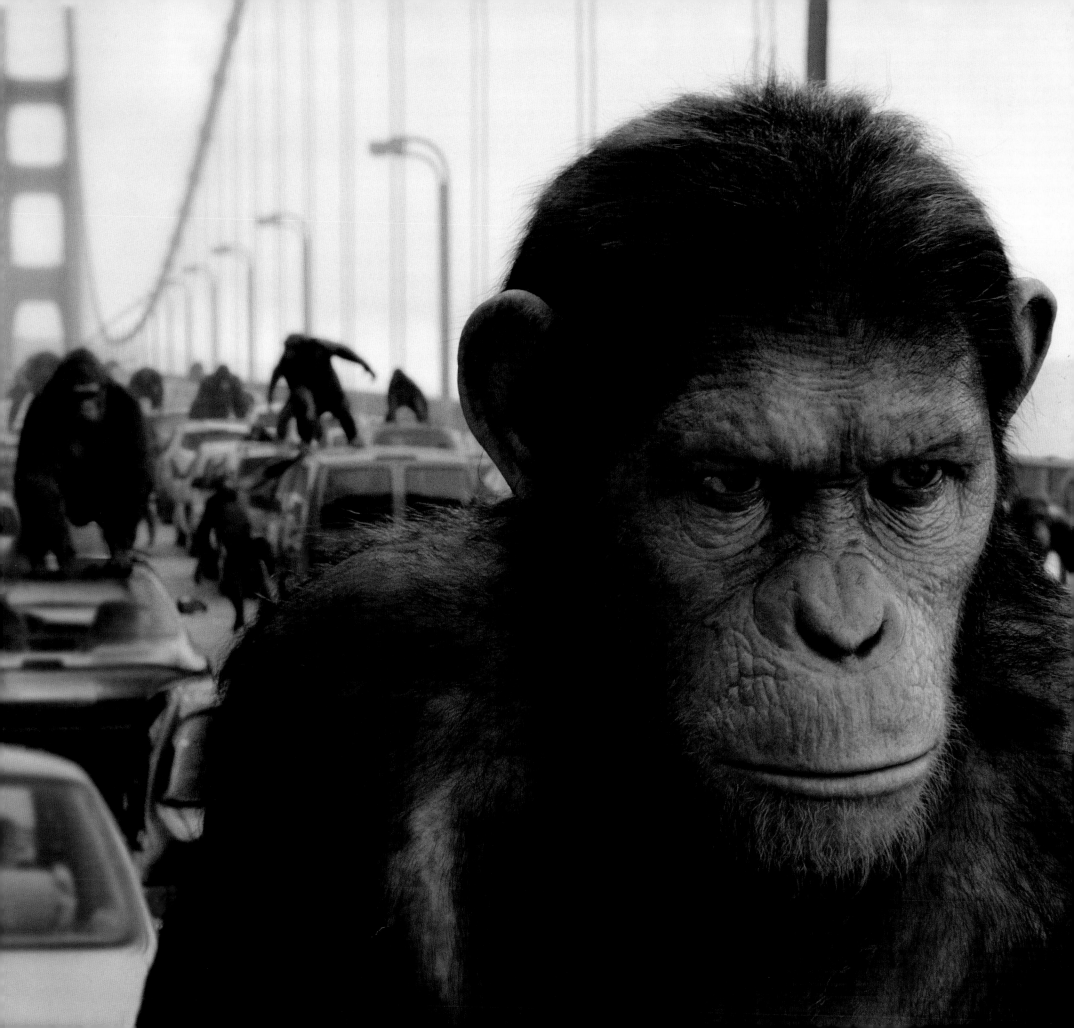

THE FOREST

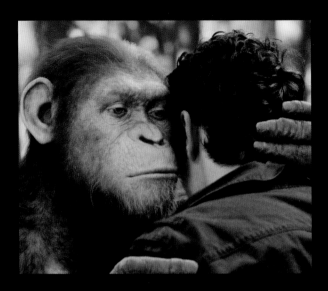

"The ending was totally different in the original script," reveals Rupert Wyatt. "Brian Cox's character, when he realizes his son has been killed by Caesar, sets off in pursuit. There was a whole ending that we shot where Will takes a bullet for Caesar. Will dies and then Caesar climbs the tree to be with his people. It was just a downer, it didn't work. So we decided it would work much better if we had a scene where Will lets him go."

"We really felt like Will had to pay for his hubris, even though we liked him. But it turns out that the test audience didn't agree with us," laughs Amanda Silver. "The decision was made to keep him alive," remembers Rick Jaffa. "The movie came out August 5th, and on the July 4th weekend, Amanda and I were in our office rewriting the ending. We said, 'Fine, he can live—but he at least has to apologize, because it was all his doing.' So they let us write the speech where he says, 'I'm sorry, this is my fault, but please come home.' And then that led on to that final line: 'Caesar is home'."

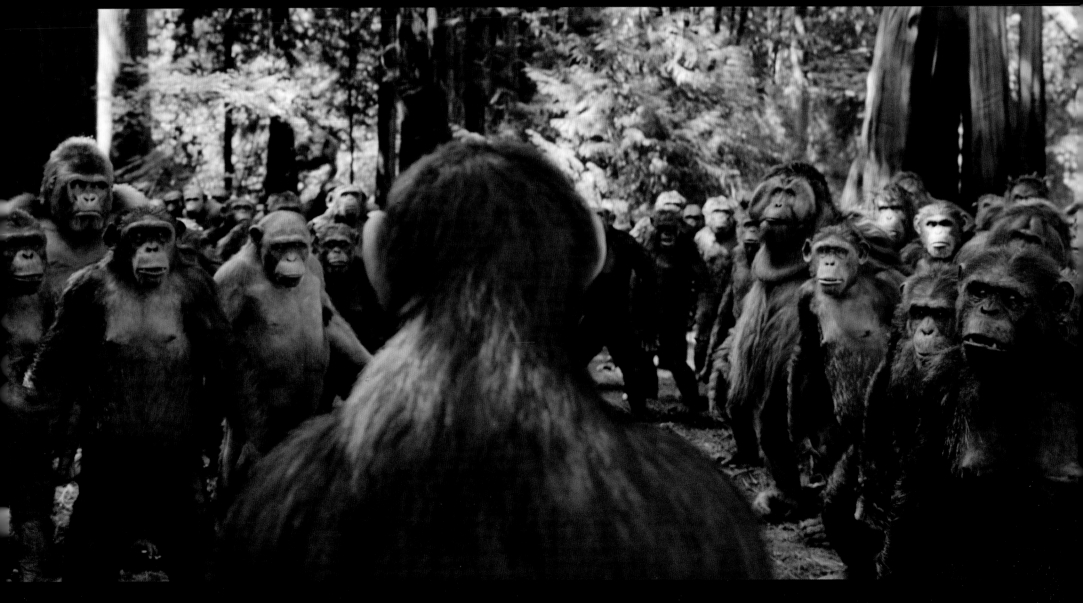

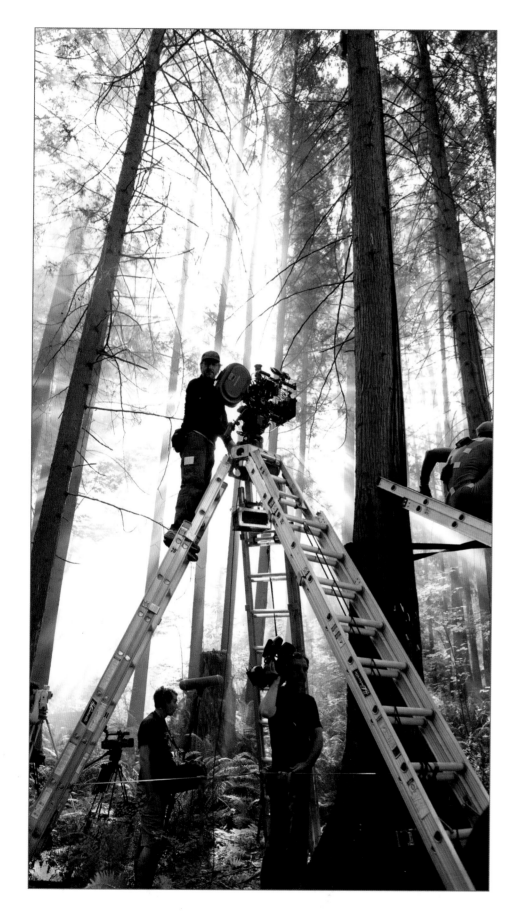

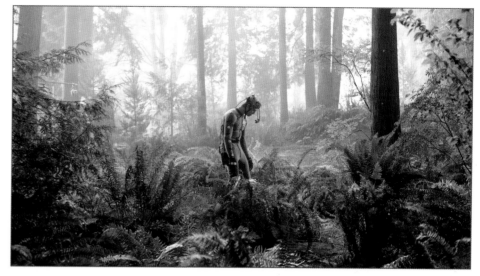

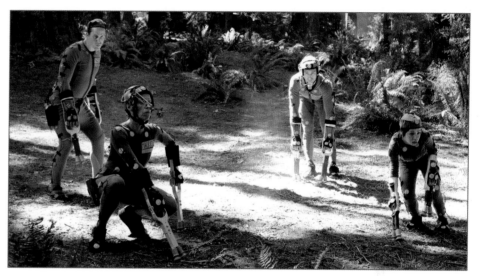

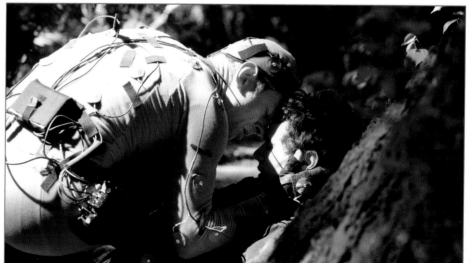

Above: A glimpse of the original ending, with Will (James Franco) dying.

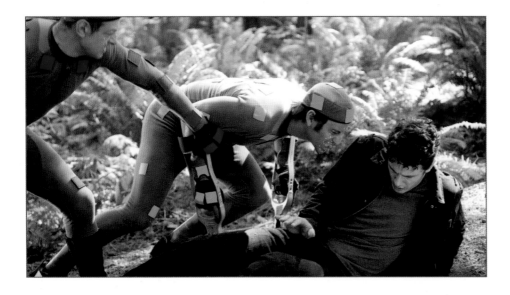

"Caesar is home."

Andy Serkis, *Caesar*

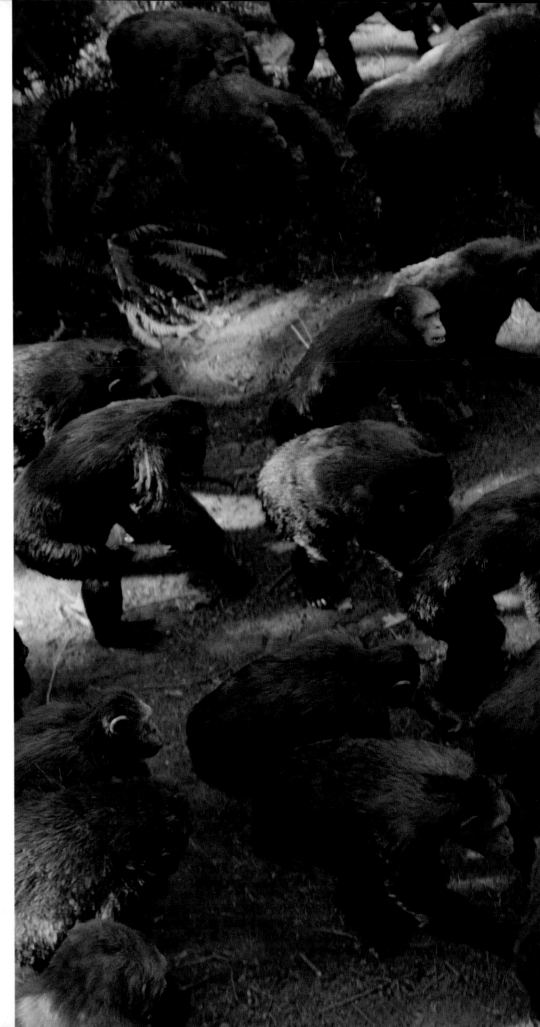

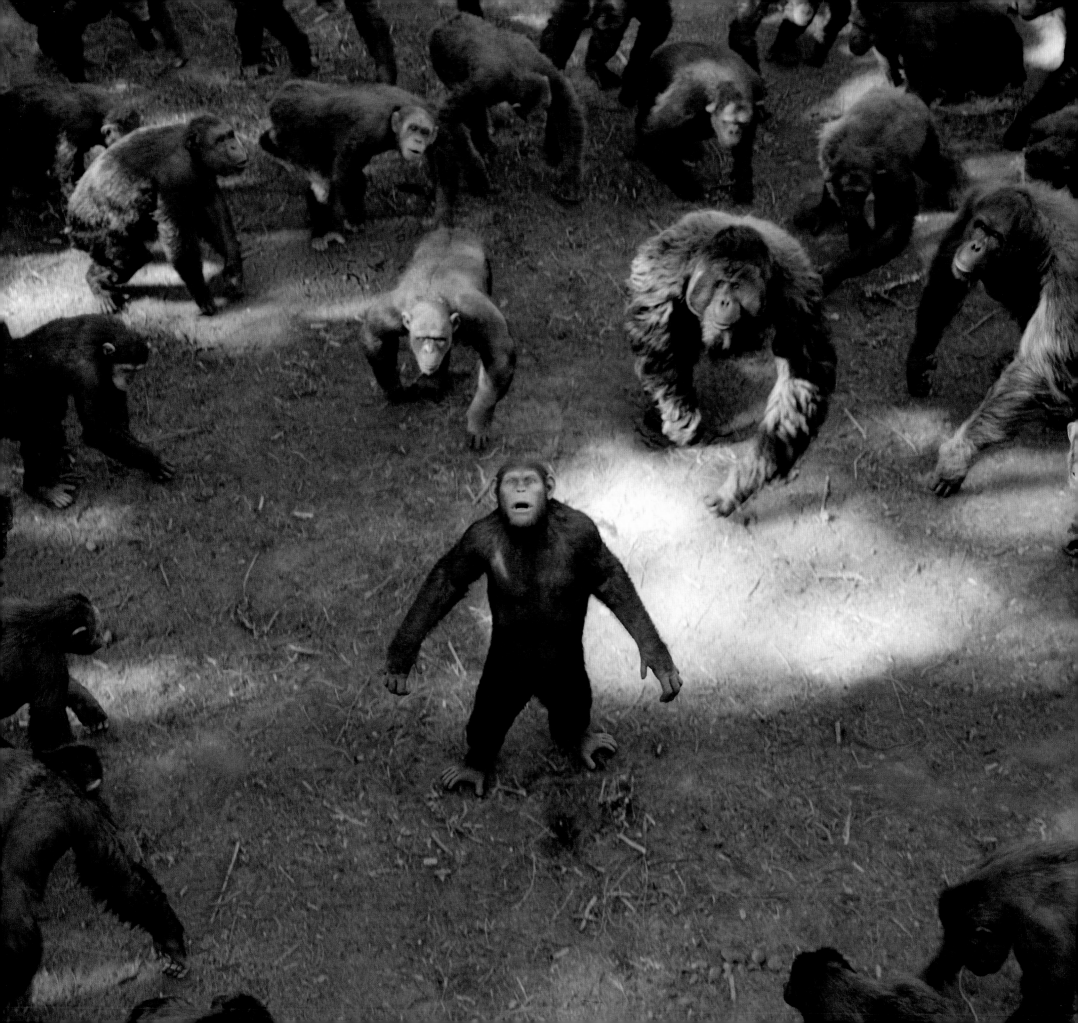

POSTERS

When it came to promoting the film, Twentieth Century Fox made a brave decision. Instead of mixing in images of the human cast on their key poster art, the choice was made to focus simply on Caesar. Putting him at the forefront of the marketing campaign shows how fears of building a franchise around an ape protagonist had been left behind. It was also an important step in positioning Caesar as the driving force behind the film in the mind of the audience. This was, first and foremost, Caesar's story.

THE SIMIAN FLU & YOU

Everything you need to know about the Simian Flu

WHO'S AT RISK?

The speed that Simian Flu symptoms manifest depends on your health, level of exposure and age. If you see someone who shows signs of illness, it's best to stay away.

HOW IT SPREADS

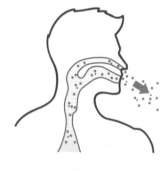

Airborne

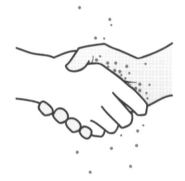

Direct Contact

Indirect Contact

HOW CAN I PROTECT MYSELF?

Wear A Mask

Minimize Contact

Avoid Public Spaces

Do Not Congregate

KNOW THE SYMPTOMS

Speed of symptoms can differ, but generally 48 hours after infection a person will experience severe headache, sore throat, weakness, fever and joint pain. After 96 hours the symptoms include nausea, vomiting, red eyes, raised rash, chest pain and cough.

After 7 days symptoms escalate quickly to stomach pain, severe weight loss and bleeding from nose, mouth, rectum and eyes.

48 HOURS — SEVERE HEADACHE, SORE THROAT, WEAKNESS, FEVER, JOINT PAIN

96 HOURS — NAUSEA, VOMITING, RED EYES, RAISED RASH, CHEST PAIN AND COUGH

07 DAYS — STOMACH PAIN, SEVERE WEIGHT LOSS AND BLEEDING FROM NOSE, MOUTH, RECTUM AND EYES

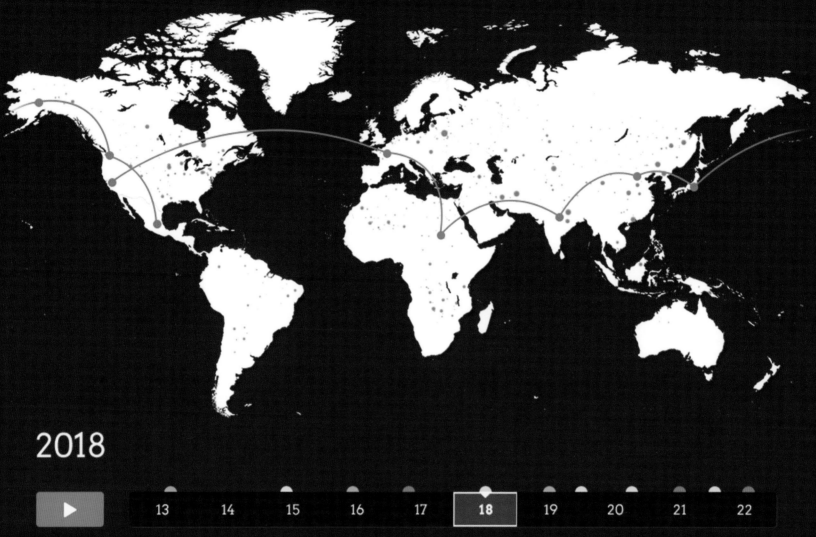

2018

| ▶ | 13 | 14 | 15 | 16 | 17 | **18** | 19 | 20 | 21 | 22 |

PLEASE NOTE: the above is a scientific projection and not actual events.

COULD WE CONTAIN AN OUTBREAK?

We are working for an international policy to defend against an outbreak.

Studies suggest population density, distance from airports, infection control practises and geography all affect the spread of infectious diseases. These and other factors need to be addressed by governments globally.

#SIMIANFLU

TwitterHandle @twitterhandle 9m
Lorem ipsum dolor sit amet, consectetur adipiscing elit. Lobortis, nulla non interdum porta, nunc tortor pellentesque dui amet.

TwitterHandle @twitterhandle 1h
Lorem ipsum dolor sit amet, consectetur adipiscing elit. Pellentesque lobortis, nulla niner dum porta, nunc tortor pellen tesque dui amet.

TwitterHandle @twitterhandle 2h
Lorem ipsum dolor sit amet, consectetur adipiscing elit. Peli entes que lobortis, nulla non interdum porta, nunc tortor pellen tesque dui amet.

THE MAKING OF

DAWN OF THE PLANET OF THE APES

REVOLUTION TO EVOLUTION

When *Rise of the Planet of the Apes* opened to huge critical and commercial success worldwide, talk quickly turned to the next installment of the revitalized franchise. "The story connected in an emotional way," says producer Dylan Clark of the audience reaction to *Rise*. "People really got behind Caesar and were excited about it. We felt like we should start thinking about a sequel, because there is so much going on in the Apes mythology and there is so much more to tell of Caesar." Peter Chernin and Clark were not content to rest on their laurels, however. Though delighted by *Rise*'s reception, they wanted to set the bar even higher for the next film. "*Rise* was a great start," says Clark. "The technology helped us tell the story in more ways than we understood when we started out. For *Dawn* we asked: what can we do better? Let's go further with the characters, let's go further with the technology."

Central to realizing this vision was acclaimed director Matt Reeves (*Cloverfield*, *Let Me In*). He joined the project not only as a filmmaker, but also as someone with a long-standing love of the franchise. "When I was a kid I was *obsessed* with *Planet of the Apes*," he laughs. "I had all the dolls, and I desperately wanted to be an ape. There was something about that make-up that John Chambers did, and seeing speaking apes – I just had this very deep desire to be an ape, it was very interesting. And it really stuck with me. When I saw *Rise*, I was so impressed with what they did, and in particular, what I thought was so remarkable about it was the way the film was an ape point of view film. I was so affected emotionally by Andy Serkis' performance, and it suddenly hit me as an adult that I had just experienced what I was longing for as a kid, which was that by watching that movie—because [Caesar is] the character that you empathize with the most, the one who you become and who you are in that movie—I finally saw a movie from that series where I became an ape. So when Peter Chernin and Dylan Clark and Fox approached me, I was very excited, because it's a world that I have been

interested in for so long, and I just love the way the new iteration of this story is such an emotional one. Those are the kind of things that I respond to in terms of getting involved with a project.

"So I went in to meet, and I told them the miracle that they had achieved in the first film really had to do with that identification with Caesar. And that what interested me about continuing the story would be to continue his story, and to see how you could take a character that was essentially a revolutionary and turn him into a leader, and what that would mean. Because it's one thing to lead a revolution, it's another to lead a society. And then for me, the important thing was to take that society and make it a family."

Matt Reeves turned to writer Mark Bomback to create a narrative with him that would be fully rooted in an ape world. "Truly [an] ape civilization movie," Reeves stresses. "Obviously given the idea that at the end of *Rise*, with a viral apocalypse that spreads out, you get the sense that when you come into this film, you're going to be post-apocalypse and you're going to see a devastated human society... I knew that would be an aspect of this story, but to me, because my emotional interest was in Caesar, it was not a 'post-apocalyptic' story, but the 'birth of an ape civilization' story. And so in that sense the title *Dawn* was very apt, because it was this exciting idea about the dawning of a new species, a coming into being."

"And that was exciting," Dylan Clark adds, "because all of the sudden we realized that we could create an Ape world. Caesar has given the apes a new beginning at the end of *Rise*—a home in the Muir woods. Now what? Where are they taking things? And what happens when humans are introduced? That was the inspiration and the idea driving us to do the sequel."

"It's about Caesar trying to maintain his victory that was so hard won at the end of *Rise*," says Mark Bomback. "It's about, 'How do I preserve this vision that I've been fighting for, this real future for apes, now that I've seen

that in fact the humans have in part survived?' He doesn't want anyone to suffer for his revolution, but the revolution itself really does come first for Caesar. When you think about the end of *Rise*—to fight armed police officers—he knew it would cost ape lives, he knew it would cost human lives. So he's not really a pacifist, he's a moral person, a moral ape, who feels a moral obligation to lead his people to a better place. He's not willfully unaware or failing to remember all the injustices that apes have suffered at the hands of humans. So I think that was something that we wanted to bring alive a lot more in the story. He has a conscience about it, but his loyalties are to apes, not to humans."

Andy Serkis, returning to the role that saw the media and fans alike calling for the actor to receive an Academy Award nomination, relished the chance to develop the character. "One of the things that I very much wanted to play in *Dawn* was that although he's setting up an ape utopia, an evolved ape society, he's not entirely throwing away everything he learned from humanity, because he is wise enough to realize that there are some things that were good about humanity, that are worth holding on to. It was a very complex journey playing Caesar in *Rise*, but doubly so in *Dawn of the Planet of the Apes*, really, because here we have this character who is grappling with trying to create this utopia. He now has a family, he has someone who he loves, he has a teenage son who he's in conflict with, he now has a newborn child who he wants to raise with all of the wisdom that he's accumulated. And yet when these human beings turn up, for him the conflict begins, because he knows he's not entirely prejudiced against humans. He wants to find a peaceful solution. He doesn't see a world where they can exist together, but he wants them to exist peacefully separately. Part of Caesar's journey," Serkis continues, "is finding that neither ape nor human are better than each other; there's good and bad in all."

"One of the most important things for me in the story," says Reeves, "was to make sure that on the human side and on the ape side, there were no villains. That all the characters arrive at their point of view via a path that you could follow and that you could understand. Even if you felt differently, you could say, 'Well, that character has been through that experience, and I if I had been through exactly that experience, I might feel the same way.' It just felt like one more way to create an ape society that

would have levels of complexity, and in that way reflect who we are [as humans]. I mean, what's so fun about taking intelligence and giving it to apes is that of course it's a story about our nature. And so any way that we can introduce that complexity into the relationships between apes, then we're reflecting, really, who we are. That was our goal."

While *Rise* pioneered new performance capture techniques, *Dawn of the Planet of the Apes* took the technology a giant leap further ahead, with even more location and exterior set shooting—up to 80% of the movie, says Clark—made doubly challenging by the decision to use huge and unwieldy native 3D cameras (which capture a 3D image in real time, rather than a 2D image which is then converted to 3D in post-production). Reeves' overriding concern was to immerse the audience completely into the apes' world. "[It] was really important to me aesthetically that the film feel as real as possible," says the director. "So that meant, let's not shoot on the stage. Let's shoot in the places that it's supposed to be, and if it is an ape civilization, then let's build that outside, let's do it in places where it will feel as if it's part of the world. And let's use real materials."

"I realized that I had sentenced myself to a very hard shoot," Reeves admits, "in the woods, in the rain, with 3D cameras, shooting mo cap! It was intensely challenging. But it was also very exciting. I just wanted to feel like we went out there and shot this, and the apes happened to be there. So that's why we were shooting in ridiculous locations under ridiculous conditions, because then it would look real." Director of photography Michael Seresin, renowned for his naturalistic lighting style in films such as *Angel Heart* and *Harry Potter and the Prisoner of Azkaban*, was a key collaborator. "[He] has been a hero of mine literally since I was a kid," says Reeves. "He's just an artist. He was involved very early on, so we were talking to him about things we might want to do photographically to create that level of intimacy and reality. It was wonderful to get to work with him."

Another key creative partner was of course Andy Serkis. "This was certainly the first time I'd ever worked with having essentially the main character not be in the form that he would be in the film ultimately," Reeves points out, "[but] the beautiful thing, at the end of the day, is that Andy is a fantastic actor. And that part of it was incredibly familiar, it's just like any other film I've worked on. He was

a giving and astonishing actor; I love working with him. We explored the story together in a way that I found really fulfilling."

For Gary Oldman, who joined the cast as Dreyfus, leader of the human survivors, the film packed a powerful punch, even before production was completed. "I went over to see Matt in the editing room, and he showed me some of the finished rendered apes, and it was pretty mind blowing. I was shocked by how wonderful it looks. And emotional. I think Matt's made something really special."

THE HUNT

Wall know where *Planet of the Apes* is going," says Dylan Clark. "We know that at the end of the series, the apes inherit the planet. They win. The fun is getting there. Matt really wanted to see this next evolution with apes – have they grown into a family? What does their environment look like?"

"What was so wonderful about *Rise* was that it was a genesis story in which you connect to one character and you see how in the smallest way it could set you on the trajectory toward a world that could be like the 1968 film," says Reeves. "Yet it was all so relatable and small, in certain ways, and very intimate. I wanted to tell a grander story,

in this one, because it was about an ape king, a patriarchal ape society led by Caesar – and yet I wanted to make sure that you never lost that intimacy."

"The idea was to have a slow reveal of their world," says *Dawn of the Planet of the Apes*' production designer James Chinlund of the film's opening sequence, which reintroduces the apes. "We were interested in trying to create sort of a primordial world, where you weren't sure what year it was. So you're moving through the primordial forest, and then starting to see evidence of them. Just seeing the apes in their natural environment... which sets up the juxtaposition when the humans appear."

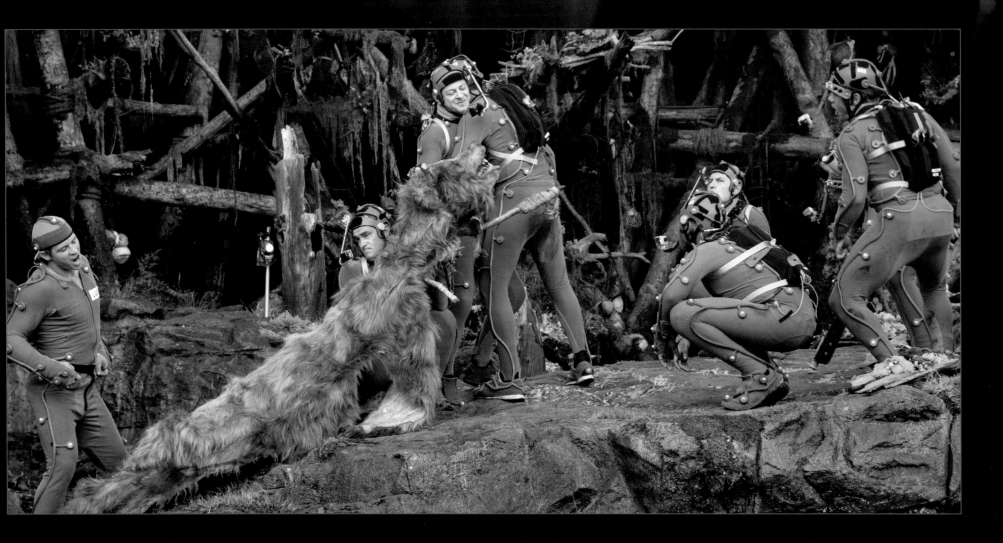

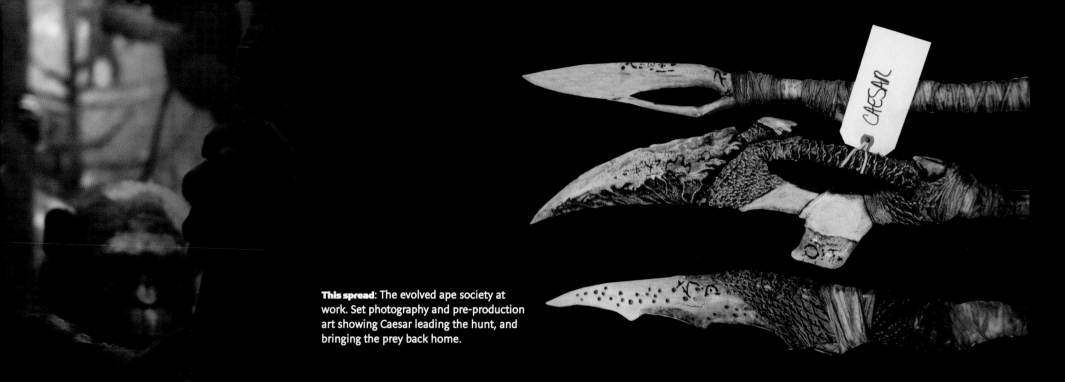

This spread: The evolved ape society at work. Set photography and pre-production art showing Caesar leading the hunt, and bringing the prey back home.

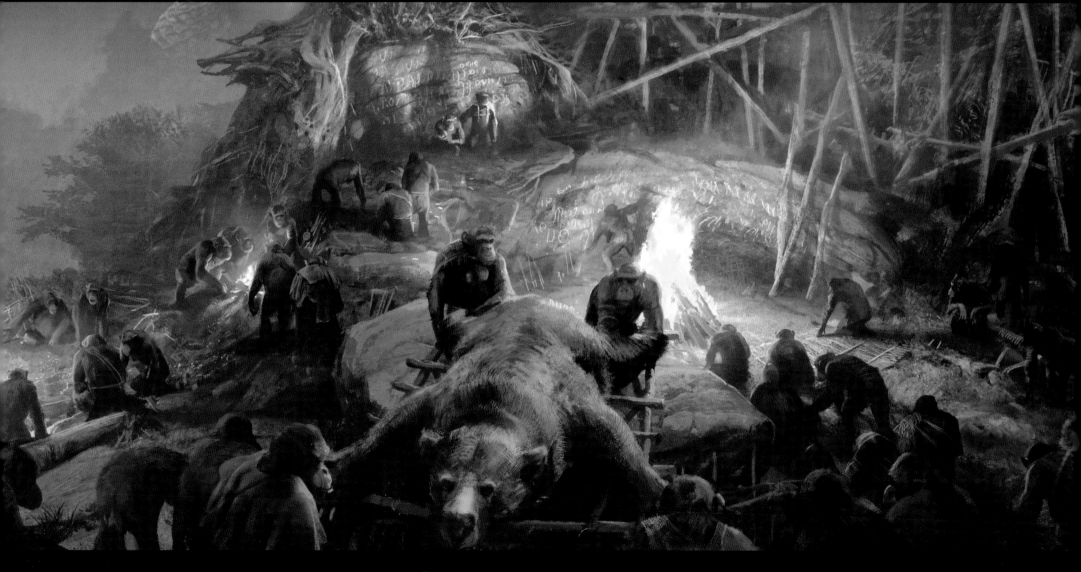

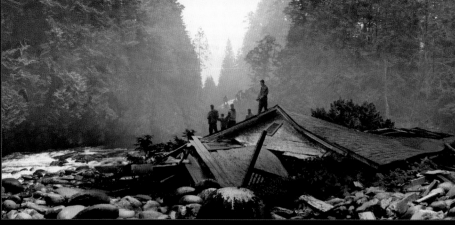

Above: The apes' life in the woods is disturbed by an unexpected arrival—humans.

Years have passed since the outbreak of the virus, enough time for the ape society to establish itself in the woods, away from human interaction, and for a new generation of apes to be born and grow up, including Caesar's son, Blue Eyes. In the film's first set piece, the young ape is seen hunting with his father.

"What we came up with for Blue Eyes is that he's an adolescent, he's got a lot to learn, and he's incredibly impulsive – he doesn't think before he acts," says writer Mark Bomback. "Caesar is very aware that one day he will no longer be here and there's a good chance that Blue Eyes will inherit the mantle of leadership. He wants to make sure that Blue Eyes will be the leader that the apes will need, as they continue to evolve and grow as a society. So Caesar's big challenge is how to make his son understand that acting on impulse is, in a sense, old genetics – that's what an animal would do. And this thing that we're trying to do is *not* act on impulse, but to act with human reason. So that's why it starts with the hunt, and shows Caesar in action trying to teach Blue Eyes how to be rational, not impulsive."

Seeing Caesar in action again gives Andy Serkis the chance to show the continuing evolution of the ape's movement. "I always tried to find something that was 'ape plus' really," he says. "So for instance, when Caesar's crouching – there's that scene in *Rise* where he's given the ALZ-13 to all of the apes and he's waiting. He's crouched as an ape, but then he's twiddling a piece of straw between his fingers. So I always wanted to offset his ape movement with something that was human, I suppose. That was just something that I felt was instinctively right. It's ape, but it's just *almost* human. Actually that progresses more in *Dawn of the Planet of the Apes*. The way he holds things, the grasp, is much more human, the way he holds himself, the way he sits is much more human."

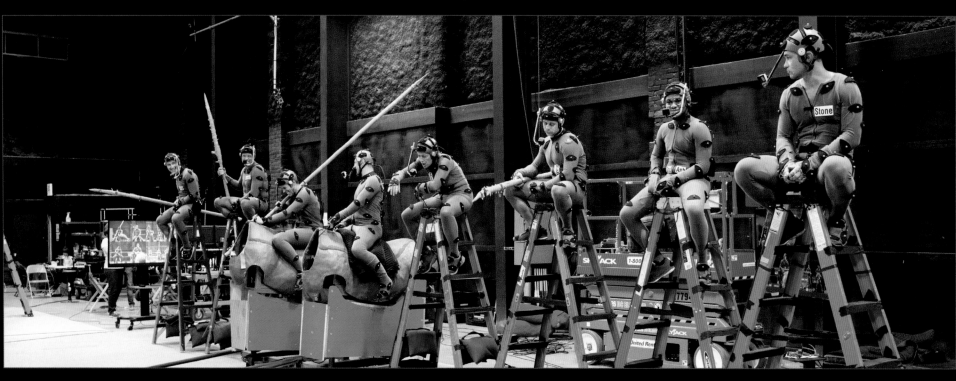

APE MOUNTAIN

A t the end of *Rise*, the apes were under attack. They ran off to hide, basically," says James Chinlund. "So we liked the idea that they had taken over this mountain in Marin County and built a stronghold up there—where I think the humans would have been afraid to go, because of the virus. They kept them at bay. So our initial design on the mountain was as a defensive structure, it's sort of a castle keep. Their different architectures are represented within that space. You'll see orangutan ideas and chimp ideas. Caesar has built his house at the top of the mountain into a tree."

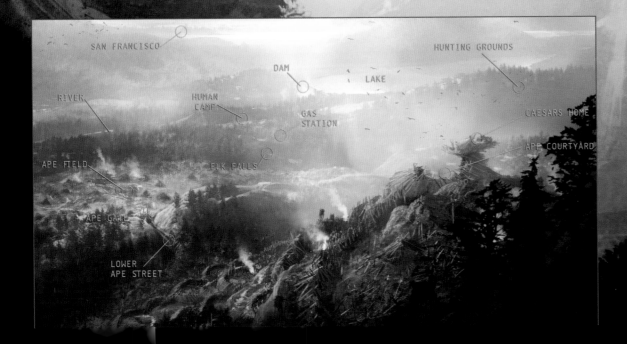

SAN FRANCISCO

HUNTING GROUNDS

DAM

LAKE

RIVER

HUMAN
CAMP

GAS
STATION

CAESARS HOME

APE COURTYARD

APE FIELD

ELK FALLS

APE GATE

LOWER
APE STREET

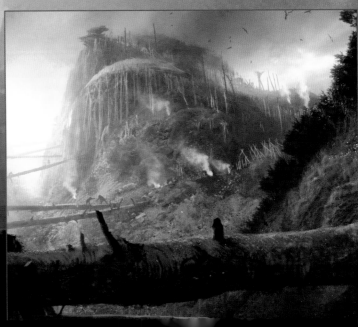

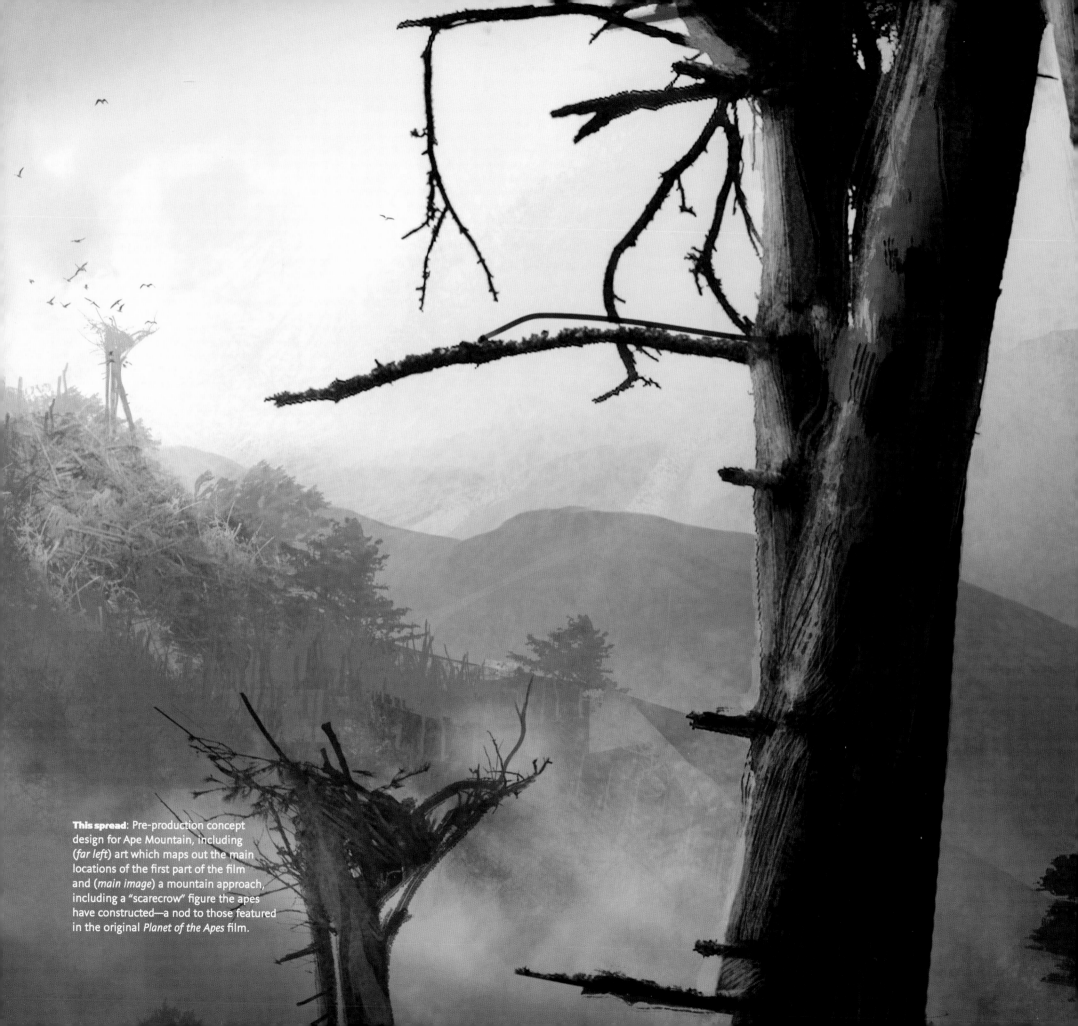

This spread: Pre-production concept design for Ape Mountain, including (*far left*) art which maps out the main locations of the first part of the film and (*main image*) a mountain approach, including a "scarecrow" figure the apes have constructed—a nod to those featured in the original *Planet of the Apes* film.

APE VILLAGE

Whereas *Rise of the Planet of the Apes* had sought to accurately capture ape society and communication as it actually is in nature, *Dawn of the Planet of the Apes* endeavored to go one step further. This time, the production was attempting to extrapolate the way in which a community of hyper-intelligent primates might evolve if left entirely to its own devices.

"I wanted everything to be very grounded in reality," says Matt Reeves. "This is the beginning of their evolution. We're not in the world of the '68 film – this is the beginning

of that. There were lots of references we looked at, tribal references and all kinds of things, to try and make it feel like a plausible reality. Because for me the fun of this franchise is that the only fantasy element is that you have intelligent apes. But other than that, they should feel like apes. And so we were trying to ground everything, so that as fantastical as certain elements may seem, they could feel like they were real."

Because this development was such a key aspect of the film, Reeves started collaborating with the art department very early on, particularly when it came to deciding exactly

how the Ape Village would look.

"James [Chinlund] was involved right from the beginning," Reeves points out. "It was an unusual experience to be working on a story while you had a production designer involved, because that could actually inform what you were doing in the story. I found that to be incredibly unusual but an exciting thing, because he was a wonderful, creative partner on that side of it."

"I've never had a production designer be so involved at the script stage as James was," agrees writer Mark Bomback. "We were envisioning it with James, so the

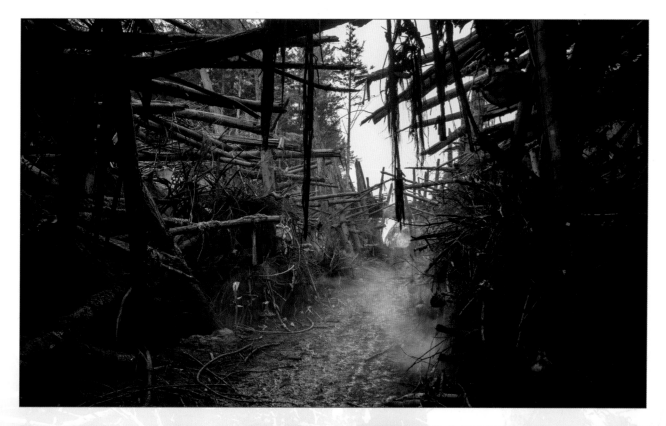

vision of it evolved as James was designing it. To me, one of the big, thrilling things in the film is when you first get a glimpse of the Ape Village. It's a community that has been built in the woods that is entirely ape-centric, that is really a tangible reflection of the evolution that they've gone through. So you can see that it's possible that it was built by apes, but it's also possible that it was built by humans. The village itself reflects that middle place that they're in on the evolutionary line."

As the conversations about what the set should look like went back and forth, the ideas gradually changed. Originally, it was imagined that ape village would have much more about it that was instantly recognizable as being of human origin – although these items would not necessarily be used for the purpose for which they had been created.

"Initially we talked about it having a lot more recovered components from human civilization," Bomback explains, "like doors, baths or other things that had been found in the forest over time. And as we put in more and more, we realized that it really needed to be rudimentary and primitive, but there would be little flashes of inspiration in the way the architecture is laid out. We also tried to make it as ape-like as possible [in layout], and allow for lots of moments where apes would be able to swing through areas or leap down through things the way humans wouldn't do."

"We looked at a lot of ape construction," Chinlund reveals. "Different groups actually have different ways of building things. Gorillas live in pods of ten, one male and

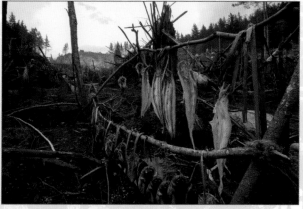

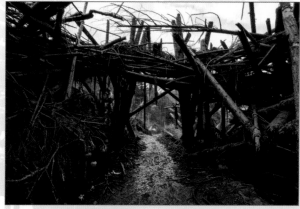

This spread: Some of the concept illustrations for the entrance into Ape Village, and the finished sets as they were built for filming.

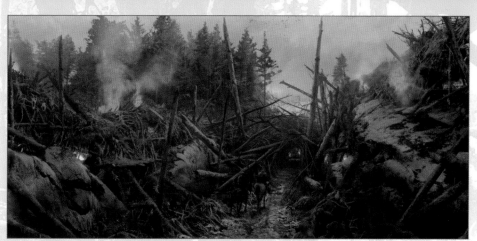

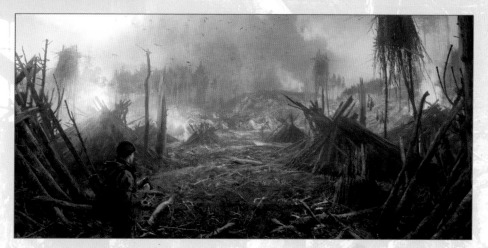

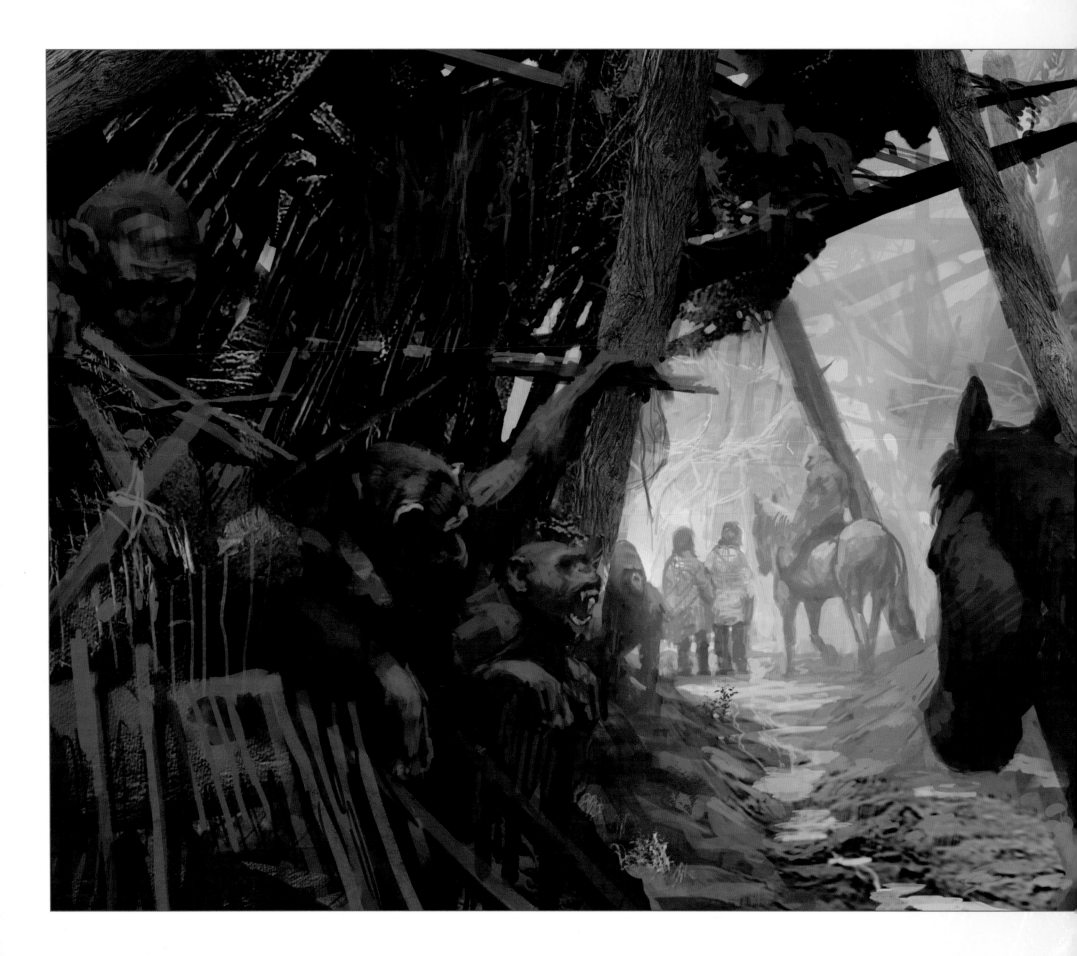

Above: Concept art showing lighting ideas for how the Ape Village would look at night.
Left: Artwork showing the arrival at the village following the triumphant hunt.

nine females, roughly. Chimpanzees live in groups of one hundred, sort of like small clans. And then orangutans are solitary creatures."

As Chinlund began to examine the kind of structures that apes build in their natural habitats, he realized that the style of their constructions meshed very well with what he was trying to achieve for *Dawn*. "The idea is that the apes have been pulling down trees, tying and lashing them together in different ways," he explains of the spiked wooden designs he came up with. "It's a brutal, physical architectural technique. They just used the resources they had to build their world."

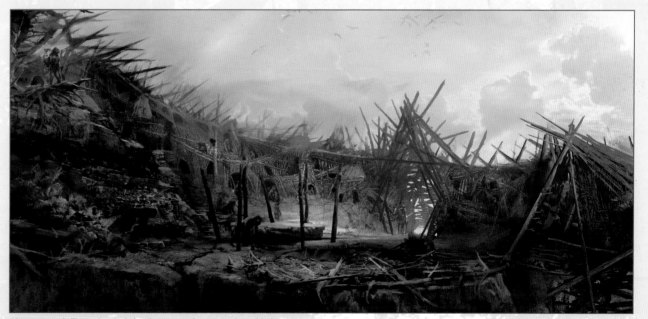

Above: An early illustration depicting the courtyard area complete with the central ceremonial stone and, above it, Caesar's 'throne' area.

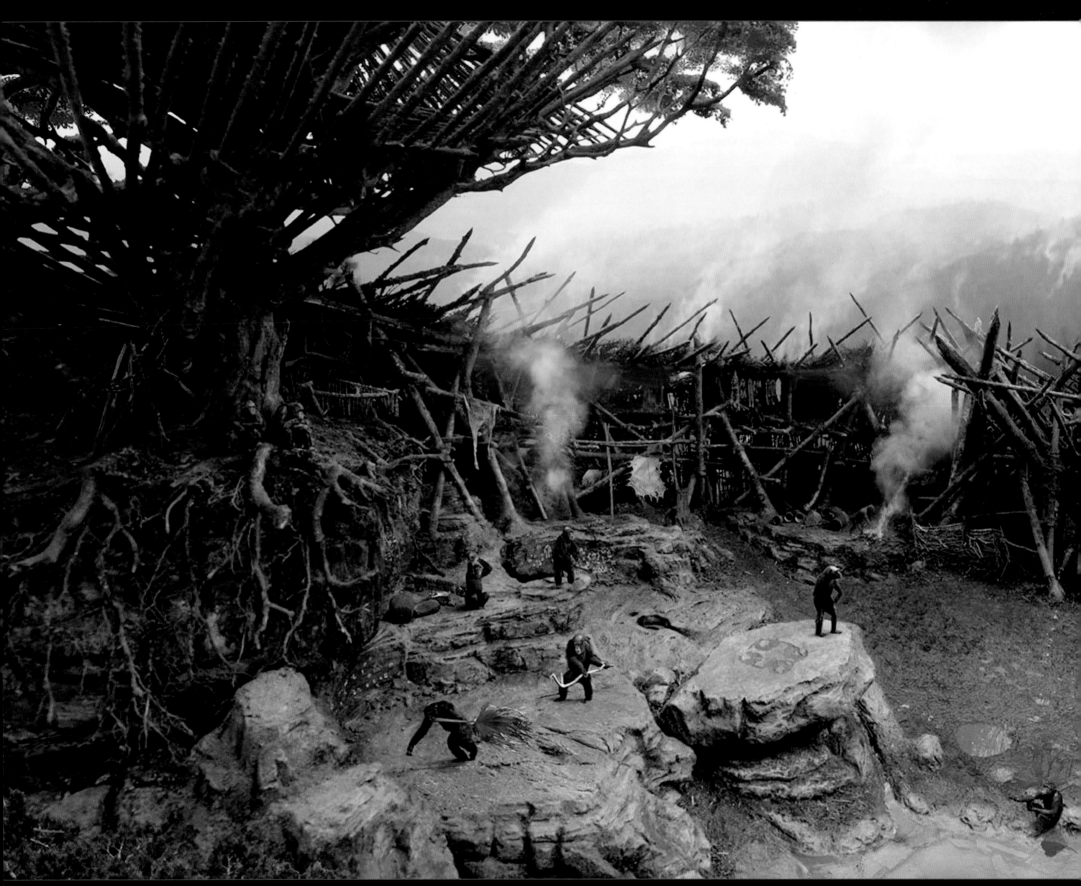

Above: Set photography of the central courtyard area, where the community gathers for celebrations and other events.

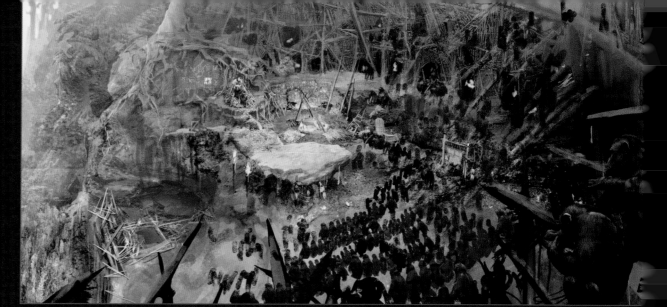

"Our initial design of the mountain was as a
defensive structure—it's sort of a castle keep."

James Chinlund, *Production Designer*

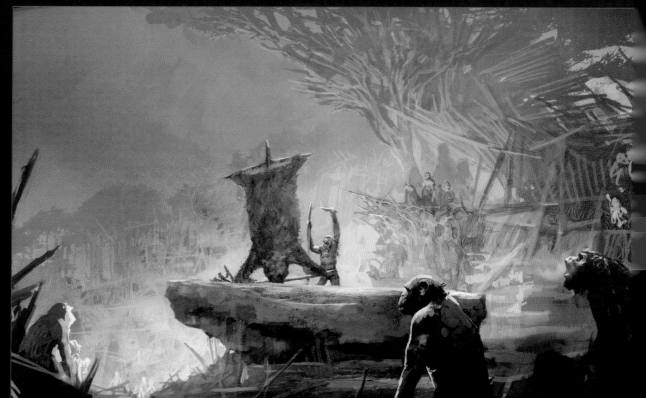

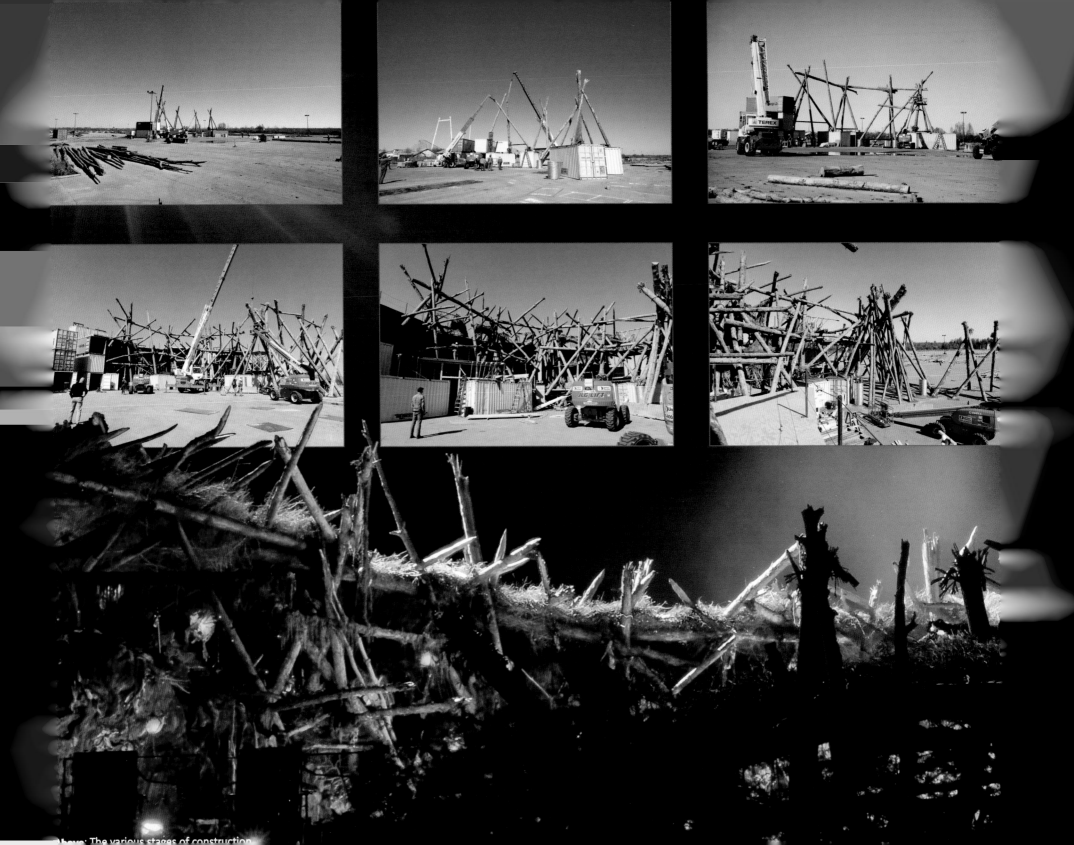

Above: The various stages of construction.

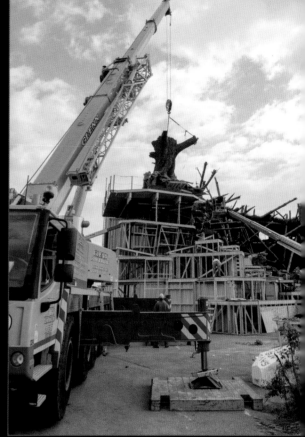

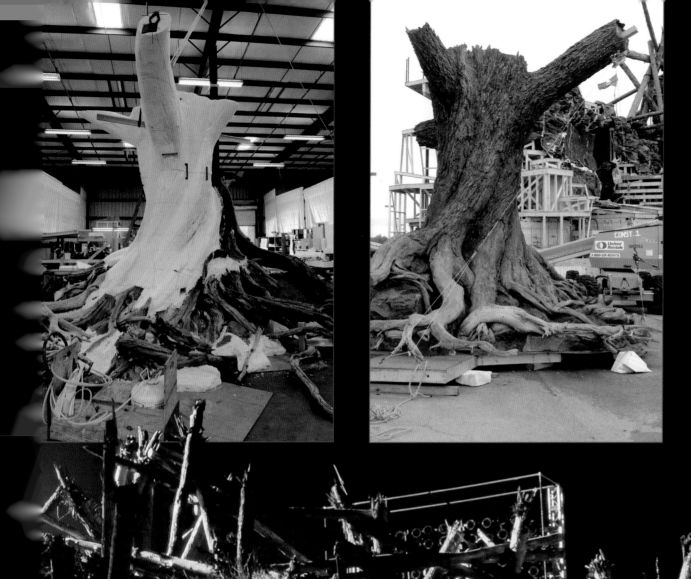

Above left to right: The base of Caesar's perch, his house built into a tree, is sculpted, painted, and moved into position during pre-production.

To realize the village as a reflection of the ape community's evolution, Chinlund worked on the basis that the primate building style had improved as the village had grown. "The idea is, as you move up the mountain, you follow their evolution. So the forms get more and more refined, until you get to Caesar's perch, which is sort of the pinnacle of the ape architecture. As you move through the streets,

you see different ape homes, tucked in along the sides. We also spent a lot of time developing water systems for them. The idea was that they would be channeling some sort of stream through the whole mountain, so you see aqueducts and things like that."

Taking the designs that Chinlund's team had created and turning them into physical sets required a lot of

space. Thankfully, the production discovered that New Orleans, Louisiana was home to exactly what they needed—NASA's Michoud Assembly Facility. This huge complex was originally built to serve NASA's Space Shuttle Program, and between 1979 and 2010 built 136 external tanks for the Kennedy Space Centers' shuttles, as well as other components. Now the government leases some

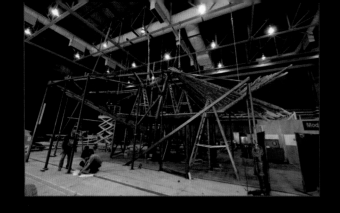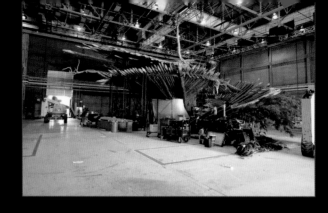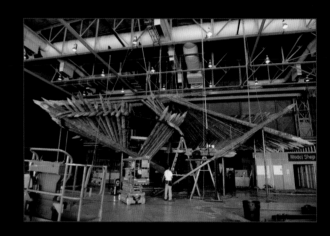

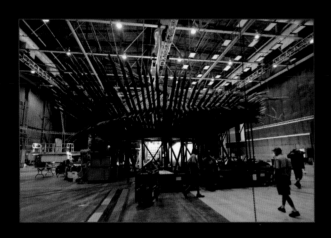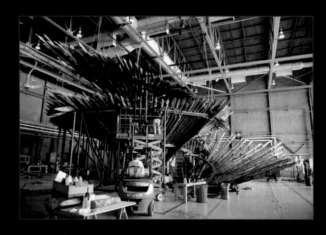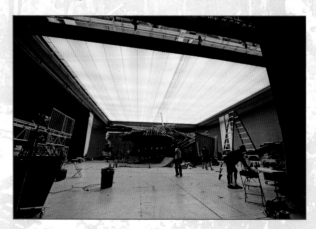

of the considerable square footage inside the facility to film productions to use as sound stages. Though location filming once again took place in the forests around Vancouver, Michoud became *Dawn*'s main production base.

"This was a huge, huge set that we built in New Orleans," says Chinlund, of the images on these pages.

"This was the main set, which is the central courtyard of Ape Mountain, with the ceremonial stone in the center. That entails Caesar's throne area, and then this huge ape housing block, and then Caesar's tree and his home sitting above it. The idea was this sort of nautilus shell form, spiraling up the mountain, and this is the last lick of that."

"[It] was all about making Caesar flesh and blood that we could connect to," says Reeves. "The brilliant thing was that he was already that from the first film, [so] this was about how do we grow that? Having an extended family and having to deal with that at the same time as he has to be a leader, and a father and a brother and a husband – all of those things make him, I think, a more vivid character."

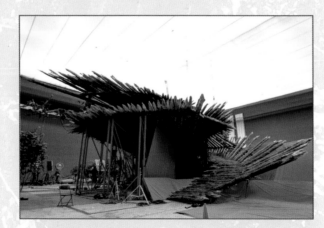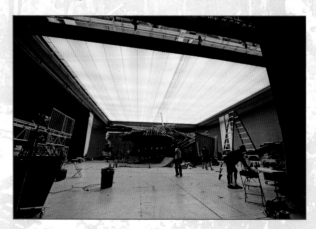

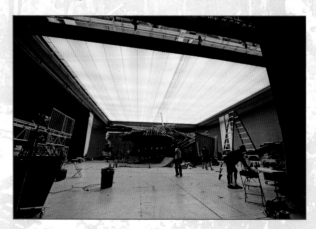

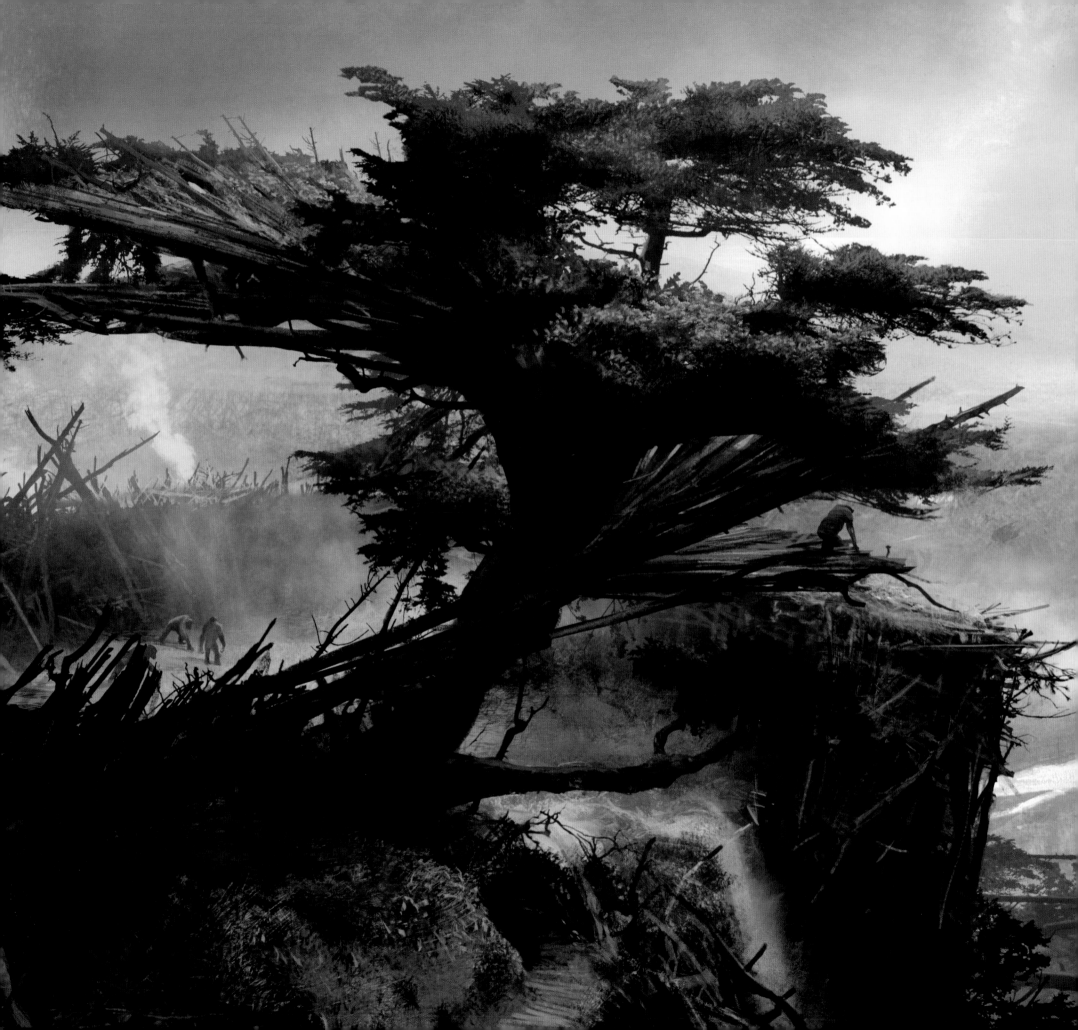

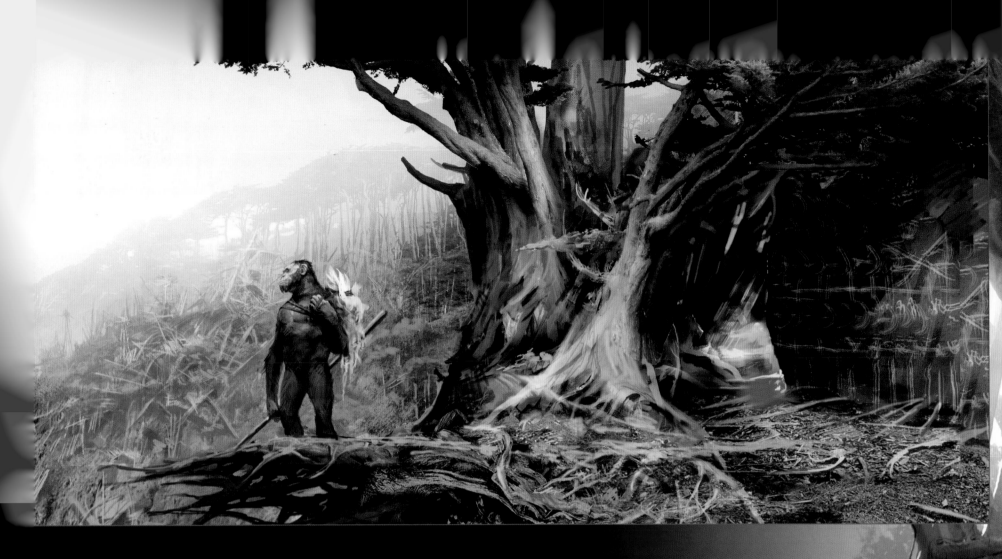

A significant part of the opening act of *Dawn*, besides showing how the ape community as a whole had advanced, was detailing how Caesar in particular had changed and grown over the years since he had led the revolution. He and Cornelia, seen only briefly in *Rise*, have become parents, and are in fact about to have another child. His wise leadership has kept him as the alpha of the group, not just over the apes, but also over the gorilla and orangutan populations. The illustrations produced by Chinlund's team reflect all of these aspects of the story, and helped pin down the tone that director Matt Reeves was looking to create.

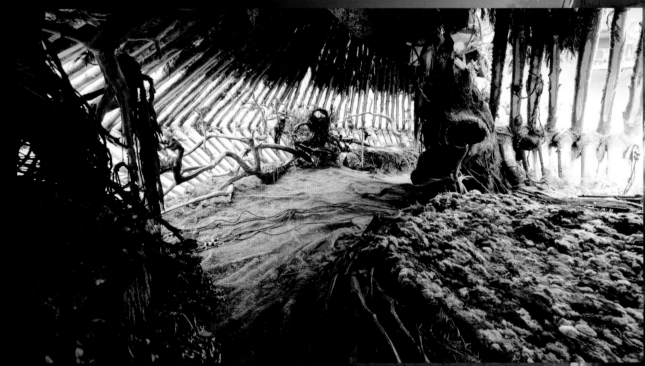

This spread: Early concept drawings of Caesar's perch both inside and out, and the perch interior set as built (*above*).

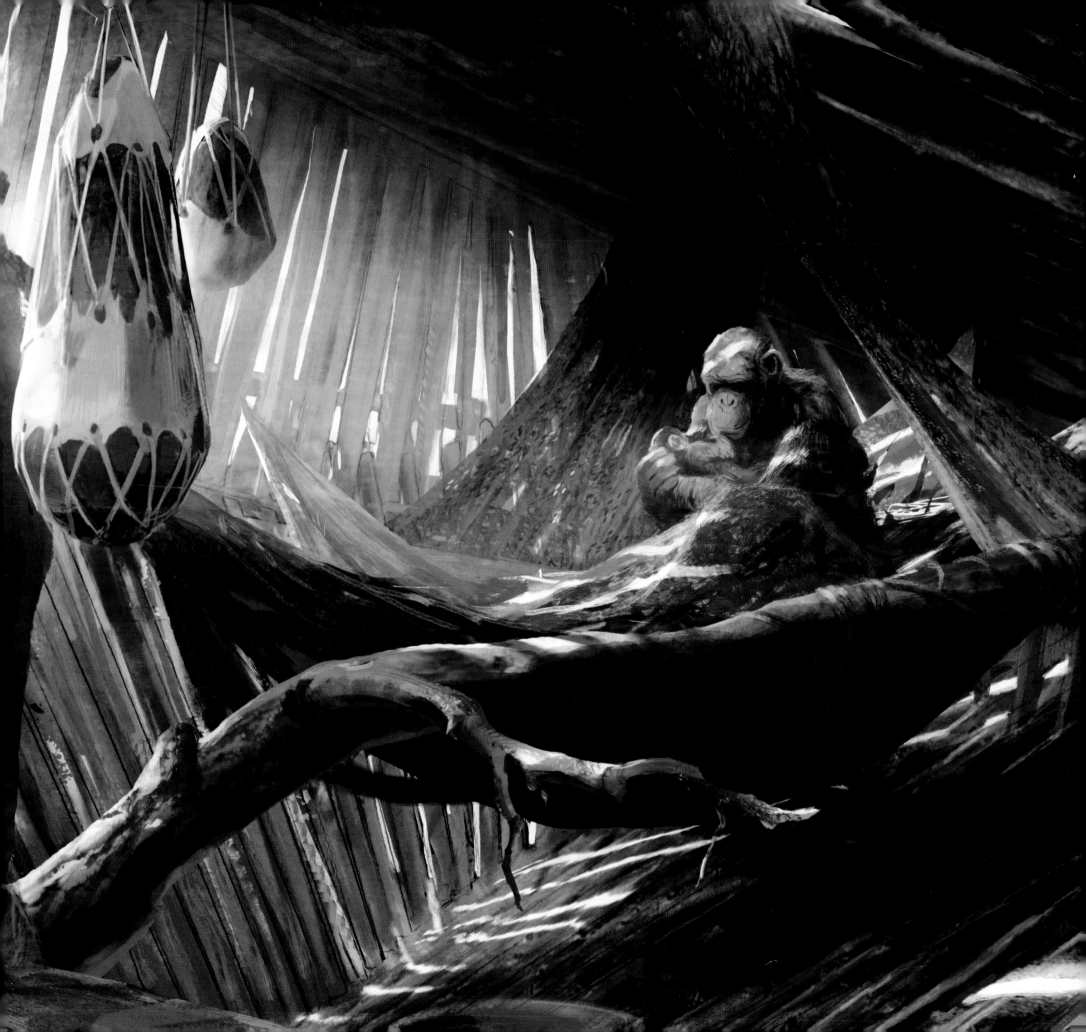

APE LANGUAGE

Symbolism has always been crucial to the *Planet of the Apes* series: from the Statue of Liberty in the original 1968 movie to Caesar's bedroom window in *Rise*. In *Dawn*, the filmmakers looked to develop this motif and create a whole written language for Caesar and his community.

"There's writing walls in the Courtyard," explains Production Designer James Chinlund. "And, early in the movie, you see Maurice teaching young chimps to write. Their story is written on the wall of the Courtyard, and we were very careful to make sure that it was a legible story. I mean, if you actually slow it down and take a look, those pictograms are there to be read. I love that if [a fan] really cares, they're going to step through the movie and find those details."

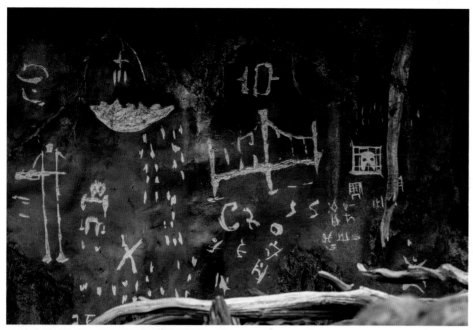

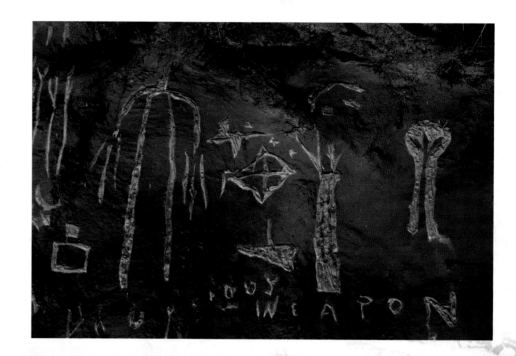

Left: Graphic Designer Andrew Campbell created the language symbols.
This page: Places, such as the Golden Gate bridge, as well as moral guidance is expressed in the drawings.

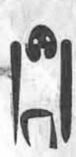

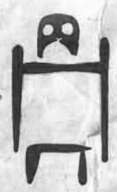

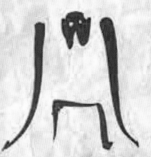

Chimp BonoBO Gorilla Orangutuan

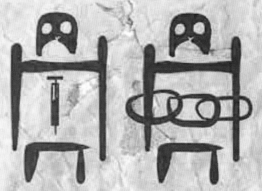

dead ape, caged ape, injected ape & chained ape

Ape family torn apart and killed

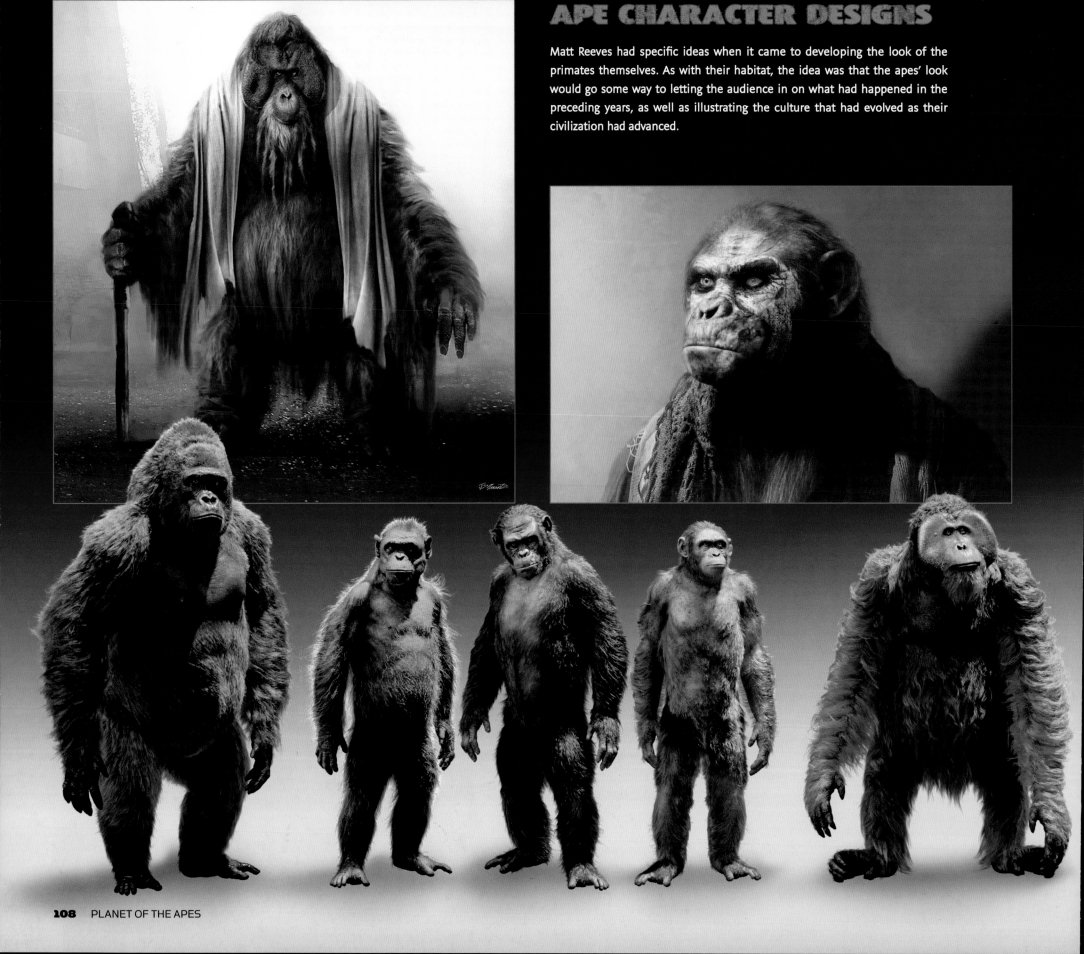

APE CHARACTER DESIGNS

Matt Reeves had specific ideas when it came to developing the look of the primates themselves. As with their habitat, the idea was that the apes' look would go some way to letting the audience in on what had happened in the preceding years, as well as illustrating the culture that had evolved as their civilization had advanced.

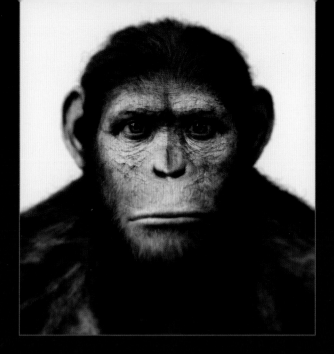
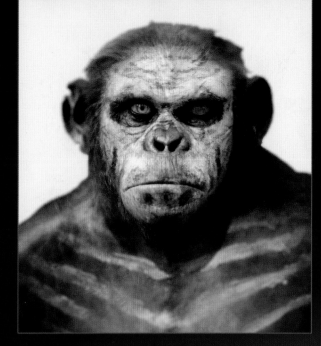
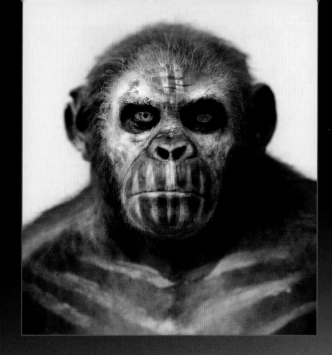

Although initial discussions centered on whether the apes would be clothed, Reeves' vision of this early stage of the ape world did not go that far. "We went through explorations for what kind of things they would be wearing, and every time we did, it seemed silly," the director admits. "I thought the only thing that makes sense is something that forms function."

"A lot of it was about function," James Chinlund agrees. "If they're hunting, they need a sling to put their weapon in, so you'll see that."

Instead of clothing, Reeves came up with a visual concept that not only showed the apes' advancement but also was so striking that it became a key element of the film's marketing: tribal face paint markings.

"The war paint was the idea of trying to think about how, because they were evolving emotionally, spiritually, and intellectually, there would be this sense of the symbolic," says Reeves. "There would be this part of their lives that could be implied, and so those kinds of adornments were exciting. They made sense, they represent something that an intelligent, sentient character might feel."

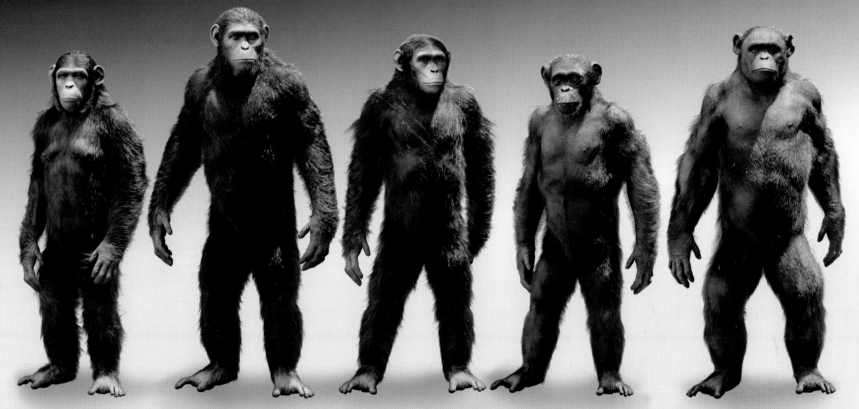

This spread and next spread: Ape character concept art, including different iterations of the ape body paint and limited items of clothing, particularly for those of Koba. Note Sims' studies for apes standing in a fully erect position.

PERFORMANCE CAPTURE

"I've never, ever drawn a distinction between playing a live action character and a performance captured character," says Andy Serkis. "They're entirely the same thing. You're just not putting a costume and make-up on beforehand, you're having the digital costume and make-up applied afterwards. The rest is pure acting."

The advances in performance capture and CGI animation pioneered in *Rise* and developed still further in *Dawn of the Planet of the Apes* have led to the most lifelike digital characters yet seen on film, and of course the work of many talented artists goes into bringing the apes to the screen, but for Serkis, all the technology is anchored by one thing: the performance. "The thing to remember is that when Rupert [Wyatt] was directing *Rise* and Matt [Reeves] was directing *Dawn*, in the edit they are cutting together those performances before the visual effects are overlaid on top, before the animators interpolate the performance. That's what the drama lives or dies by, and that's what the performance capture really is—it's literally another bunch of cameras recording an actor's performance. I think it's taken a long time for the film industry and the acting community [to realize that]. Gradually, that has changed. Certainly since I first started doing this on *Lord of the Rings*, it's changed dramatically in terms of its perception."

Prior to the development of the technology used in *Rise* and *Dawn*, the actors' faces were animated using traditional key frame animation. Animators would

Above: Matt Reeves and Terry Notary at work in the volume.

Right: Terry Notary and Andy Serkis in full performance capture gear, complete with arm extensions designed by Terry Notary. A tiny video camera and light are affixed to a head-mounted rig to capture the actor's facial performance in closeup. The exact pattern of facial dots used was refined for *Dawn* to more accurately capture expression and muscle movement.

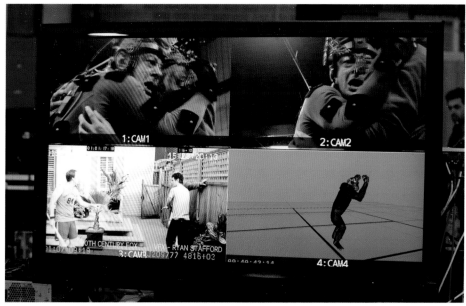

Above: Elements of a scene coming together, from close-ups, to a medium shot, to an early CG render giving position and movement.

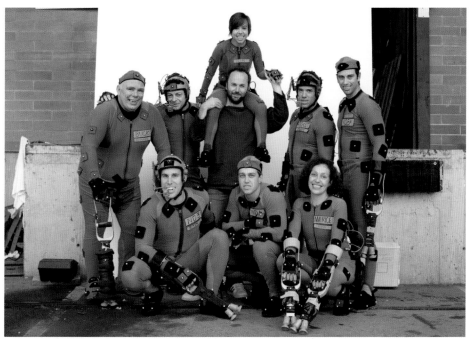

Above: The apes of *Rise* gather for a group shot with their director. Left to right: Richard Ridings (Buck), Andy Serkis (Caesar), Rupert Wyatt with Devyn Dalton (Cornelia), Terry Notary (Rocket and Bright Eyes), Chris Gordon (Koba), front row: two of the ape stunt men and Karin Konoval (Maurice).

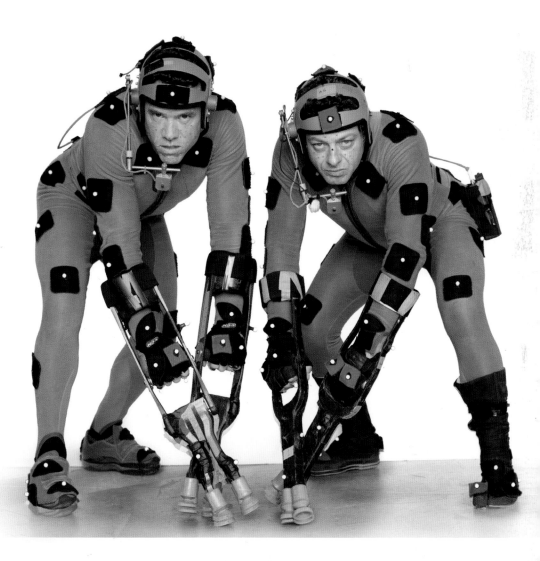

essentially create movement inspired by reference video of the actor's facial performance shot on the motion capture stage. "In traditional animation with a key frame approach, you might have a team of thirty different animators working on the same character," Weta Digital's visual effects supervisor Dan Lemmon points out. "Keeping the facial expressions and the continuity of performance through the intermediary of thirty different personalities can be pretty challenging."

With performance capture, the dots on the actor's face drive the animation of the animated character's face, in the same manner that those on his body drive the animation of the character's body. "So being able to have a single person making those character decisions allows for a really consistent through-line to the performance.

The technology also allows, for the first time, the ape actor to perform scenes on set with the human actors. Previously, the motion capture actor would have been represented on set by a tennis ball suspended from a rod, to which the human actor would have to attempt to interact. "Having them physically present on the set as well is a huge bonus. It's very difficult for actors to give compelling performances to a piece of string or a tennis ball floating on a stick, which is what we resorted to in the past. If you can actually have somebody there, who they can act to and have a bit of back-and-forth with, you end up having a much more believable performance."

The process has come a long way since Andy Serkis first played Gollum in *Lord of the Rings*. Back then, it was just body movement that was being captured, no facial expressions, and while Serkis did film alongside the actors on set, those shots were used mainly as reference for the animators; all the actual motion capture was shot later, away from the live action set on a separate green screen stage, or 'volume' (so named because it represents the volume in space in which the actors are performing representing the set which will later be added digitally).

"After two years of finally getting the body to work on *Lord of the Rings*, when we came to *King Kong*, we thought we were ready to tap facial capture," remembers Weta's senior visual effects supervisor Joe Letteri. "So we came up with a system to actually mark up Andy's face and analyze and interpret the facial expressions and to transfer what Andy's emotional expressions were onto the muscles of King Kong. That worked pretty successfully for us, but again there was no physical interaction, because when Andy was on set as Kong, he was up on a scissor lift, because he needed to be at that 25ft high eyeline. So there was no one-on-one interaction for that, it was all done with Andy after the fact.

"After *Kong* we came to do *James Cameron's Avatar*, and we wanted to combine these two, and so the idea there was we had the performance capture for the body but at the same time we were recording the performance of the face. We came up with a new system of using a

video camera on a head rig, because director Jim Cameron wanted to give the actors more flexibility to move, and so having a head rig-mounted camera gave us that." The head-mounted rig, or Camera Boom, as it is called, features a metal bar mounted in front of the actor's face with a tiny HD camera with a wide angle lens. The camera records the actor's facial movements, both for visual reference for the animators and to photograph marker dots painted onto specific points on the actor's face. A ring of LED lights is also present, for night scenes, for example, which might otherwise be too dark to allow the HD camera to pick up the markers properly. "We break down each of the facial muscle movements individually and analyze how the actor's face moves," Visual Effects Supervisor Dan Lemmon describes. "We analyze that, from the information from the dots – not just at the corners of the mouth, etc., but at points which show us which muscles are firing when they make expressions. Those points are then matched up with points in the same musculature of our animated character." Letteri continues: "So that put everything together: the head, the body, everyone being able to work together—but because that happened in a virtual world, again there was very little physical interaction where we had to deal with live action characters.

"So when it came around to doing *Rise of the Planet of the Apes*, we had one thing going for us, which was that Caesar and the apes were roughly human-sized, and we thought, well, okay, ideally now we can have Andy and the other ape performers in there working with the human actors, because they are the right size—we can get that intimate interaction that we want. But how do we do this without having to go back and essentially re-perform or key frame all that? Can we capture the information right on set? So we took the whole idea of performance capture, and integrated it into a live action set. Our crew was there now, just like the grips and the gaffers would be for every set that required the apes. We had to get in there and set up a whole camera and lighting rig system for the performance capture cameras. But that tied it all together. It meant we got Andy's performance—directly what he was doing on the day. There was no guess work, and it really just gave a nice integrated performance."

Photographing the actors doing scenes requires several steps. First, the actors—the MoCap actor (e.g. Serkis) and the

Right: Caesar is tormented at the primate shelter, from onset footage to final rendered frames.

human actor (e.g. James Franco)—shoot the scene together normally, as if MoCap wasn't even involved. "When we first started," recalls Serkis, "James was worried about it for about an hour on the first day, and then he totally got it. I told him, "Don't feel that I'm here as a reference. I'm just here being the character, and you're acting opposite me.' His acting as Will was no different than my acting as Caesar. We were just two actors playing opposite each other—except that I was wearing dots all over my face and had a head-mounted camera on!"

Serkis and his scene mate would do several passes at the scene together on set for the camera, and then several more passes would be made with just Franco, repeating the same moves he had just made with Serkis there, but cueing his eyes to a tennis ball or piece of tape suspended in front of him, held at precisely the spot where Serkis's eyes were moments before. A third pass is then made with no actors there, simply for the sake of picking up the image of the set. A fourth pass is made using a two large balls held by a visual effects assistant—one gray and the other silver, to help visual effects artists to see how light reflects off of objects in that spot on the set.

Those second and third passes are there to provide background information of the set for where Serkis's image is removed and replaced with the digital Caesar, but where there might have been overlap where Serkis's body extended beyond where Caesar's does in the image. For example, if Serkis's shoulders stick out further than Caesar's, the visual effects artists can put back some of the background to cover that up, taken from the pass where there was no actor in the frame.

What's more, the groundbreaking infra-red (rather than reflective) sensor technology that the performance capture cameras used to track movement meant that the system could even be used outside on location, in bright sunlight. "Weta of course broke the mold again, and were the first visual effects company who were able to do that," says Serkis. "It was a very, very big stride forward, that we repeated to an even greater degree for *Dawn*, because of course on *Dawn* it was much more epic, we were out in rainforests, so it was even more challenging."

Above: Andy Serkis as Caesar, when taken into care at the Primate Shelter.

Left: Dan Lemmon: "We wanted to make sure that we matched as faithfully as we could the great performance that Andy gave. The thing that was going to resonate with people in a new and different way was those character turning points... digital characters emoting in a way that you'd never seen before."

Playing Koba in *Dawn of the Planet of the Apes* was Toby Kebbell's first experience of performance capture, and one which he found called on a full range of acting techniques. "You've got two different disciplines: there's theatre, which is this very large performance to give the ape the movement that's required, to give the ape the body language—all of that feels very theatrical. And then you have this ultra subtle film performance, because you have a camera five inches from your face! When you're coming into contact with any of the humans, you've got to appreciate that they're basically looking at a guy in a grey suit with a helmet. He might be screeching, or he might be aggressive or he might move like an ape, but he's definitely not an ape. So if you're not honest with it, if it's not genuine, then they have nothing to react to. They may as well be looking at a tennis ball. So you find yourself doing your performance [even] when the cameras are all on them, you do a full-bore performance for them. That was what was what we agreed upon: we shook hands in the ape camp and said, 'We go all-out every time, so that they believe they're looking at apes.' And it got creepy for them—we would walk around like apes in the Vancouver woods, and you know, Keri [Russell] and all of the actors would be like, 'Holy **** dude, all I'm seeing is an ape.' That's what you needed to offer them so that their performance was as rich as it could be."

For Serkis, a key part of the success of both *Rise* and *Dawn of the Planet of the Apes* is that the directors understood and embraced the technology, but never got distracted by it. "You can get totally side-swiped by the mechanics of it all," Serkis admits. "In the wrong hands it could be 'Well, you're an actor, and you're a walking visual effect.' Both Matt and Rupert treated the performance capture actors exactly the same [as the other actors], and that can't be underestimated really. They are both spectacular storytellers, and in these behemoth productions, in these huge technical monstrosities of productions with hundreds of people and technicians, they always kept it about the moment, about the acting, about the emotion of the scene. They managed to carve out time in the most extraordinary of circumstances, within that big machine, and always made it intimate and about the story. They both did that to a huge degree, and you don't often get that, to be honest."

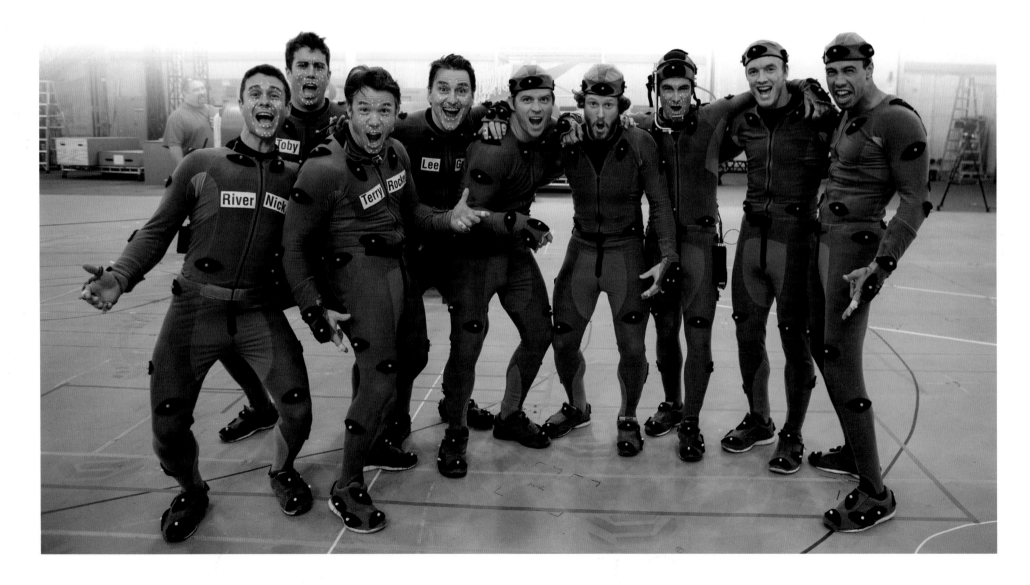

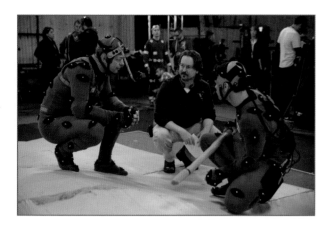

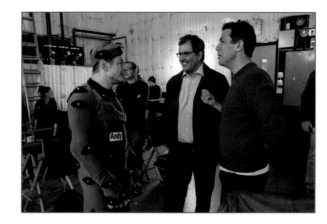

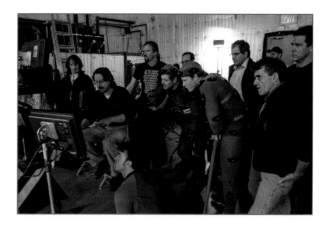

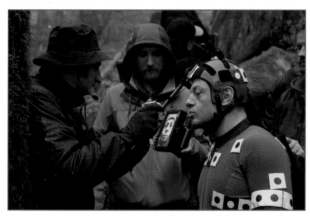

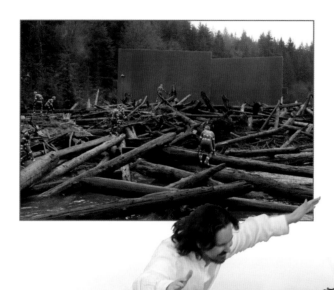

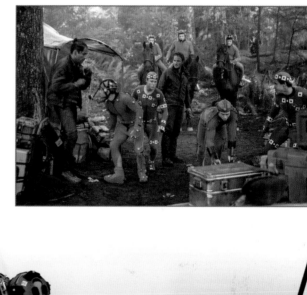

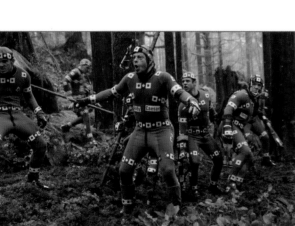

Left: The actors and ape performers at work in the volume.

Above: Working in the volume and out on location. For Matt Reeves, producers Peter Chernin and Dylan Clark, and all the actors, a feeling of tangibility and realism was crucial for creating this new planet of apes.

SAN FRANCISCO

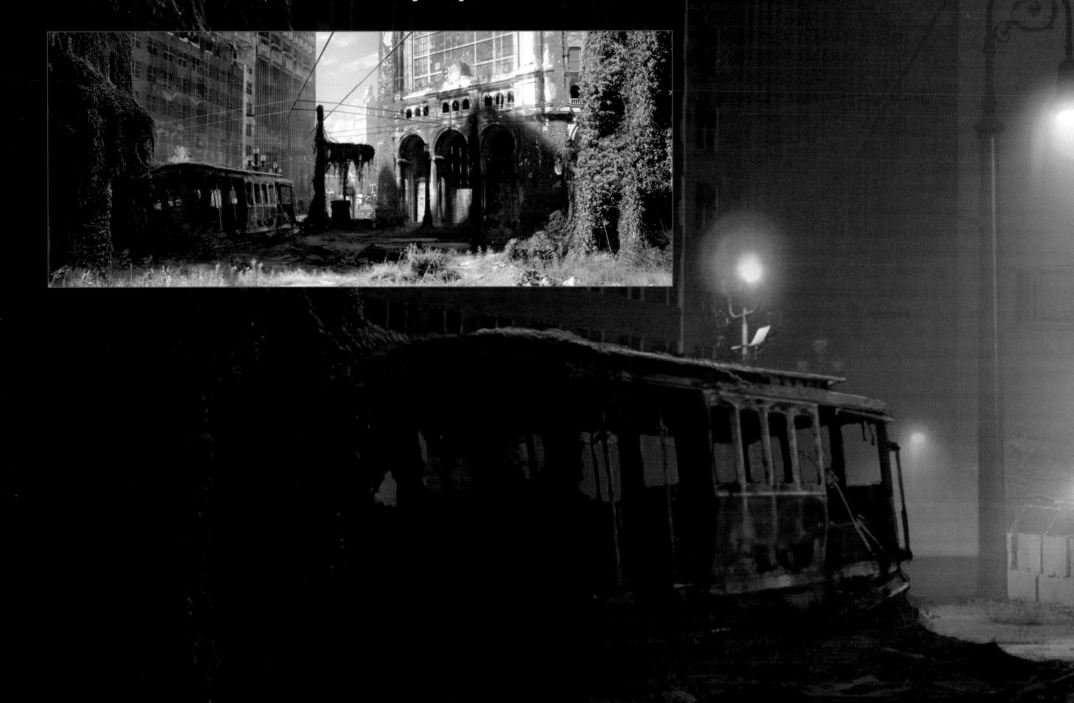

I was just so excited about the opportunity to build a world that was healed by nature," says James Chinlund. "There are a lot of scientific projections out there about the world after humans, and the idea that nature would quickly bounce back and start wiping out all the toxic mess that we've created. So taking a city and actually letting it become a green world was a hugely exciting challenge to craft."

This spread: Early concept art for the streets of San Francisco slowly returning to nature.

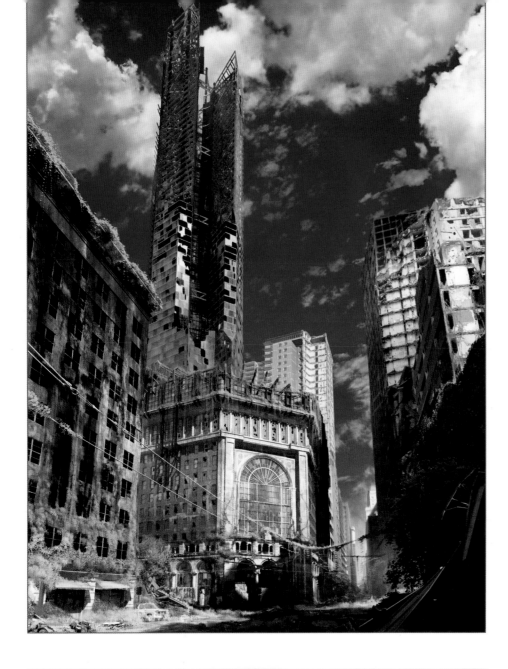

Above left and above: Early concept art showing the half-built tower that would form the backdrop for the film's stunning climax, and the human colony that has established itself at the base of the building.

"This is not a post-apocalyptic movie. It's the beginning of two new worlds—an ape civilization and a fresh start for humans. Ultimately this is a movie about two separate species of families fighting to survive."

Dylan Clark, Producer

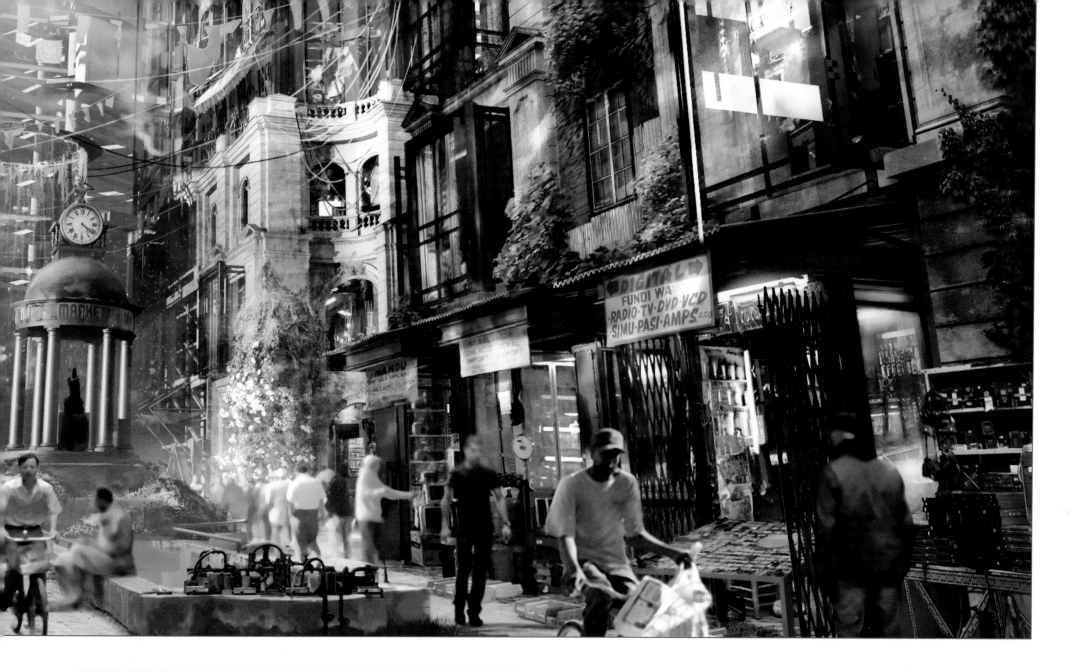

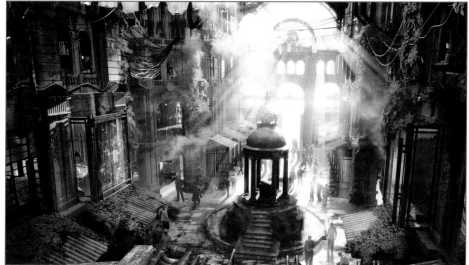

Above: Chinlund says that he didn't want to go for a "doomsday, post-apocalyptic scenario. We wanted it to feel beautiful."

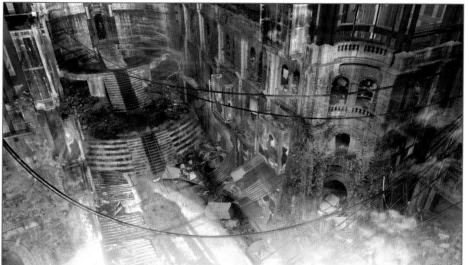

Above: Eagle-eyed viewers will note that the streetcar seen above is the same one ridden by the apes during their exodus through San Francisco in *Rise*.

Below and opposite: Building the sets for the human colony, including the radio room.

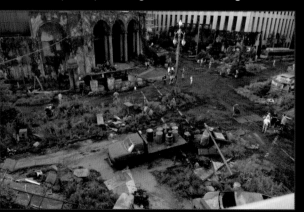

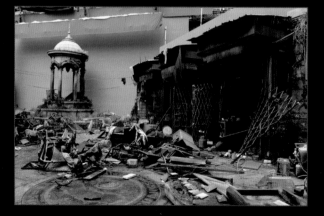

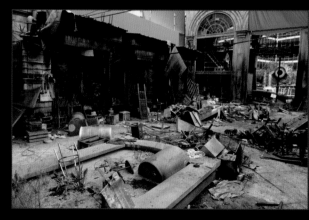

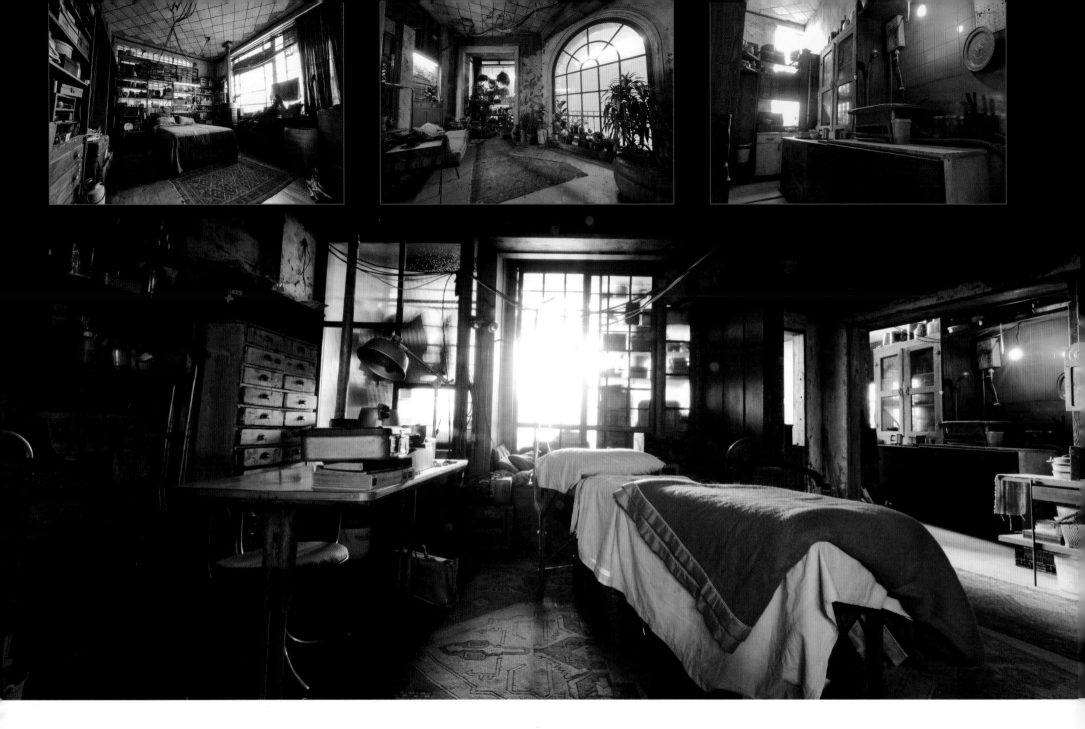

Much as in the way that Caesar's perch overlooked the rest of the ape village, the building that dominated the remains of human civilization in San Francisco was the incomplete tower complex. "They've holed up in this half-finished piece of architecture," explains Chinlund. "It's based on One Market Street in San Francisco, which at the time the virus struck, the builders had taken an old building, took the guts out of it, and built this hyper-

modern skyscraper. We loved the idea of the old and the new, and seeing human evolution and achievement all wrapped up into one thing and then sort of frozen in time.

"The idea is that they've all moved in here to pool resources and share food—a village within the city. We were trying to create the idea that they would have moved into a beautiful place that had great light and feeling. So these are all the various homes of the people in the story.

Ellie has her apartment up here, the radio room, it's all built into that."

The interiors of the human colony, as with around 80% of the film, were built on an exterior set location. "We took over a huge area in downtown New Orleans," says Chinlund. "We had a six week closure on this street junction at Rampart and Common. It was a big deal down there."

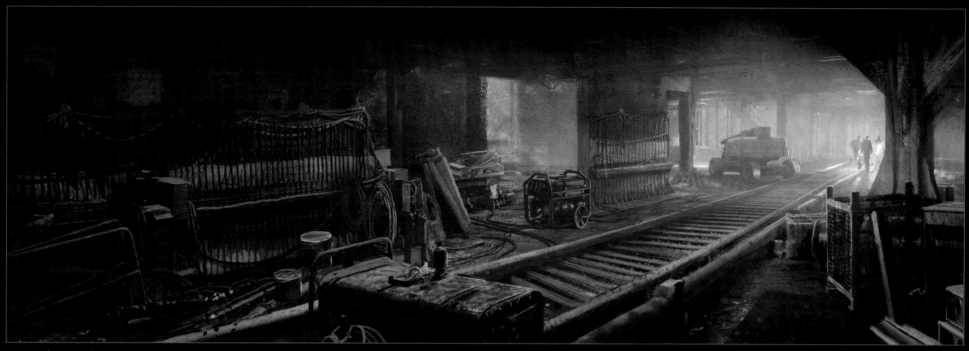

Above: The tunnels beneath the tower, home to an uncompleted BART subway station/transit center under Market Street.

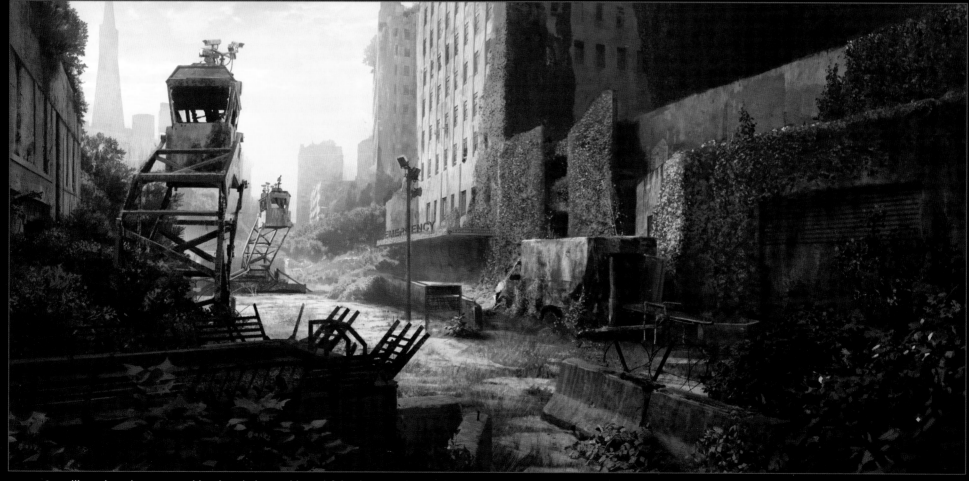

Above: Surveillance/guard towers outside a hospital are evidence of the desperate human fight against the virus.

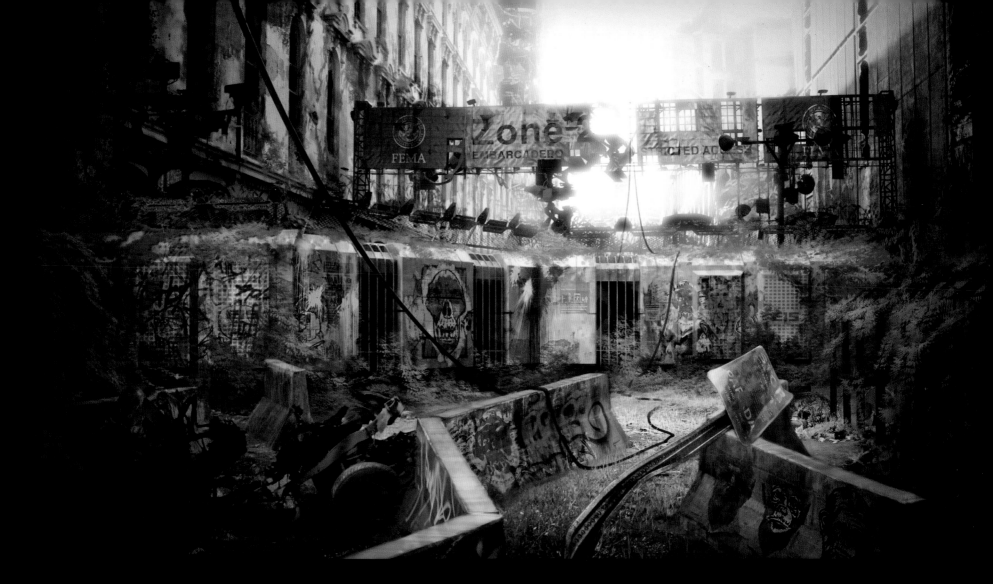

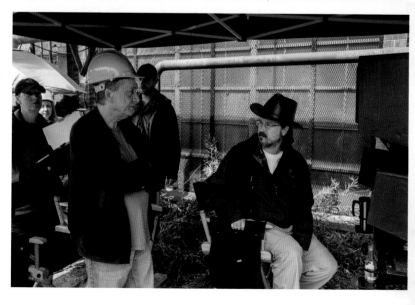

THE HUMANS

"For the humans," says Matt Reeves, "the world as we know it has been ripped away from them. They are trying to claw their way back to some kind of existence that has meaning. And of course all of that is based in family, and the idea that they are a kind of damaged family that is trying to heal itself. Jason Clarke's character Malcolm [is] willing to put himself into potentially very dangerous circumstances in order to fight for a way to get back to that, a way to make his family whole again, even if all of the pieces aren't there. With the pieces that *are* there — with him and Ellie [Keri Russell] and his son Alexander [Kodi Smit-McPhee], that they might actually be able to be healed and be a family again, he would throw himself in front of anything [to achieve that]."

Dawn of the Planet of the Apes also introduces Dreyfus, played by Gary Oldman, a former police officer who lost his entire family in the virus outbreak and now finds himself charged with the safety of San Francisco's remaining

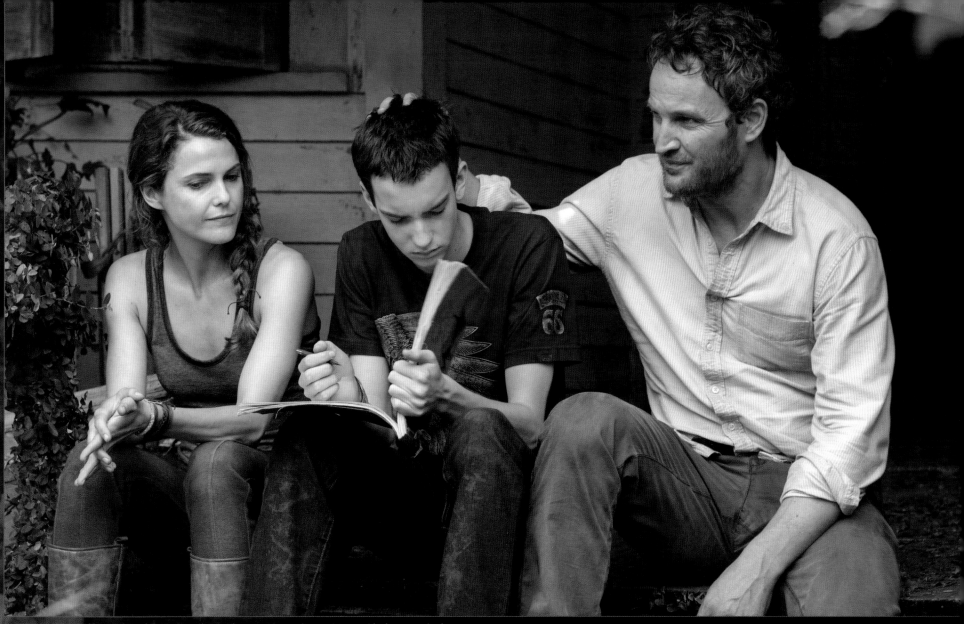

Above: Keri Russell as Ellie, with Kodi Smit-McPhee as Alexander and Jason Clarke as Malcolm.
Left: Gary Oldman as Dreyfus, with his fellow human survivors in the San Francisco colony.

human population. Oldman says he sees Dreyfus as a somewhat reluctant leader, someone who assumed a certain position without ever seeking it. "It fell to him to lead this community," says the actor. "He was designated leader. I think if you're going to protect and rebuild a community, then he's the perfect person, in a way. It's instinctual for him, through his previous training. So he's sort of an ideal candidate."

The actor also has great sympathy for the position in which Dreyfus finds himself, and the extreme measures

he is willing to take. "I can absolutely justify everything he does – I would do the same. It's not [a case of], 'Let's make it even, let's get revenge.' We've been wiped out once before. After everything we've been through, I'm really not even going to take a chance. I'd rather shoot first and ask questions later."

The flipside of Dreyfus is Ellie, the medic. "We wanted someone who would remind us that the apes themselves aren't responsible for how they are," explains Mark Bomback, "that in fact, it's the humans who created the

apes by testing the drugs on them. We also wanted to show a basic human story about how people feel, and tell that through the triangle of Ellie, Alexander and Malcolm. We wanted the audience to root for the survival of the humans, as well as the apes. It makes it more compelling that way."

"When I was looking for the actors, I was just looking for people who I felt had a rich interior life, a rich emotional life – and that was true on the ape side and on the human side," says Reeves of the casting process for

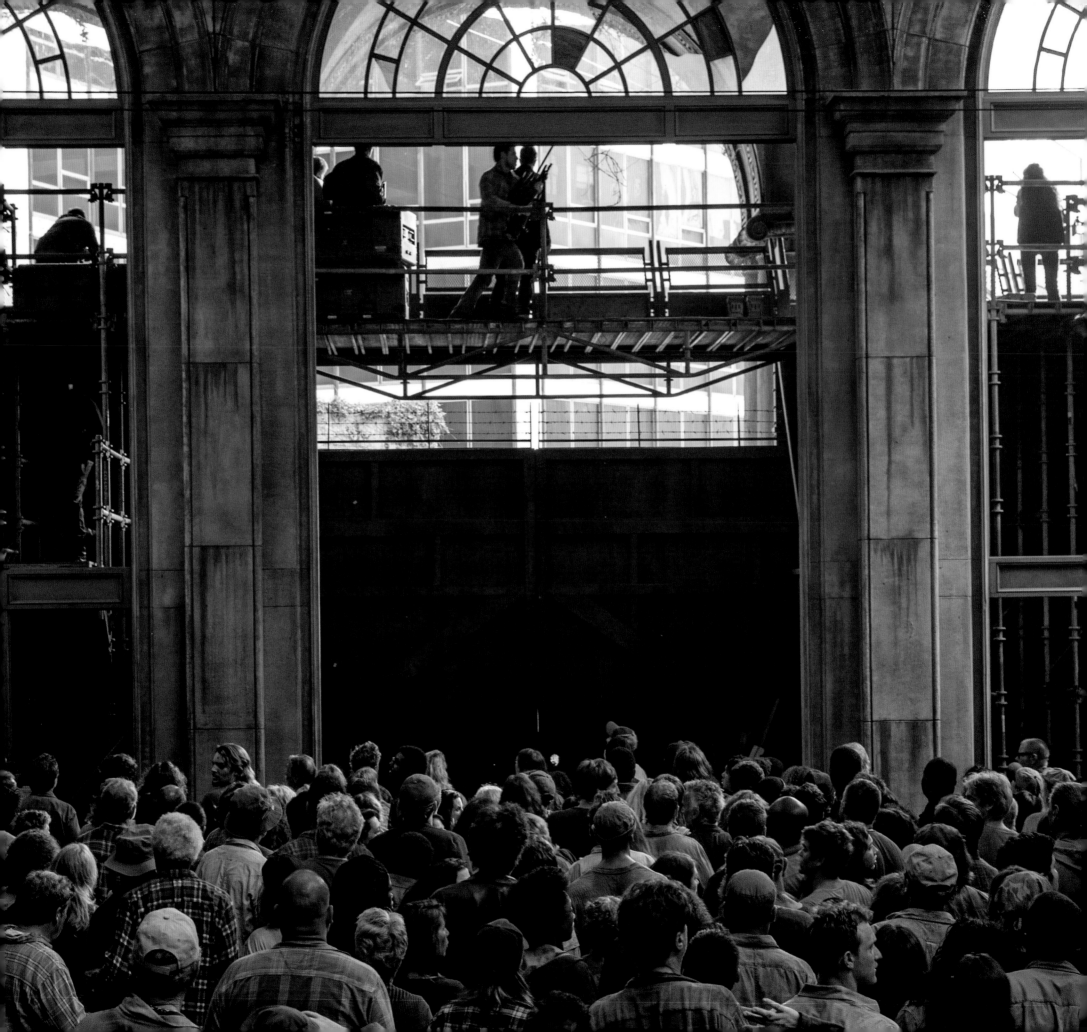

the movie. "The complexity came in when, in order to get certain moments that would play in the movie, you would have to remove the ape performers [from the shot], and our human characters would have to play to nothing. Andy [Serkis] would talk them through off-camera, but that was a real challenge. There's no way you can completely know whether the actors are going to be able to create that, but we worked really hard at that and I had a lot of faith in them and they did it beautifully."

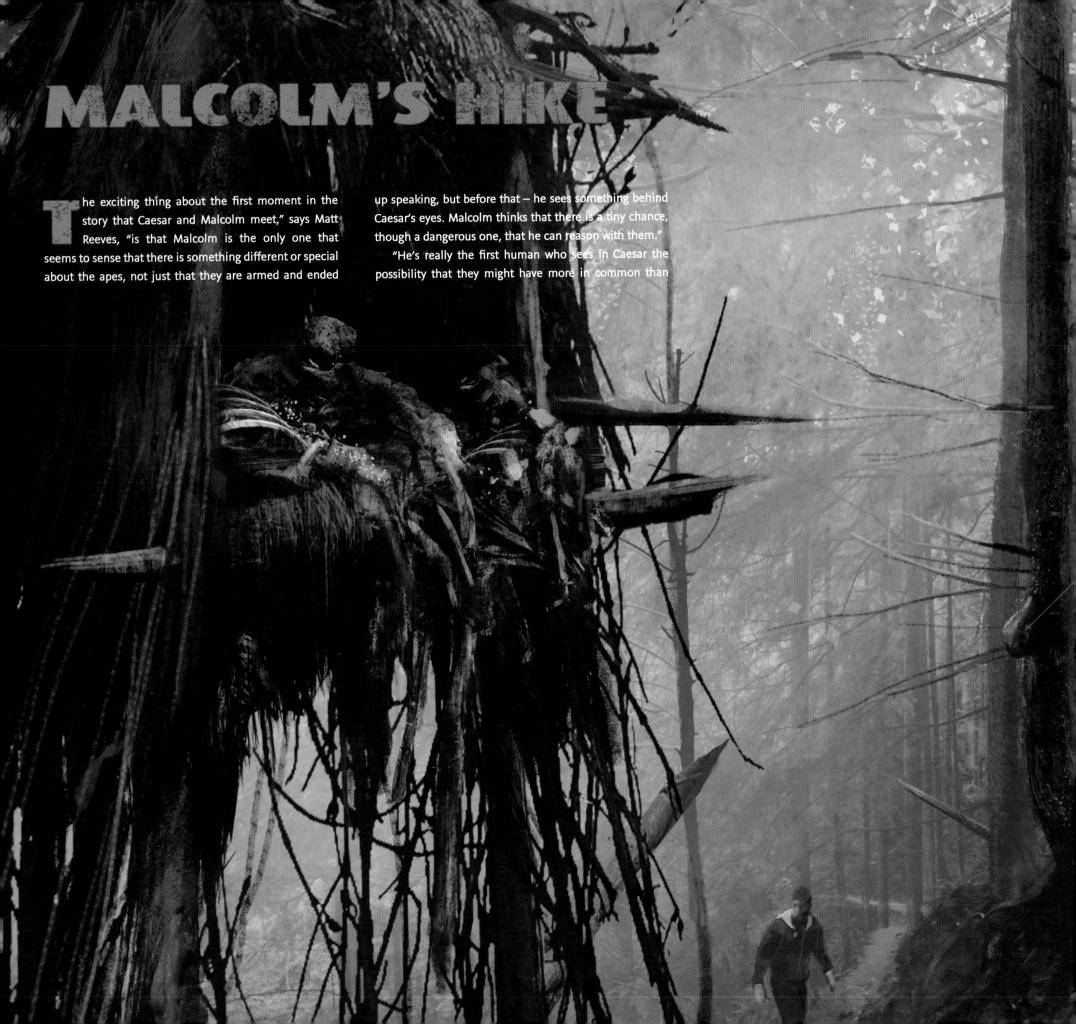

MALCOLM'S HIKE

The exciting thing about the first moment in the story that Caesar and Malcolm meet," says Matt Reeves, "is that Malcolm is the only one that seems to sense that there is something different or special about the apes, not just that they are armed and ended up speaking, but before that — he sees something behind Caesar's eyes. Malcolm thinks that there is a tiny chance, though a dangerous one, that he can reason with them."

"He's really the first human who sees in Caesar the possibility that they might have more in common than

they might on the surface assume," agrees Mark Bomback. "Like Caesar, he's not looking to cohabit with another species, he just wants to make the world a better place for this child he's spent years trying to protect. He knows that the only route there is through some kind of peace with the apes."

Reeves points out that the first section of the movie plays out almost entirely from the apes' point of view, "seeing their world as they experience it. So it was a fun thought – how do we take this world and shift the point of view [to a human's], so that you can go up on this kind of a hero's journey for Malcolm, for him to go up that mountain and face this challenge, to take a bet on this hunch that he has about Caesar. I'm hoping that people will feel it's a thrilling and terrifying sequence."

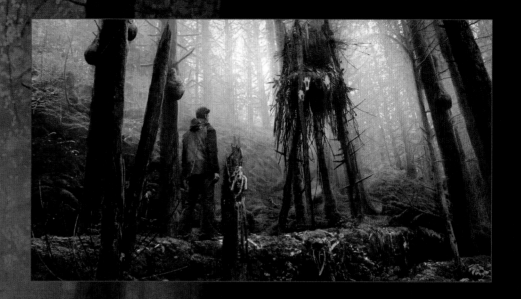

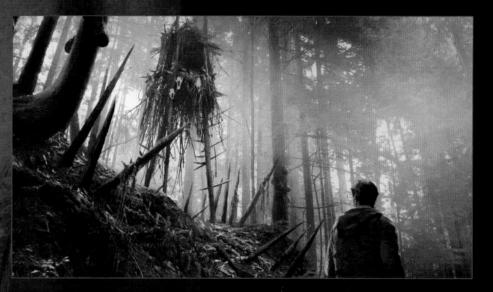

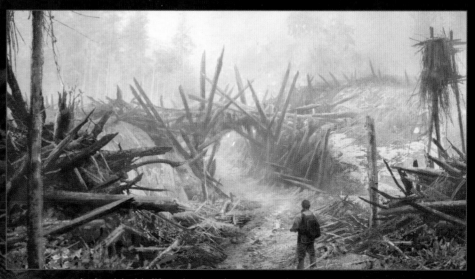

This spread: Malcolm risks his life trying to gain access to the dam. Here, concept art shows his lonely trip through the forest back to the Ape Village.

THE DAM

The gist of the conflict is, the humans are looking for power," explains James Chinlund. "They've been running on diesel and various alternative fuels. But they're getting to the point where they really need to come up with an alternative source. The hydroelectric dam is the answer.

"The feeling was that they should really feel like they're going to the moon, or something like that. This is a dangerous expedition, where they're equipped with the best available resources that the humans have—the last batteries, the best vehicles, the last fuel. It was very important to Matt [Reeves], first of all, that it was

a discovery. So it's hidden under this logjam, and they have this amazing moment of discovery. There was a lot of work I did with Matt, specifically, on story beats. He was interested in having a very tense, dramatic sequence where the humans go into the dam and try to make it work again."

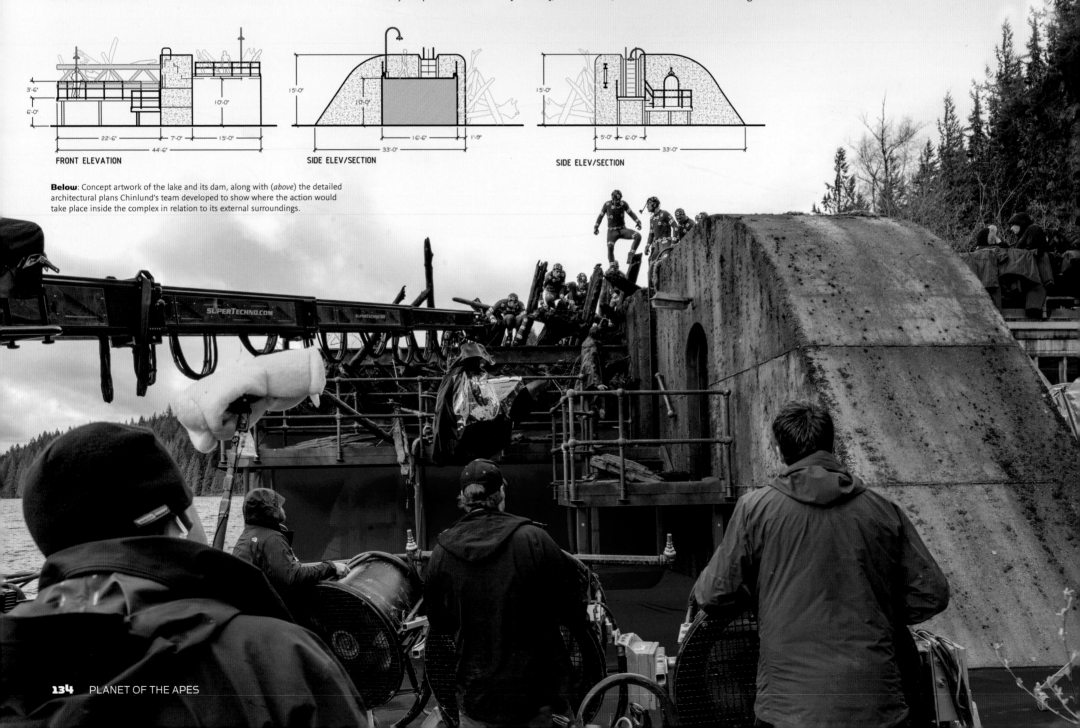

FRONT ELEVATION

SIDE ELEV/SECTION

SIDE ELEV/SECTION

Below: Concept artwork of the lake and its dam, along with (*above*) the detailed architectural plans Chinlund's team developed to show where the action would take place inside the complex in relation to its external surroundings.

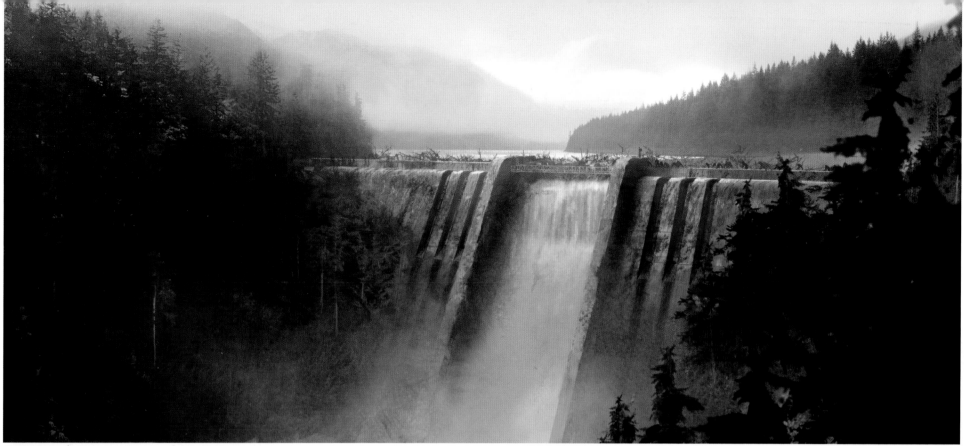

Above: Filming the humans and apes descending into the dam's entrance.

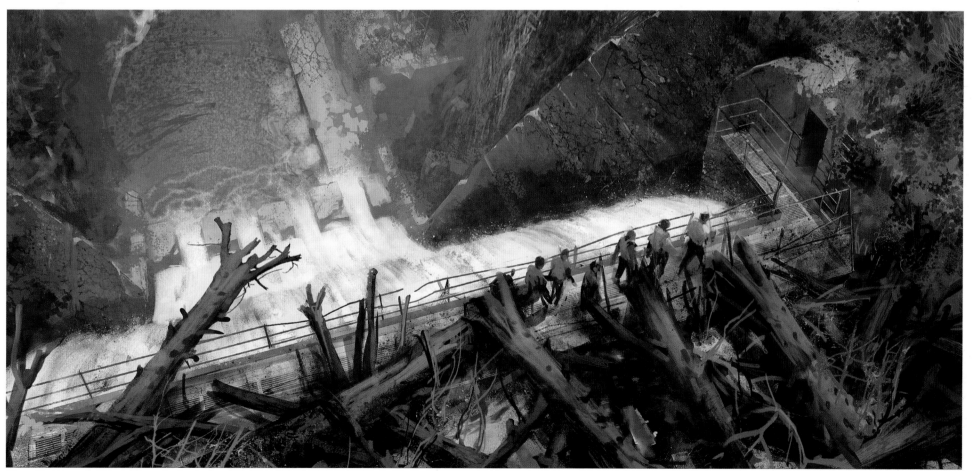

Above: The idea was that from a distance, the dam itself would be hidden from view by logs that had washed downstream over the years..

"Since *Rise*, humans have had limited power. They've been running on fuel, and fuel has a limited shelf life, so in about ten years the fuel itself would no longer be able to generate power, and then they really would be in need of [a new source]. When I said to James that we were doing the dam, he sent me plans of dams in that actual area, so I started writing towards that," Mark Bomback recalls. "I would say to him, 'OK, there's a tunnel here—I might be

using that,' and he'd say, 'Oh, good—I'll design for that.' It really was a privilege, and not done on that many movies, that the writing and the art department are in sync. Really, each was inspiring the other. This would not be the same film without James, I can't say enough good things about him."

One of the biggest script challenges was to explain to the audience the history of the world since we had last

seen it in a succinct and subtle way. "We wanted you to catch up with what had happened without giving you any kind of massive information dump," Bomback explains. Instead of having the explanation come out directly in lengthy conversations between characters, Bomback and director Matt Reeves worked closely with Chinlund so that this information was incorporated into the sets and background, telling the story silently.

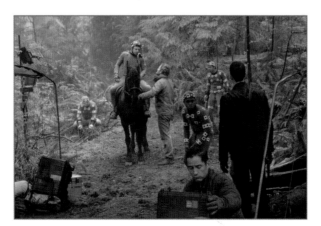

Top: An early concept design for the humans' forest camp and (*above*) the set as it was constructed for filming on location.

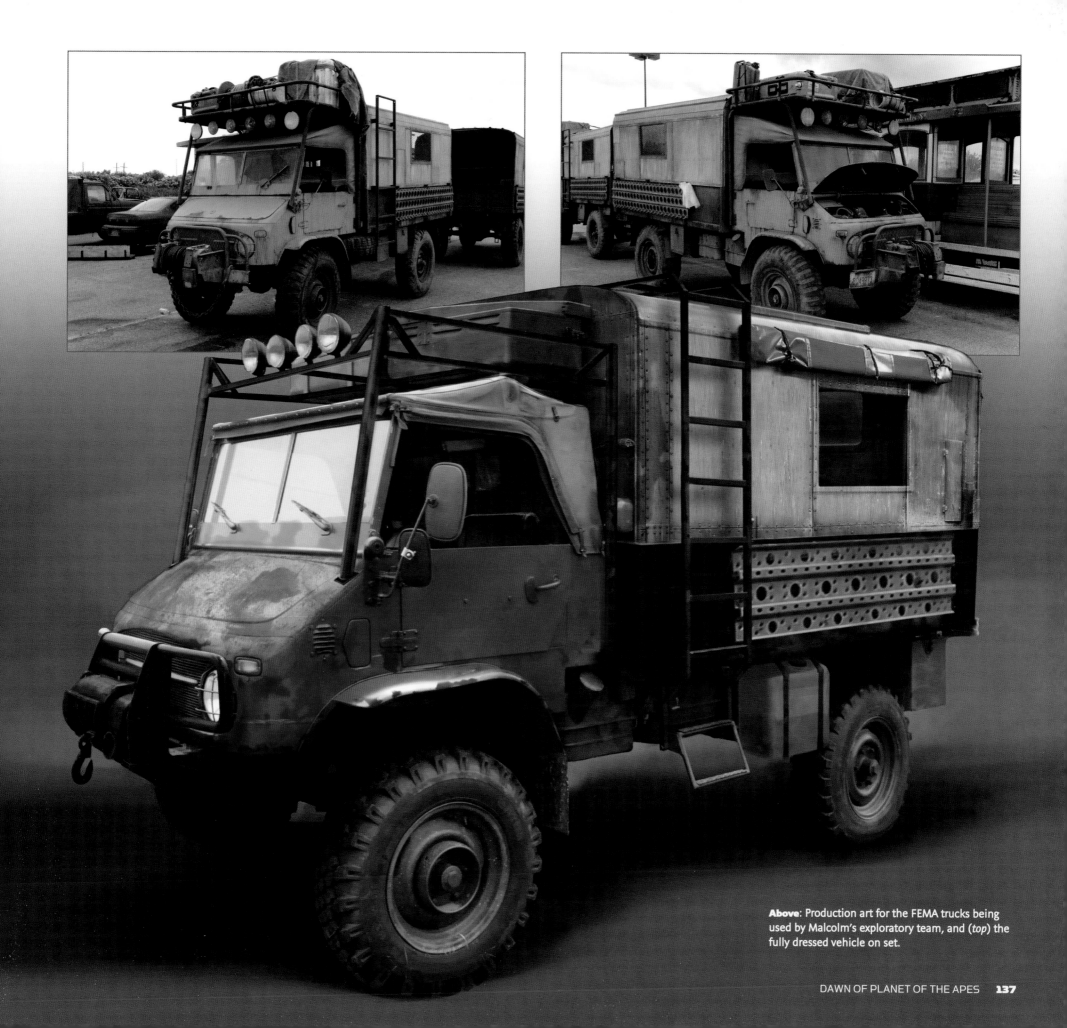

Above: Production art for the FEMA trucks being used by Malcolm's exploratory team, and (*top*) the fully dressed vehicle on set.

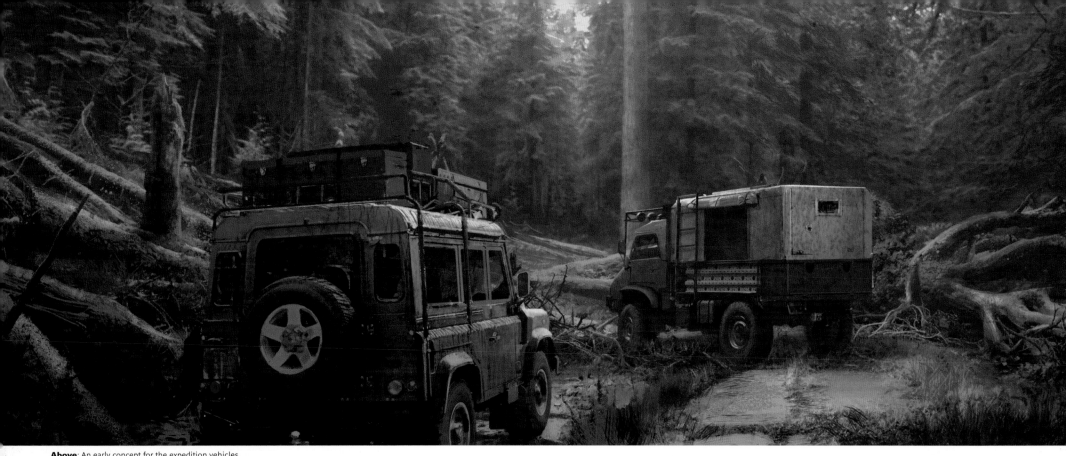

Above: An early concept for the expedition vehicles.

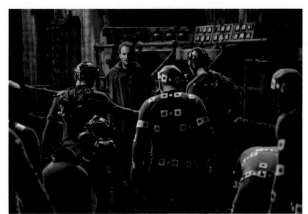

Above and below: Shooting the interior and exterior of the dam scenes.

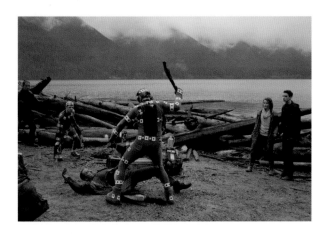

"We spent a lot of time thinking about the way the humans are living, and looking at different temporary power systems," recalls Chinlund. "They have these crazy cars, where you see a big fire box on the back of it, using a gasifier. This is a real thing. Gasifiers use wood—they build a little fire in a sealed chamber, and the wood off-gasses methane. You can capture the methane and use that to power a car—so you can literally run the methane into your fuel tank."

Right: Chinlund's designs for the vehicles made use of his research into current small-scale alternative fuel production.

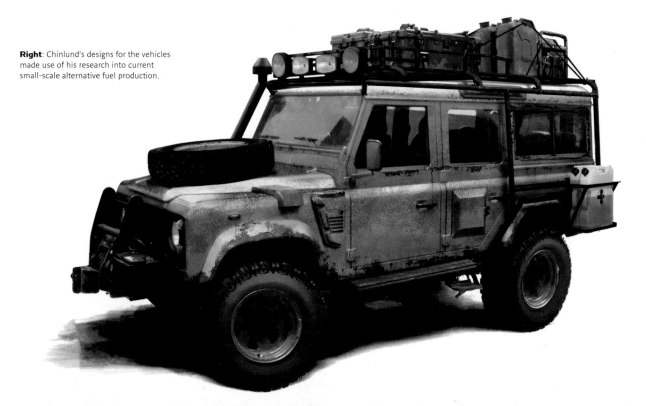

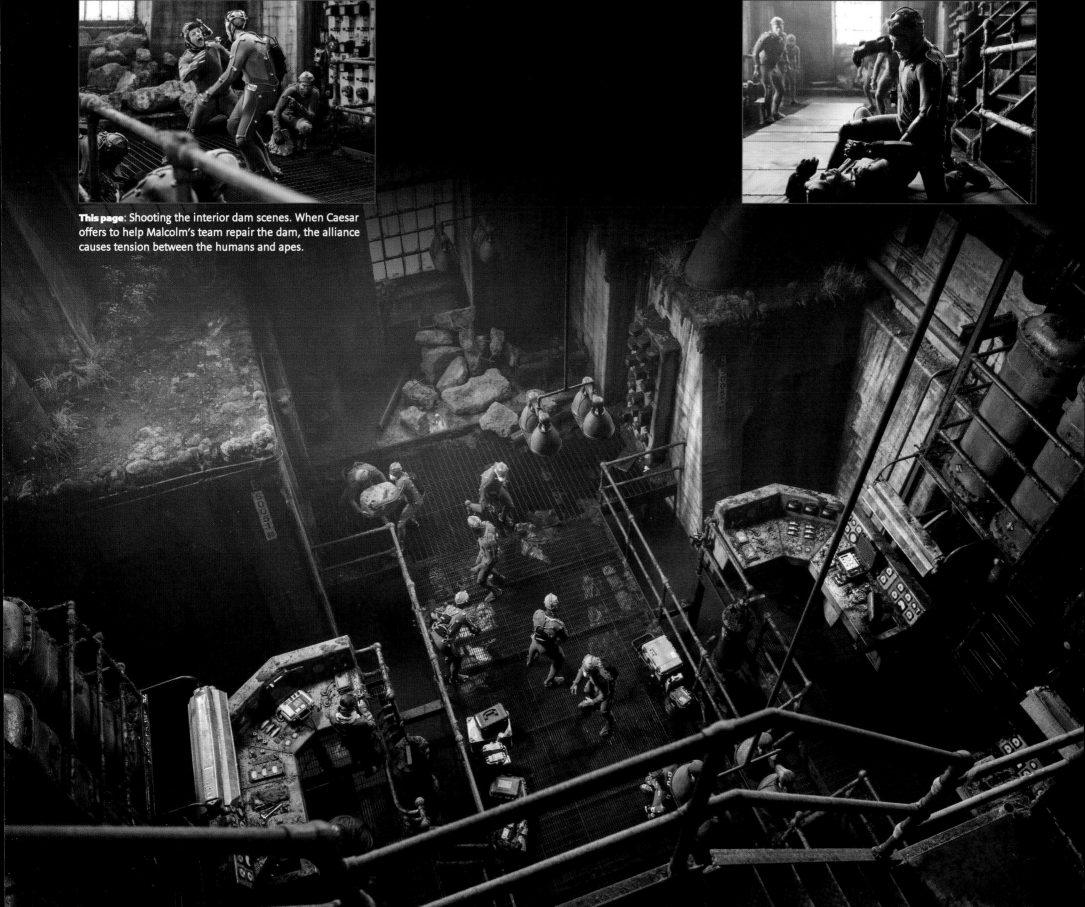

This page: Shooting the interior dam scenes. When Caesar offers to help Malcolm's team repair the dam, the alliance causes tension between the humans and apes.

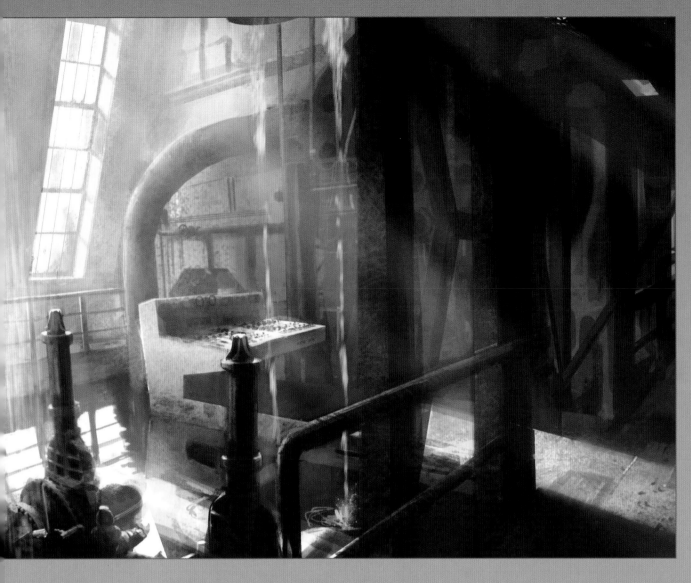

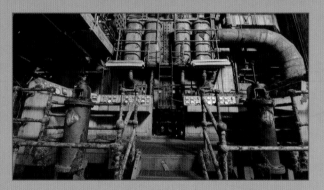

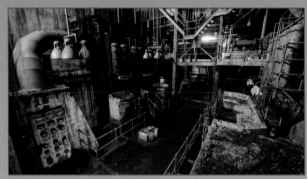

The location for the exterior of the dam and its surroundings was Golden Ear Provincial Park in British Columbia, Canada, while the interiors were shot at a disused power plant in New Orleans. Although certain aspects were digitally enhanced, both locations required a lot of work from Chinlund's team. "We built almost all of it," he says. "We added a big part of the dam at Golden Ear as a concrete element, like the shoulder of the dam, and then we had a discrete set in the power plant location in New Orleans that was meant to be more the center of the dam. Then we built this part on the shore, where Malcolm jumps in. It was quite a construction."

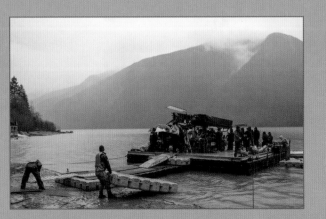

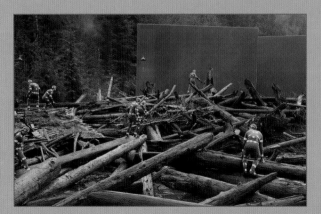

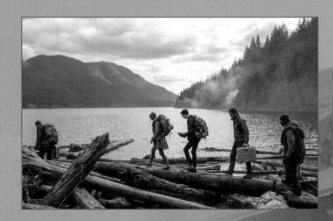

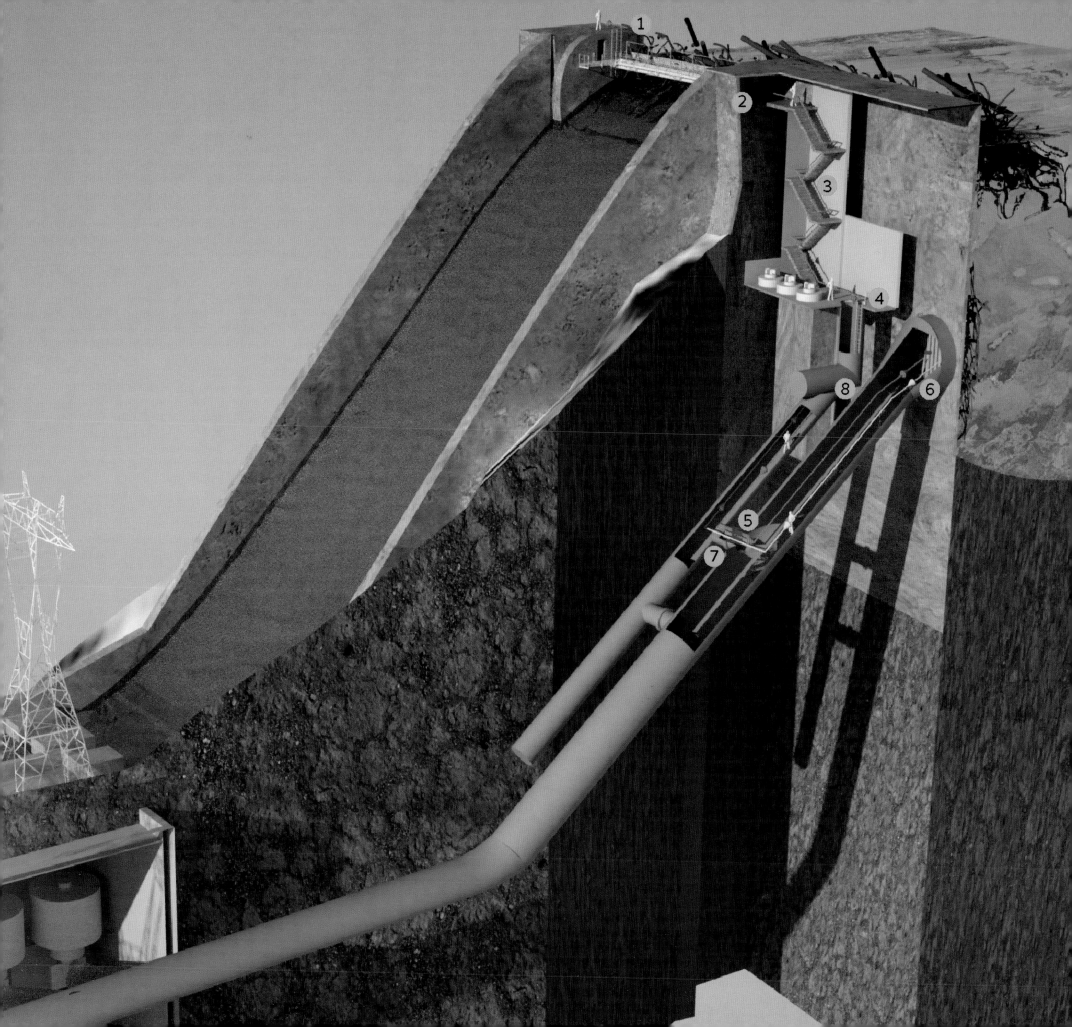

KOBA

"Caesar and Koba have very different points of view on humanity," says Matt Reeves. "It's because of their world experience, what they've been through. Caesar has been treated poorly by humans, but he's also known human love, as the adopted child, in a way, of Will. So he has a very complex and shaded view of humanity. He has the sense of the capability for darkness, but he knows the potential for something greater than that. Koba doesn't know that. He had been treated so miserably by humans, he had seen only their worst side, and so he has a point of view about humans that is completely justified. There was no interest in making him just be set against humans for no reason – he has good reason, he has been tortured and experimented on."

British actor Toby Kebbell joined the cast of *Dawn* to play the part of the former lab ape. Kebbell spent a long time thinking about Koba's mental make-up and understanding how his brutal experiences at the hands of humans had made him the character we see now.

"Sometimes, no matter what you do, you can only hold on to those things you understand clearly," explains Kebbell. "What's very difficult is what Koba understands clearly is violence and damage. While in the ape camp, while surrounded by apes, Koba is a strong, well-respected member of the group. But he mistrusts humans so badly that a slight lunacy occurs [when they reappear]."

"The backstory we created about our relationship was that Koba found it very hard to let go of his racism, if you like, against human beings," Andy Serkis adds. "Caesar had brought him around so that he was able to concentrate on what apes have and life without humans. Actually, were it not for a rag-tag bunch of humans wandering into their territory, this story would have been completely different. But it ignites in Koba a reaction that is very different to Caesar, because of his experiences."

For Kebbell, the point of no return in Koba's relationship with Caesar is also when the audience sees just how far the apes have evolved. "We have a very vicious fight inside the dam, where Caesar dominates him in front of the entire troupe – and the humans," says the actor. Koba must make the supplication gesture [the palm swipe, based on real chimpanzee behavior and first introduced in *Rise*] yet again. "That's the third time he's had to supplicate to Caesar in a very short amount of time. I discussed it in detail with Matt and also with Andy – and that supplication is the first time you see what intelligence really is. Intelligence can be complete manipulation. He doesn't mean that supplication *at all*. That's something we worked hard to get across. Intelligence goes both ways. It goes towards the good, and it goes towards the deceitful, and that's really the divide."

Kebbell thinks that Koba's rebellion is born out of desperation that Caesar was willing to trust the humans in a way that he, for very good reasons, never could. "When he's having to supplicate because he's spoken out of turn, it starts to feel to Koba, that actually, this is a kingship. What I really tried to get in there was there was just this thirst to be heard that turned into this bizarre yearn to control everything that happened. That is a dictatorship, but he felt like he was in one, so he just created his own. It's like, if we're just making dictatorships, then I would prefer mine over someone else's. And that's really what I was trying to portray."

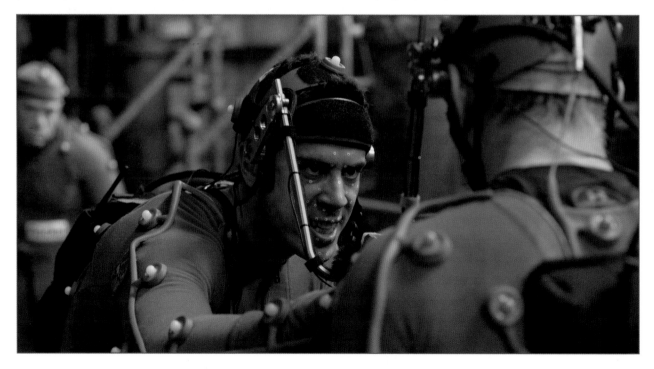

Above and right: Toby Kebbell and Andy Serkis filming scenes in full performance capture rigs as Koba and Caesar.

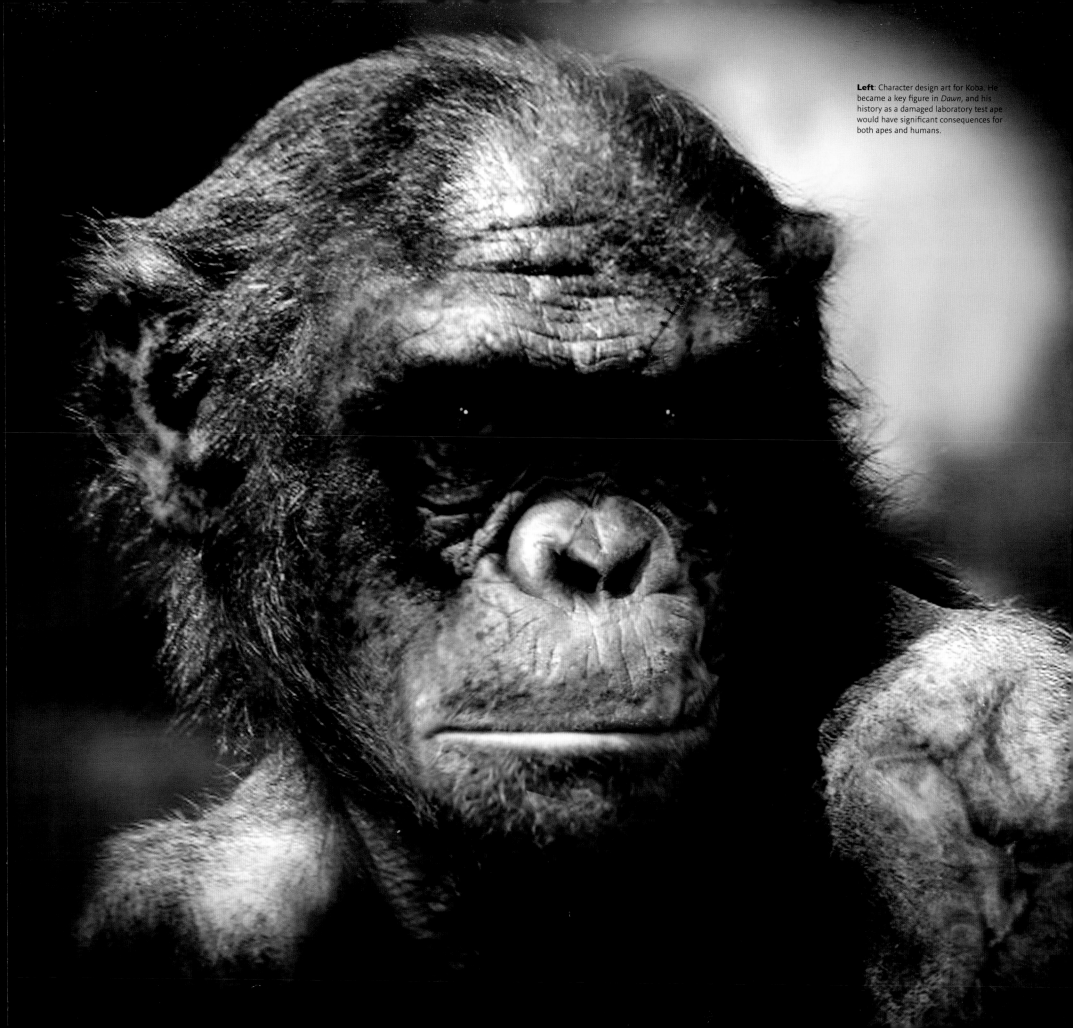

BLUE EYES & MAURICE

The idea of bringing Blue Eyes in was, in a way, to show all the challenges that Caesar had, [and to] understand the complexity of the stakes he was dealing with," says Matt Reeves of the character of Caesar's son, played by Nick Thurston. "The one thing I know having become a father is that the stakes rise exponentially in your life, when you have a child. You want to protect them, provide for them, care for them, love them—you want the best for them. And for me it was interesting to find those sorts of tendrils growing off of Caesar that would have that level of emotional depth—all of which was to serve to make you feel for him and make you understand his plight. To have all that going on while these gigantic stakes about survival come into play. And I think everyone can relate to the idea of having to deal with your son and trying to explain the ways of the world to him, and at the same time let him become who he is."

"Maurice is one of the most captivating characters in *Rise*, aside from Caesar," says Reeves of the Orangutan who returns in *Dawn*. "Karin [Konoval], who plays Maurice, spends a lot of times in zoos. Since the first film, she has formed such a deep and profound connection with Orangutans. She paints with them, she understands them on a really deep level. It's really amazing. There's something about her performance, there's something about how Weta has realized that character in particular, that I think that Maurice is one of the most photo-real characters, and there's a wisdom to the character. There was no question that he had to continue and that he would play a vital part in this society. The idea of watching Maurice teach the other apes language and pass that on to future generations seemed like it would be an incredibly exciting thing."

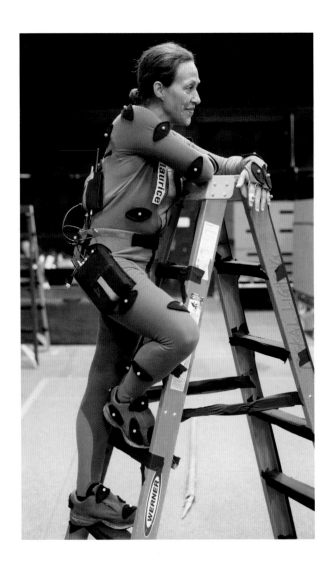

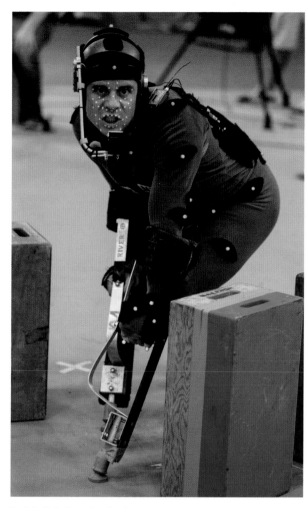

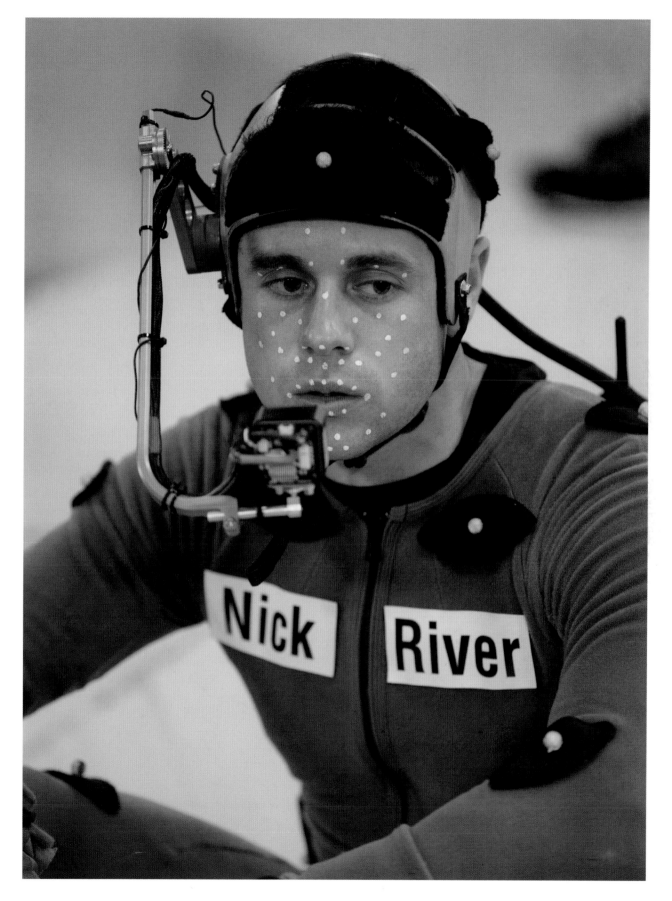

Far left: Karin Konoval as Maurice.
Left: Director Matt Reeves and producer Dylan Clark on set.
This page: Nick Thurston as Caesar's son, Blue Eyes.

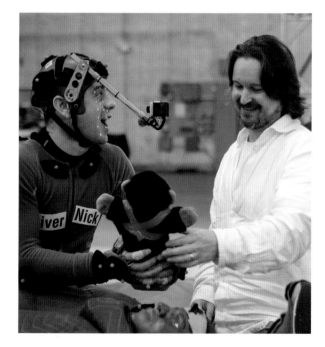

FORT POINT

"This is Fort Point, which is an actual location under the Golden Gate Bridge," says James Chinlund. "So we built our own Fort Point in New Orleans, but you'll always have the feeling that you're under the Golden Gate Bridge through digital set extension."

"It's located underneath the San Francisco side of Golden Gate," adds visual effects supervisor Dan Lemmon. "There's sort of an archway that spans the distance between the land and the first stanchion, and it's right near there. The idea is, in this world, the humans have reclaimed Fort Point as a military outpost, and it's where they've got a stockpile of weapons."

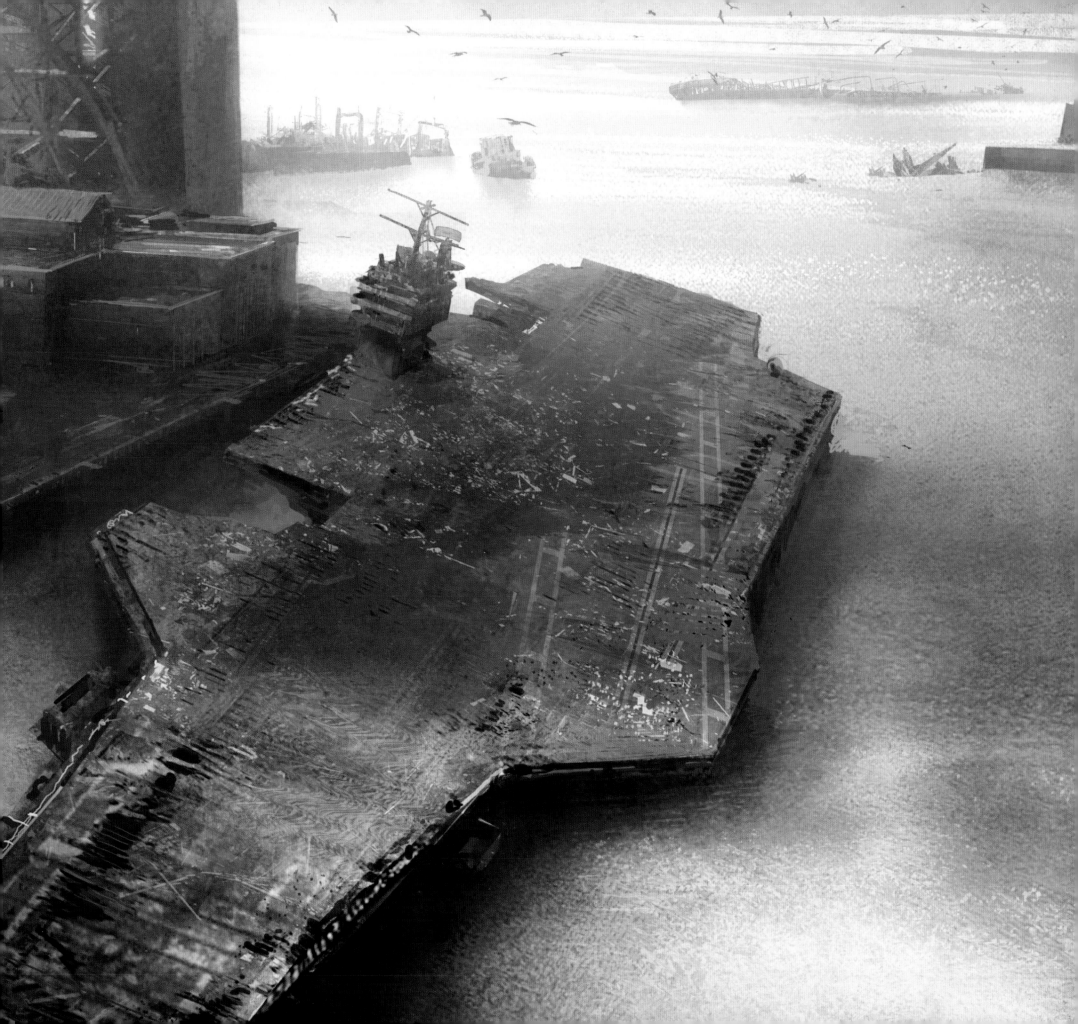

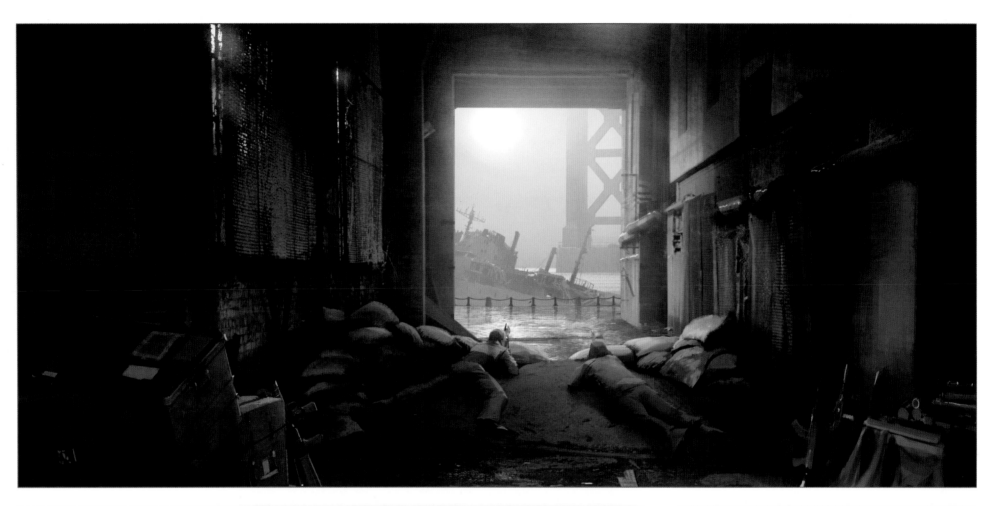

Above and left: Concept art for part of the Fort Point complex, alongside the finished set.

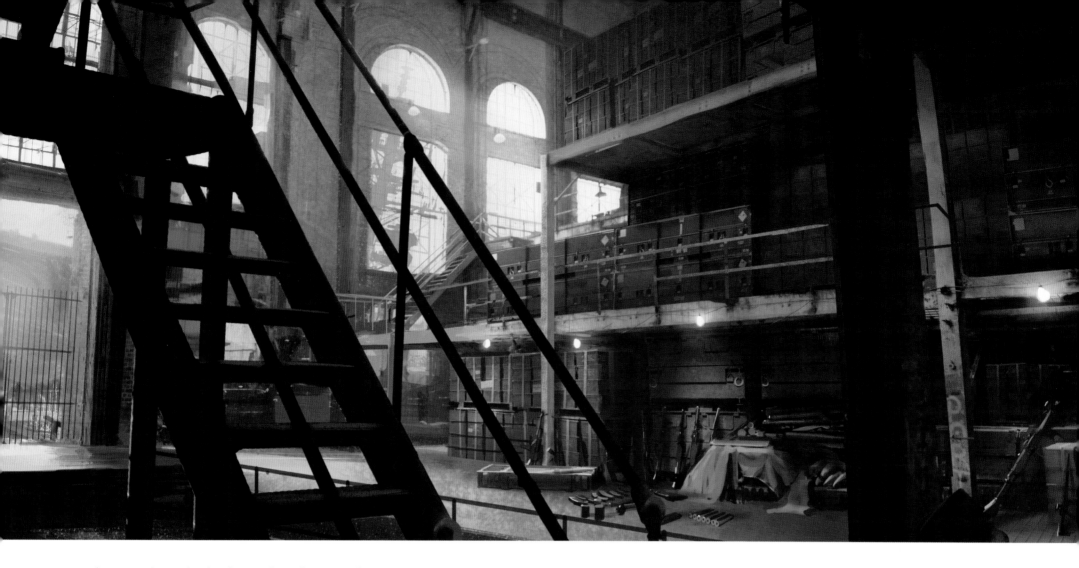

The Fort Point setting is where Koba's plans to make sure the apes are safe from humans take a distinctly sinister turn. For Toby Kebbell, the scenes in which Koba uses his intelligence to deceive the two human guards stationed in the armory are particularly memorable.

"It's one thing to manipulate the apes, but it's another to manipulate the humans, and that's where we really see Koba's intelligence," says Kebbell. "That was my favorite scene to shoot. When I come back to visit them and they're firing off guns and drinking liquor, that's when we really see who Koba is. I had an idea of how to play this scene, and Matt [Reeves] was very noble in his trust of me. We worked it out there and then on that day, a very hot day in July in New Orleans. It was sweltering and exhausting and right at the end of the day. It allowed me to do everything that I'd learned up to that point. It let me run riot and really play an ape. I got to be the ape that we as humans know now, and then in addition the very manipulative, very intelligent, very cold-blooded Koba."

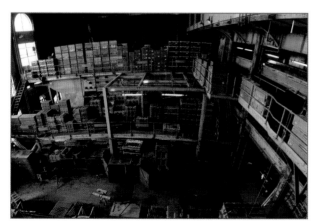

Top: Concept art for the armory interior, with (*above* and *right*) shots of the finished set, which used parts of the same power plant in New Orleans that became the interior of the dam.

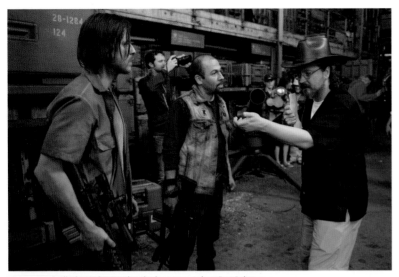

This spread: Filming Koba meeting the human guards at Fort Point.

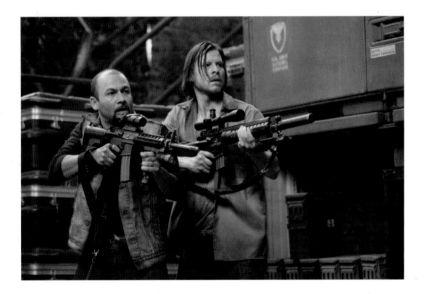

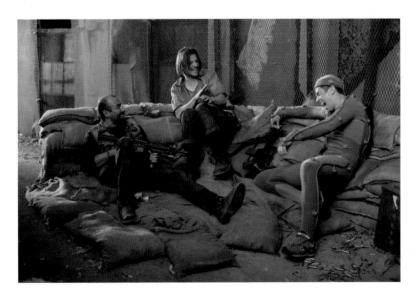

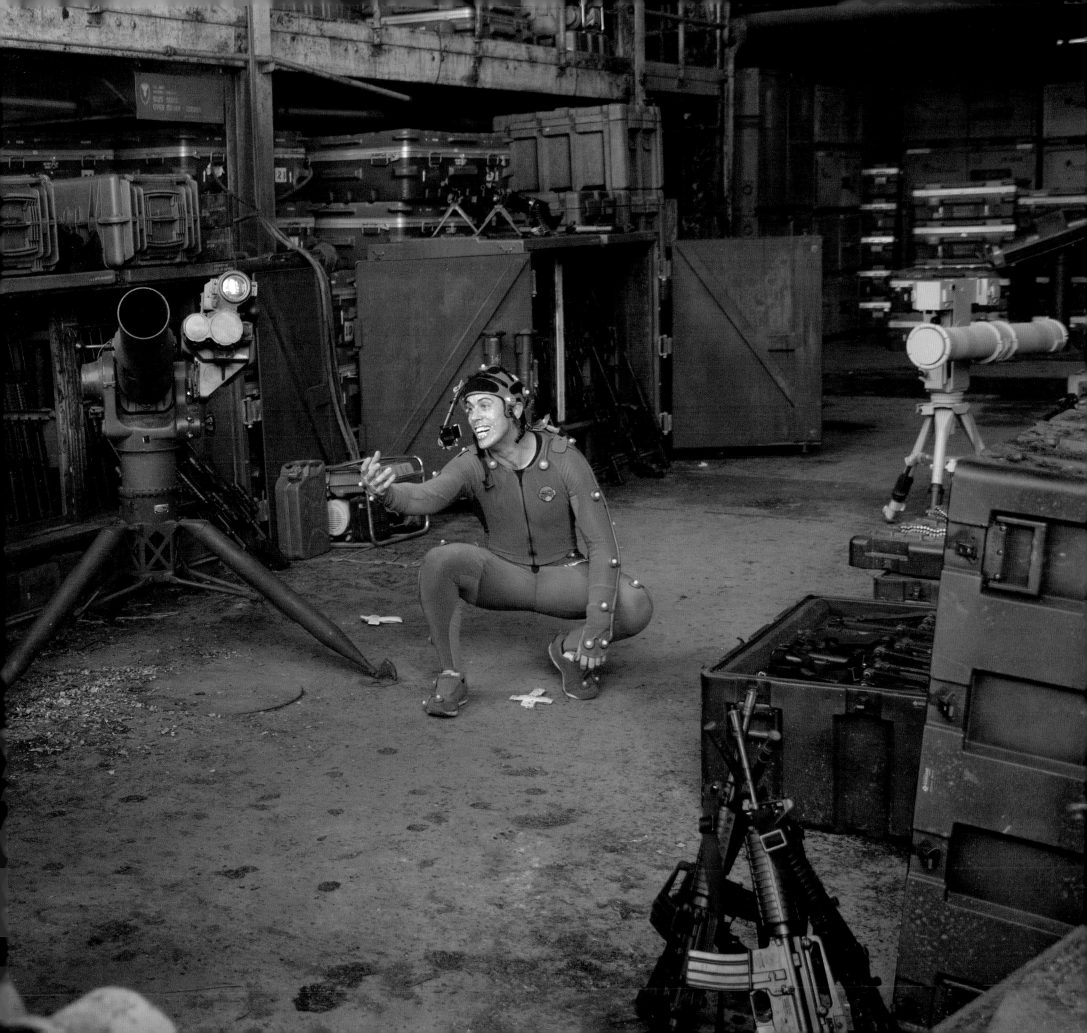

ATTACK ON THE CITY

s the apes descend on the city in the wake of Caesar's supposed demise, they pass various reminders of times after the fall of human civilization, such as the government security measures established to maintain law and order, presumably during the panic started in the wake of the virus outbreak.

"We loved this as a way of telling the back story without telling the whole story," said Chinlund. "This was a military checkpoint at Golden Gate Bridge, where they would scan people as they entered or exited the city, to see if they were carrying the virus. The idea was, during the pandemic, they had set up all these quarantine checkpoints all over the city. So you see evidence of the pandemic—riot and mayhem, things like that."

The production was also keen to make sure that, even though the majority of filming was accomplished elsewhere, San Francisco itself was properly represented. "We have a big sequence in City Hall, we shot a bunch in there," says Chinlund. It's an amazing space—the idea is that Koba and his boys go in there and roust some humans. I'm really excited that we got to incorporate a real piece of San Francisco into our world."

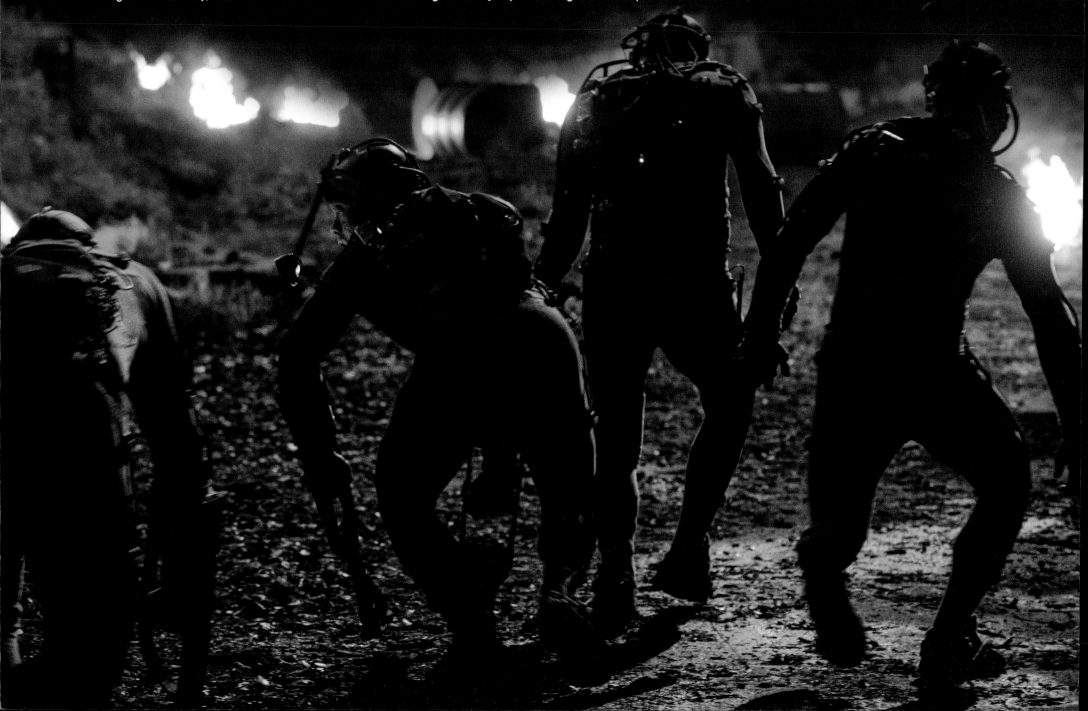

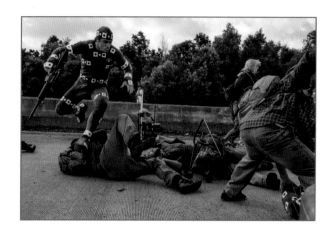

This spread: Set photography and concept art showing the ape army pouring into San Francisco.

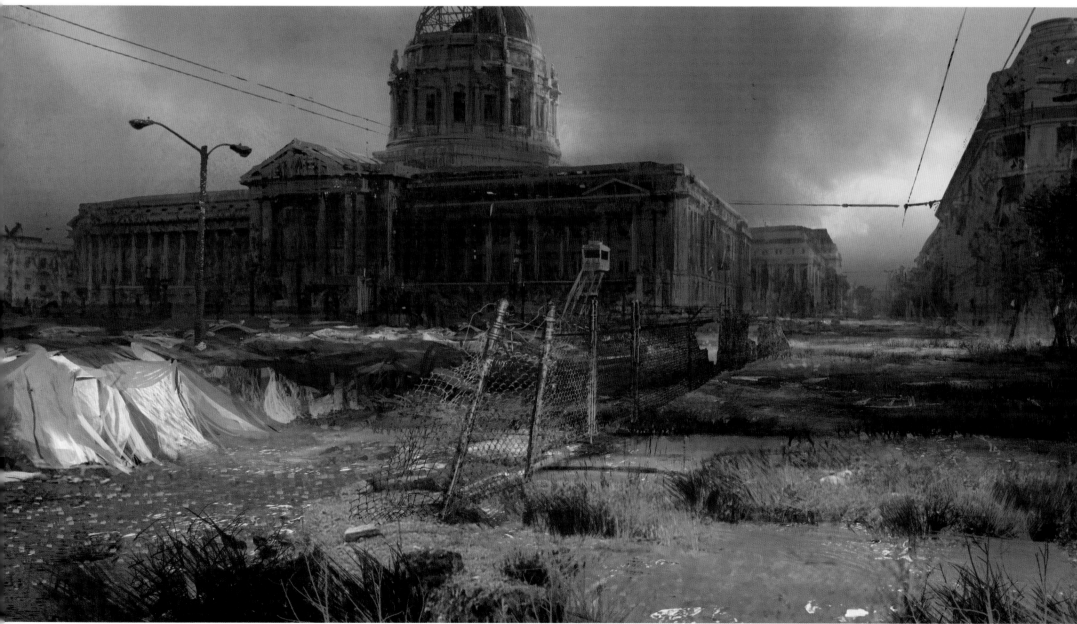

Above: Concept design for a semi-derelict version of San Francisco's imposing City Hall.

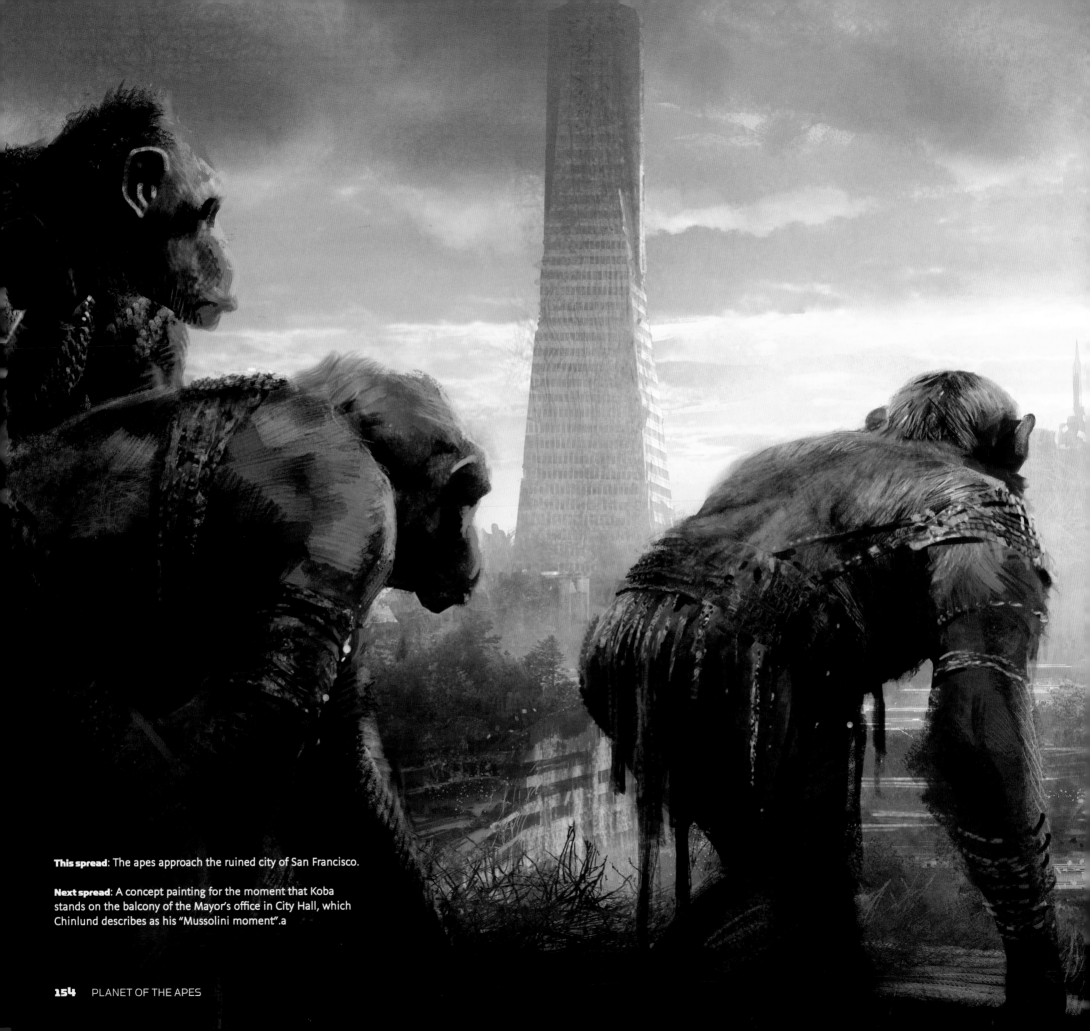

This spread: The apes approach the ruined city of San Francisco.

Next spread: A concept painting for the moment that Koba stands on the balcony of the Mayor's office in City Hall, which Chinlund describes as his "Mussolini moment".a

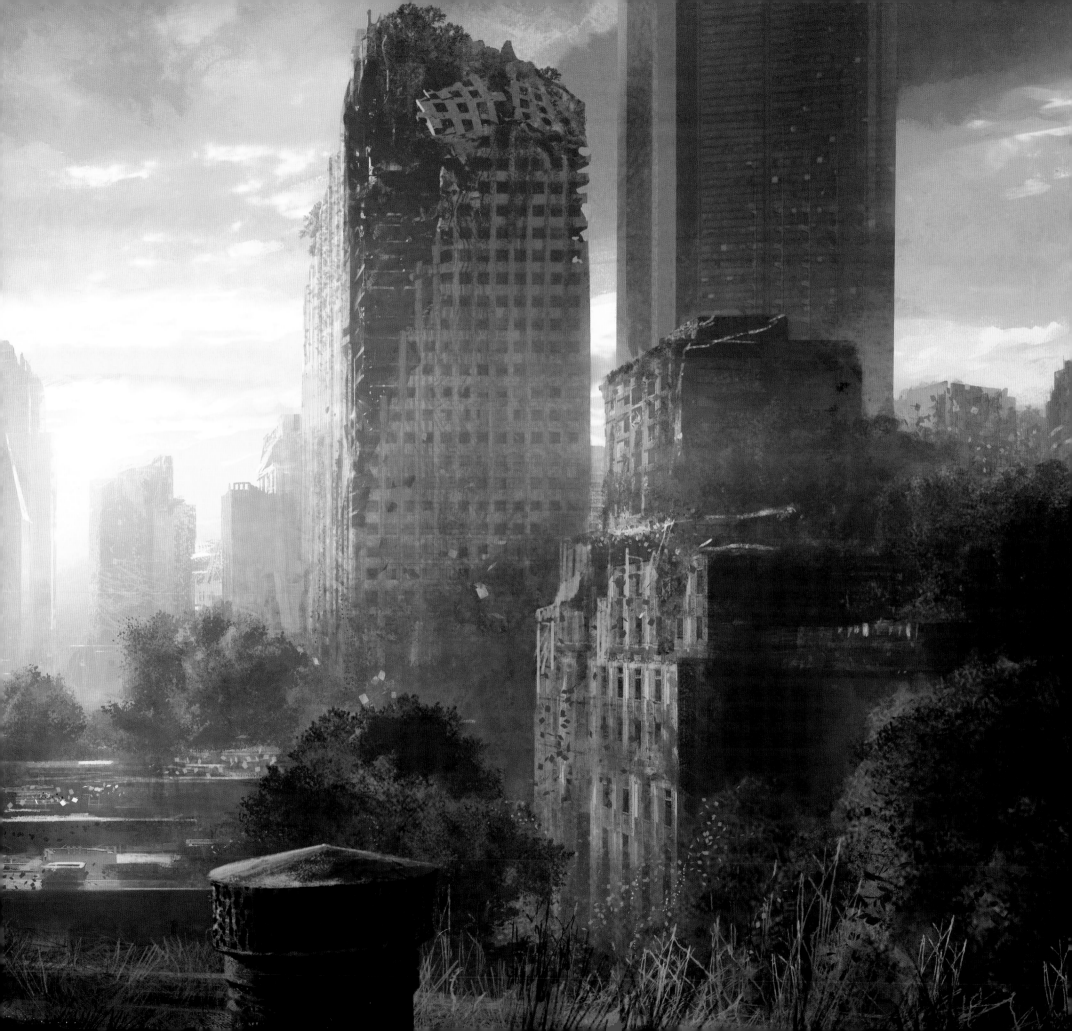

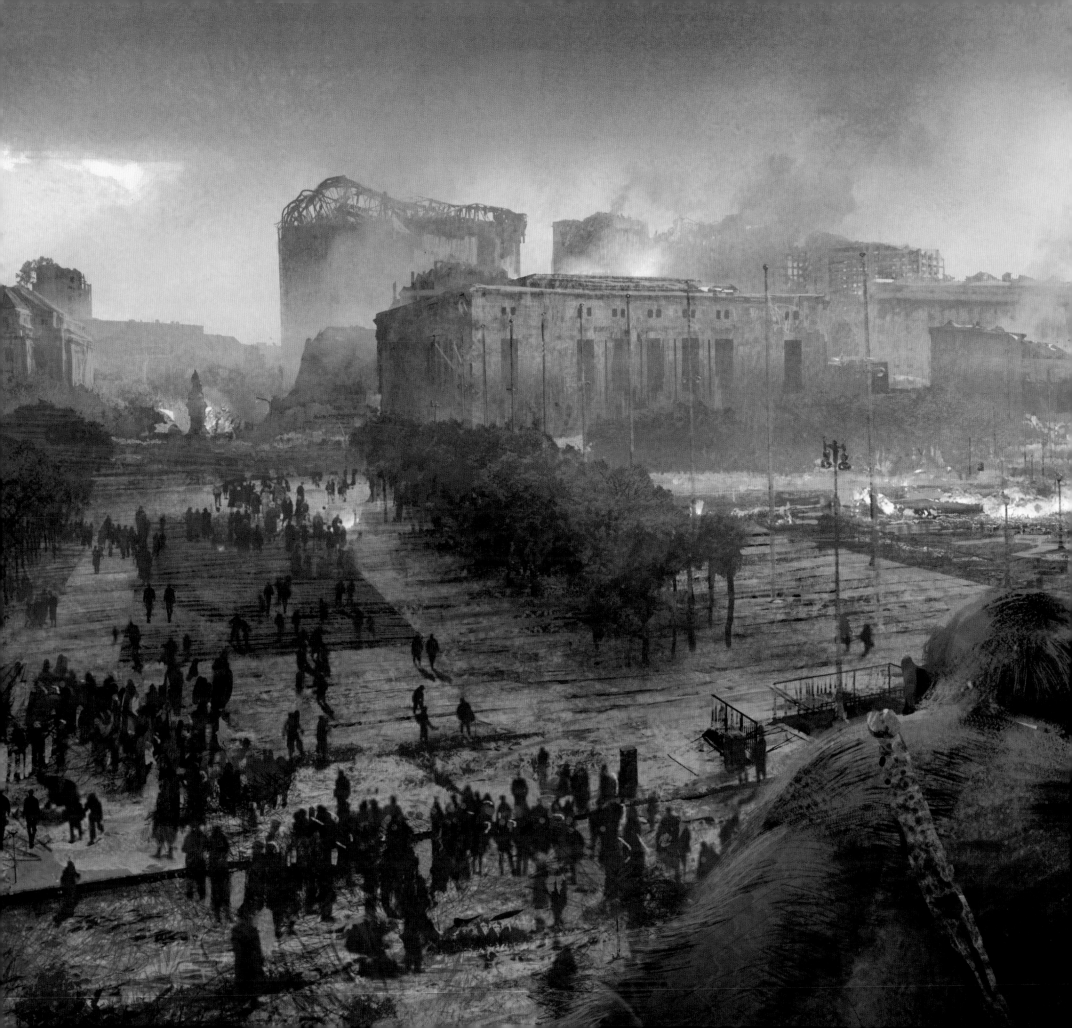

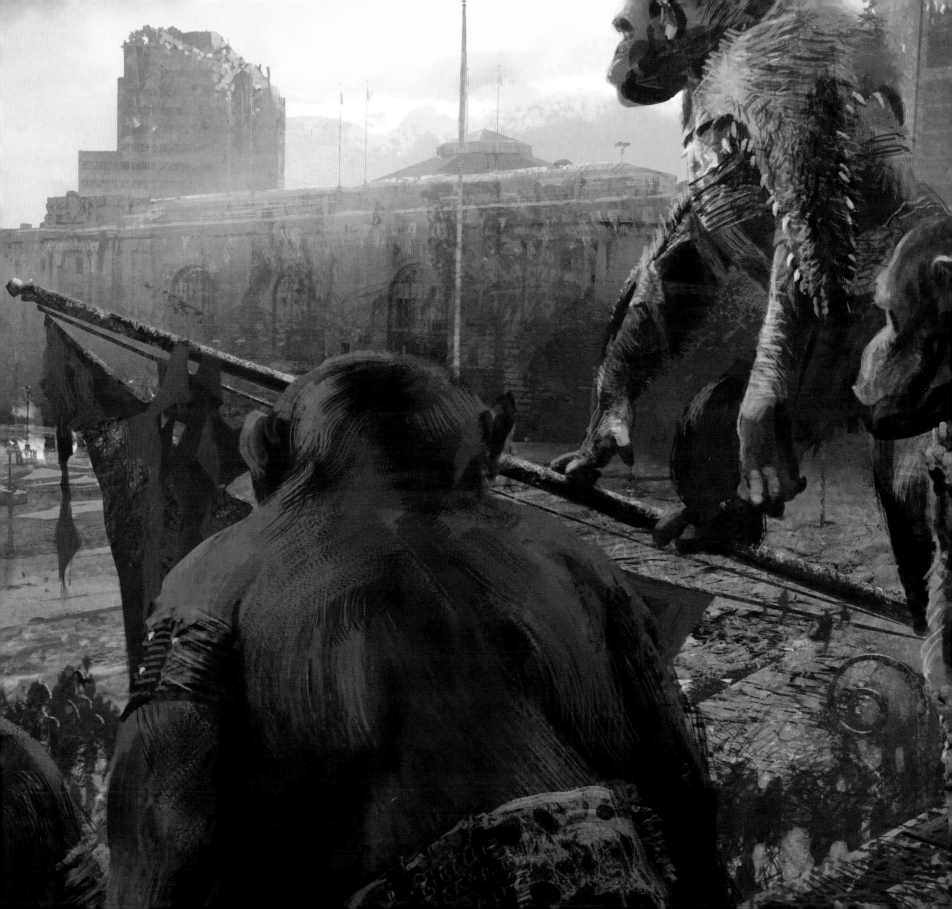

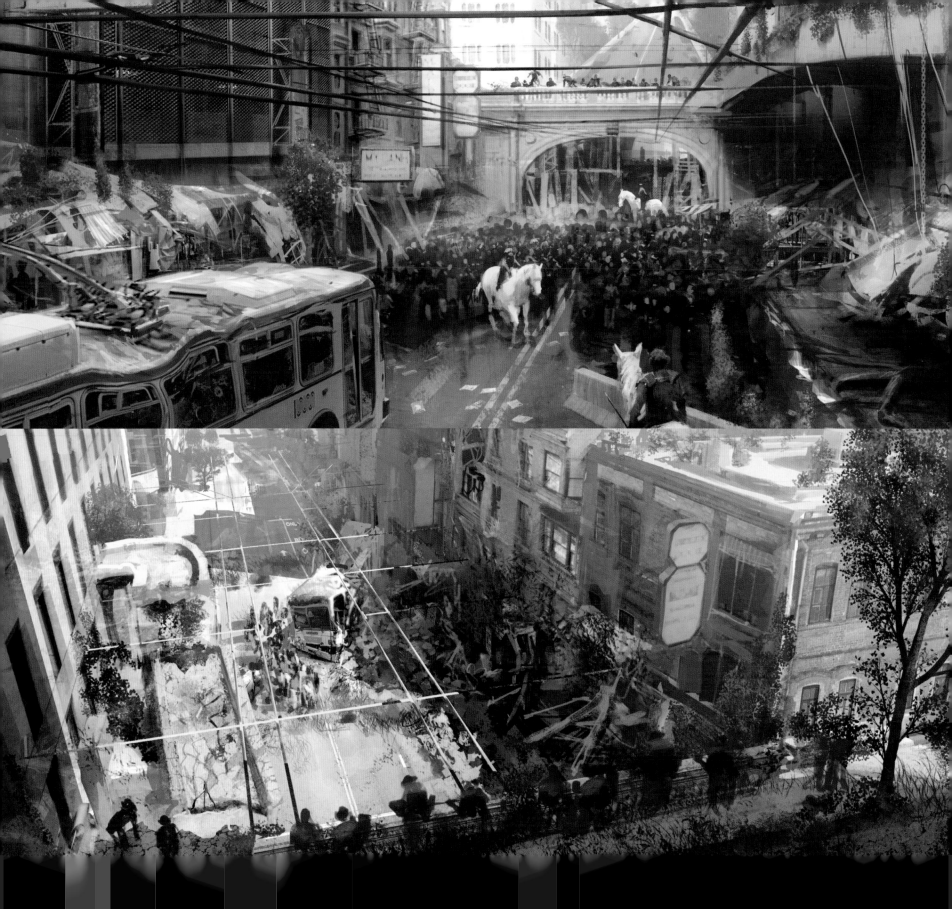

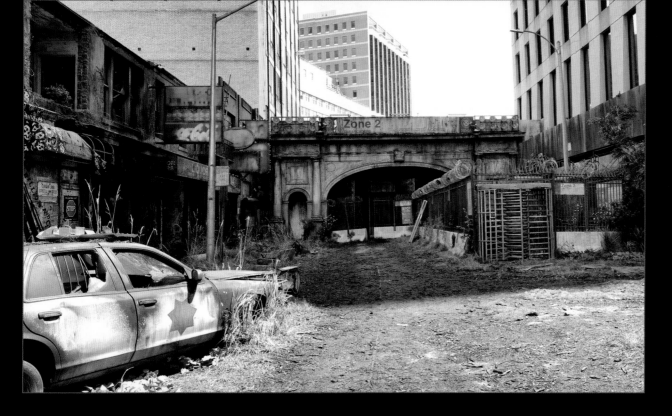

When the apes invade San Francisco the humans are herded and hunted, as Mark Bomback explains: "The round up is supposed to be very reminiscent of the way the apes were rounded up in the jungle at the beginning of *Rise*."

As with earlier films in the Planet of the Apes series, such grim scenes of social unrest communicate ideas about both humans and apes. "If you think about the original films," says Bomback, "and its metaphor about racism—that the apes are the human racists—this is the new idea that we're playing with: You see a lot of stories about how much animal is inside every human, and so we're flipping that and saying, how much human is inside these animals?"

This spread: Some of the concept art and photography that went into creating the tone of the apes' attack on the human colony.

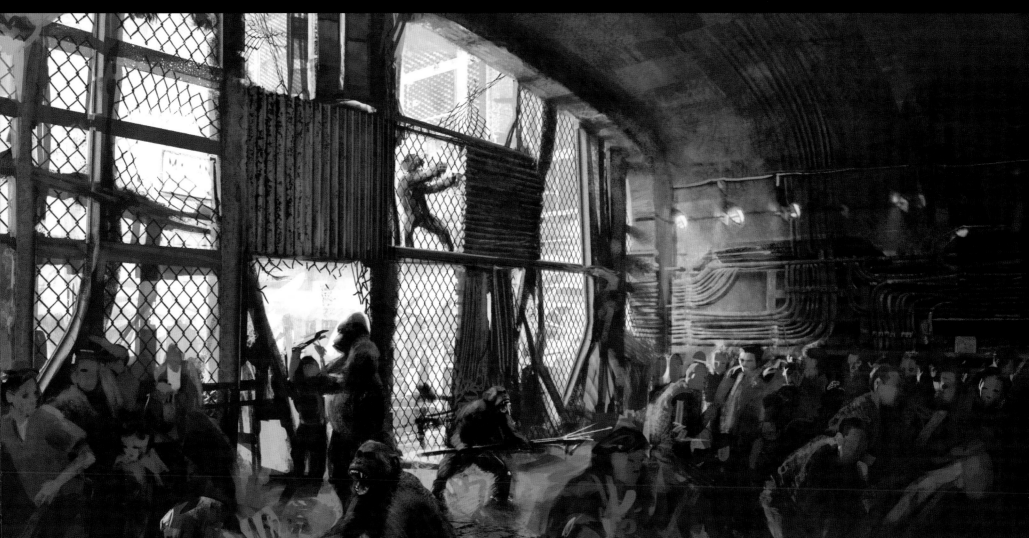

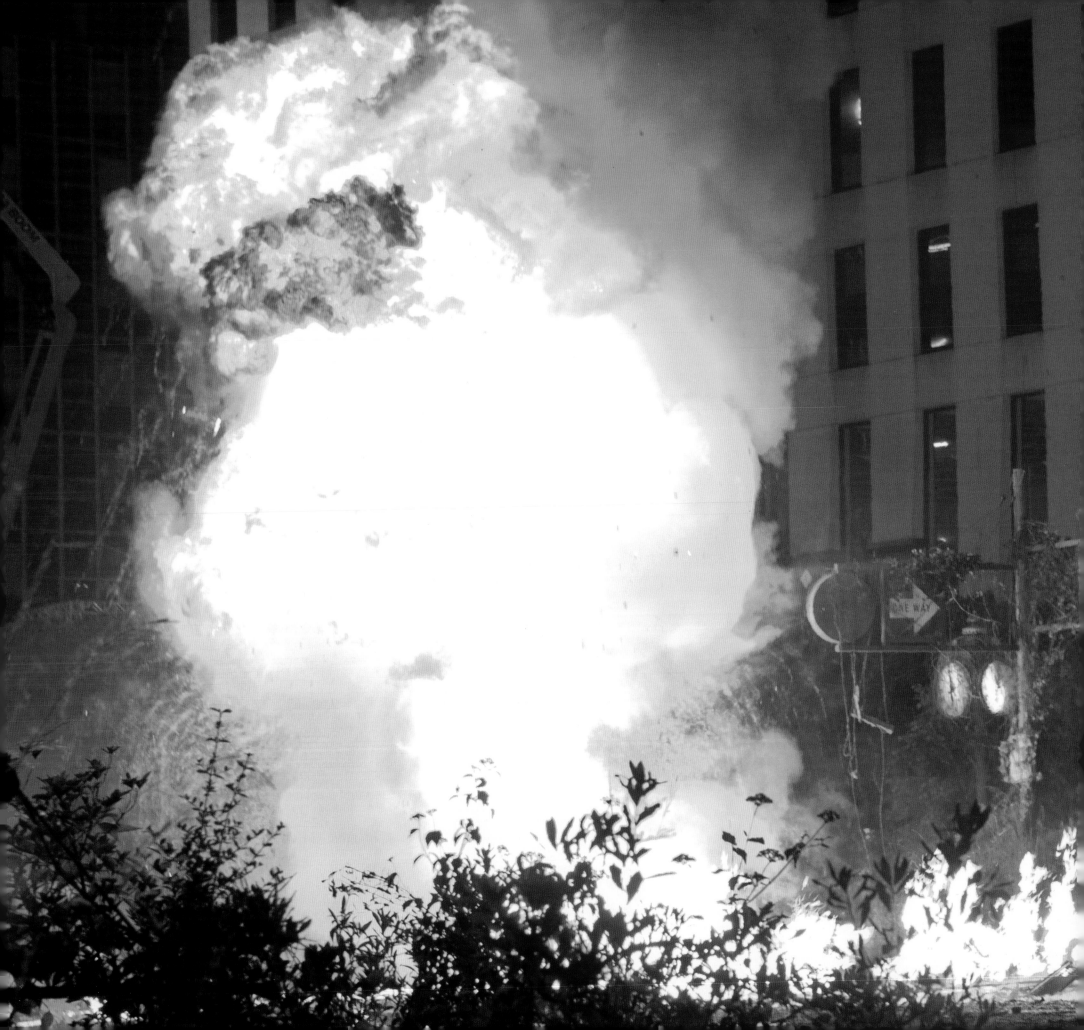

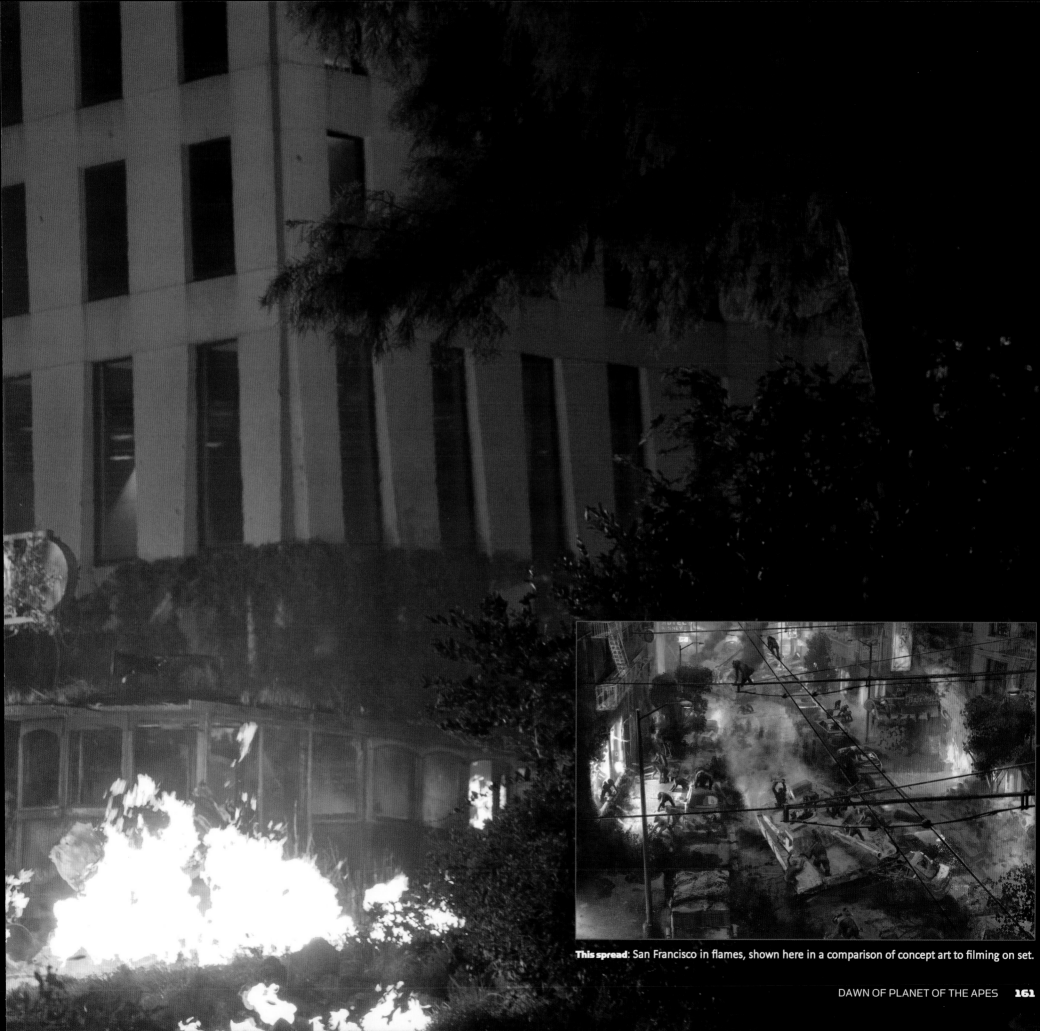

This spread: San Francisco in flames, shown here in a comparison of concept art to filming on set.

WILL'S HOME

One way to further illustrate the progression of post-virus decay was to return to places familiar to the audience. One such place was Will's house, the environment that so shaped Caesar's life as a young ape. Since *Dawn* was filmed in New Orleans, instead of Vancouver, where *Rise* was shot, production was unable to return to the same location. A close approximation was found in New Orleans, which Chinlund skilfully covered with overgrowth similar to that scene elsewhere in the city to hide any differences. Inside, the art department endeavored to include as many echoes from the original set as possible.

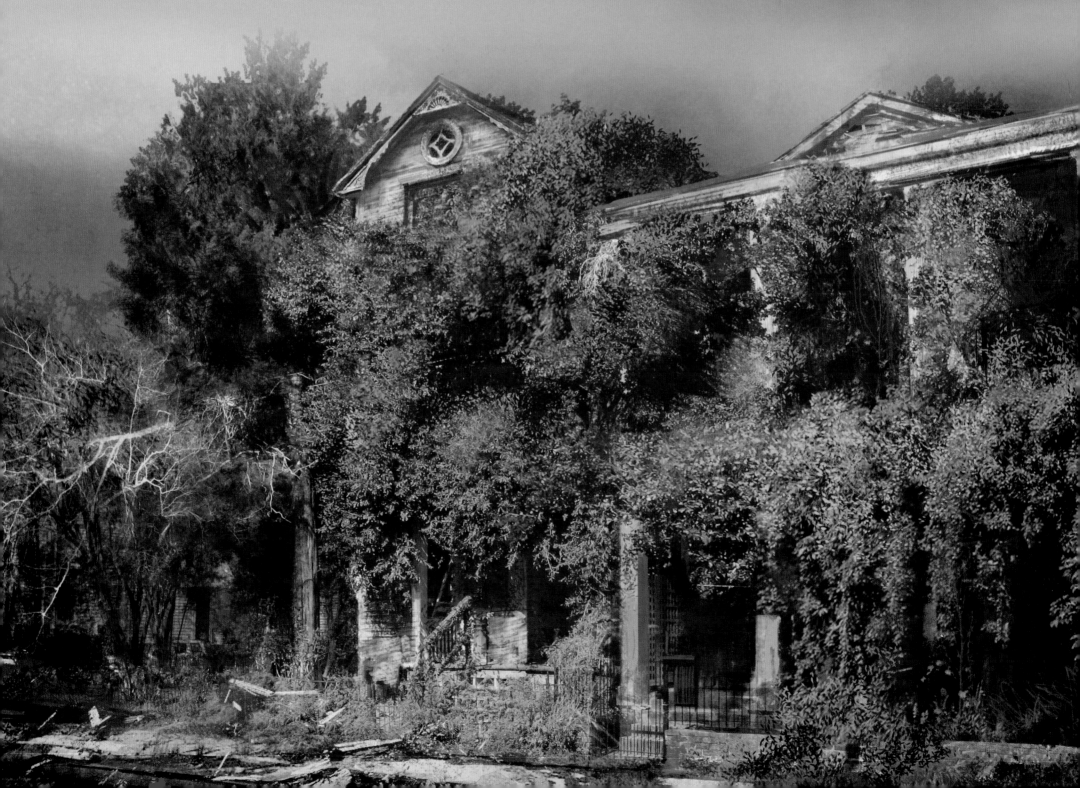

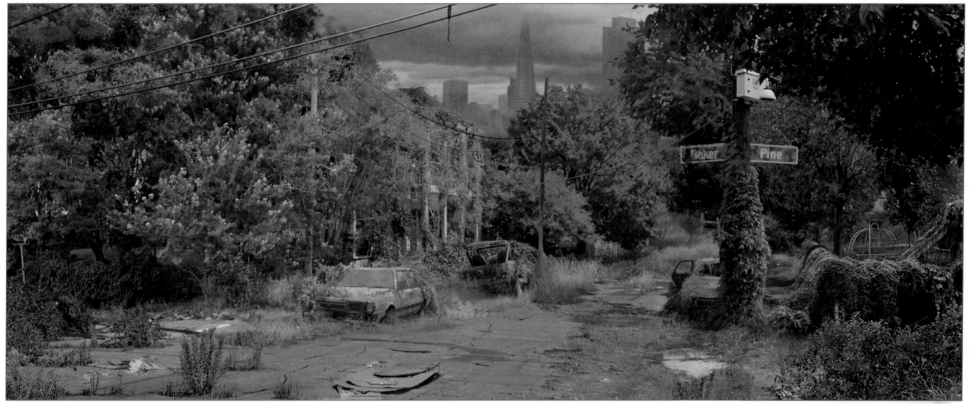

Above: A piece of concept art depicting the overgrown street that was once Caesar's home.

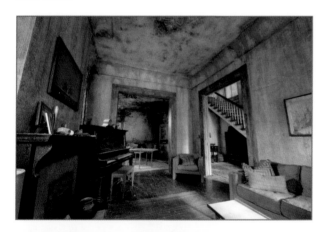

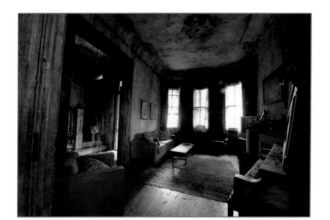

"This is a house in New Orleans that we took over," Chinlund explains. "It's just sort of in a frozen moment. We didn't spend a lot of time in the first movie in the living room, but you'll see his piano, that Will's father was playing. Caesar's attic has suffered a cave-in, like a tree has fallen on it, but there's his window. This is post-pandemic San Francisco, which shows you just how far things have fallen."

Left: The interior sets of Will's home, filmed inside a real house in New Orleans. The living room contains a piano, familiar from the first movie.

"Caesar goes up there and has a moment, looking at some old video footage of him and Will."

James Chinlund, *Production Designer*

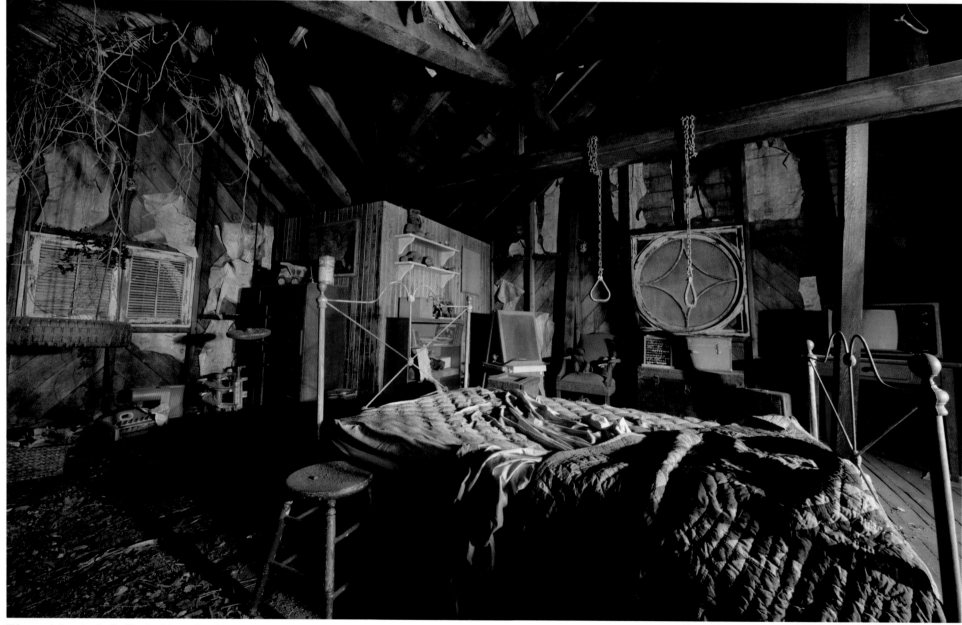

This spread: Caesar's attic, dilapidated and decayed but with its iconic window still intact.

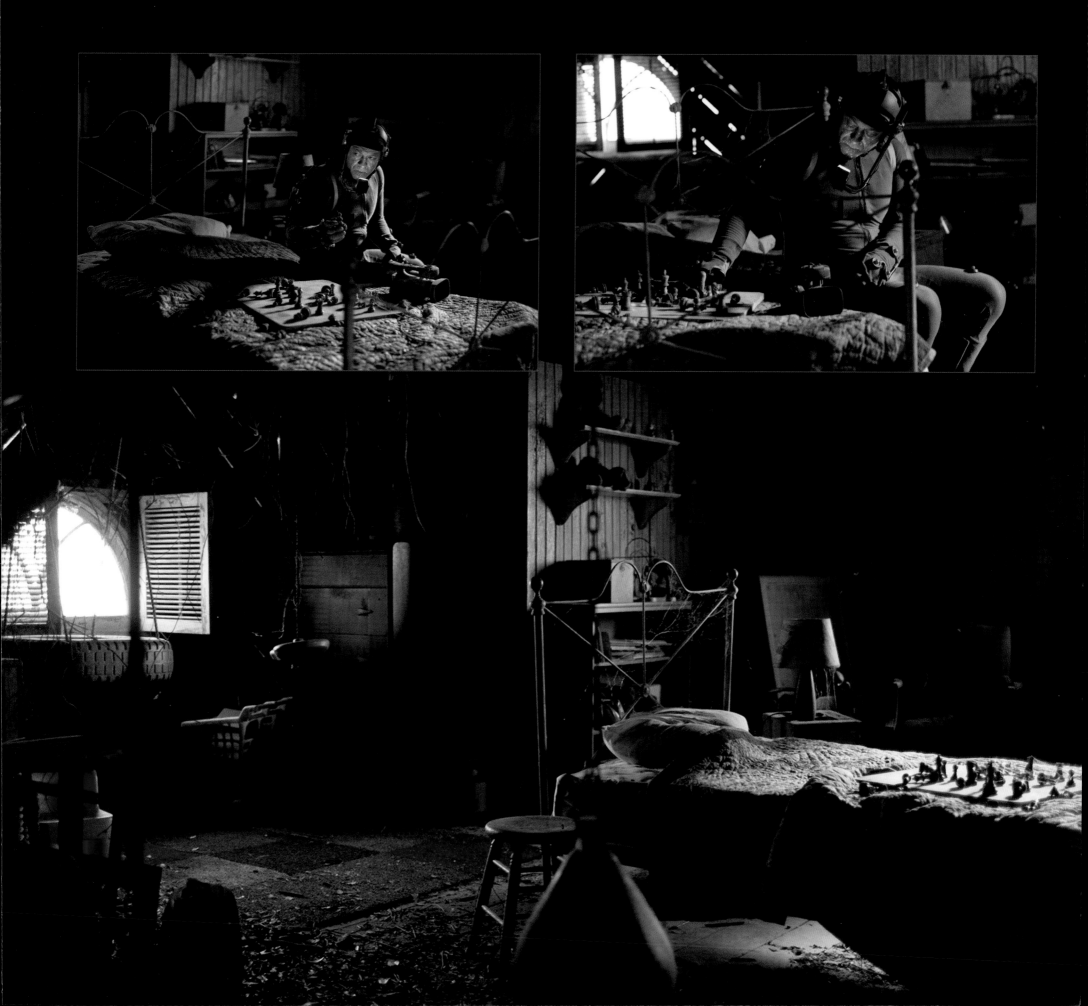

KOBA'S TOWER

Taking a place that actually exists in the present day and using it as the site for the human colony was another part of James Chinlund's plan to set *Dawn* as firmly in San Francisco as possible. "We really tried, as much as we could, to make this feel like a familiar place to the people of San Francisco," he says, "to make it feel like you were there."

"It's based on an existing building that is in San Francisco, but re-imagining it as if it were in the middle of a renovation," adds visual effects supervisor Dan Lemmon. "So it's loosely based on the building that's currently at One Market Street, but with fairly substantial modifications. It's the same kind of thing—we've got a very contemporary glass and steel tower being built on the existing shell of a turn-of-the-century mid-rise building."

Chinlund's team did several detailed architectural sketches to show how the site would look inside and out and what it would be used for in the dystopian, post-virus world in which *Dawn* is set. The idea was that the whole of the building has been turned into living space

Above: A schematic of the human colony building. At the bottom, it's possible to see the façade of the old building still standing, with the new glass skyscraper rising behind it.

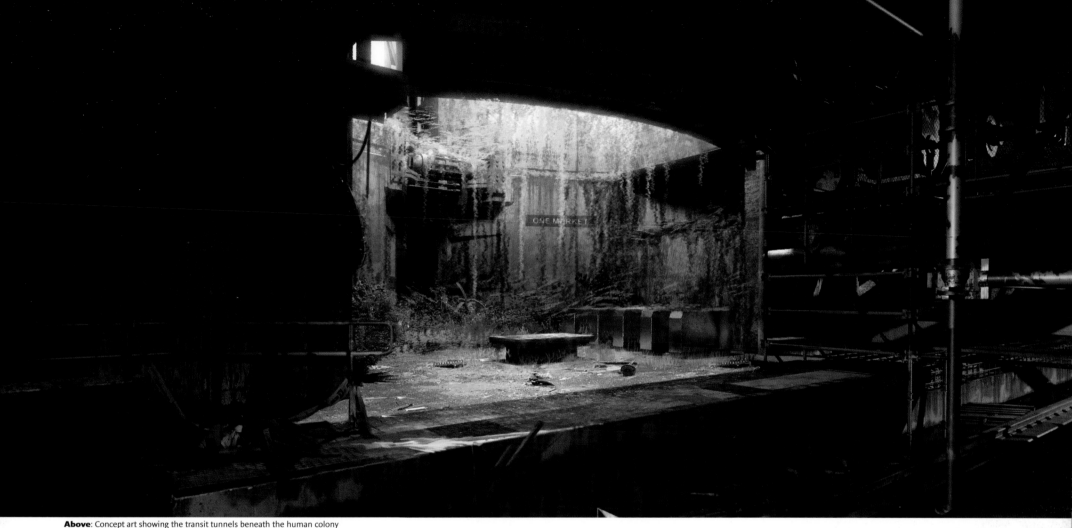

Above: Concept art showing the transit tunnels beneath the human colony building as they would be in the post-virus world.

Above and right: The interior set that developed out of the designs.

for the remaining population, taking over all the offices, restaurants and shop space that would have been there originally.

The climax of the story takes place not only in the high, unfinished upper floors of the building, but also within its very foundations. This allowed Chinlund to create the dark, underground tunnels to which a desperate Dreyfus retreats when he thinks all is lost. "I think it's always been a fantasy of all people to imagine what it would be like to be alone in this big world," says the production designer, "finding these cathedral-like chambers and hidden worlds. Using the tunnels was certainly a way to show just how layered and labyrinthine this whole world could be. It was also a useful tool, the idea that the humans had built what was to have been a transit hub, but which now allowed for people to come and go in the battle."

Meanwhile, hundreds of feet above, the bare steel girders of the unfinished building became another vital piece of the story. The idea of the final, brutal fight between Koba and Caesar taking place in such an extraordinary location again let the designer explore the dichotomy of

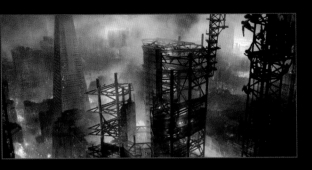

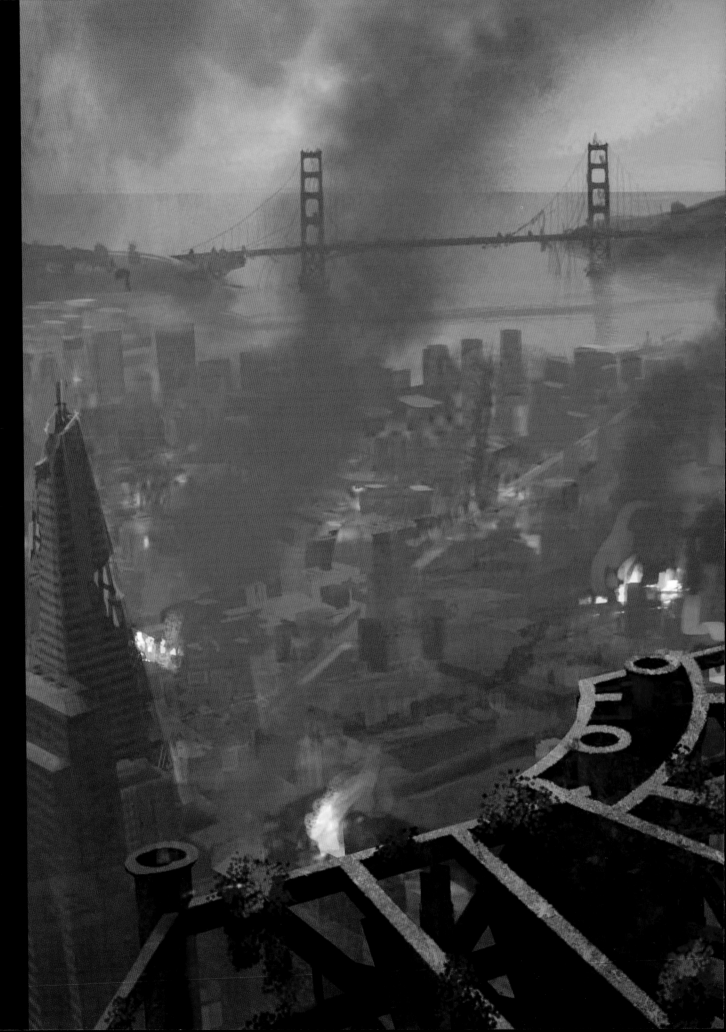

beauty versus brutality that he had added to all his scenes depicting humanity after the fall.

"It's twofold," he explains. "Seeing this beautiful piece of unfinished architecture, and the melancholy feeling of the end of humanity. It also just gives you tremendous vista and scope. The backgrounds let you tell the story of San Francisco and the state of humanity in every shot."

Although Chinlund was able to create physical sets for the underground tunnels, for the action that takes place up at the top of the tower, the team turned to the expertise of the artists at Weta Digital. "We built some elements of things for texture reference, and we designed every square inch of this piece of architecture in the computer," says Chinlund, "but at the end of the day, it's a digital set."

The fact that there would be no physical set for director Matt Reeves to walk around and experience prior to filming made the pre-production designs and renderings all the more important. A director needs to be able to see a set in order to decide how it should be shot, where the lighting should be, what angles the cameras should be set at, and so on. With an entirely digital environment, pre-visualization is achieved through sketches, paintings, and animatics.

"We did light studies trying to do an analysis of how it actually works, to help Matt see it," explains Chinlund. "I'd seen an image of a real skyscraper fire in Russia, which was a huge inspiration for us in terms of lighting during the final battle. We loved the idea that Koba and his clan went up there and built fires. You really get this sort of 'burning torch' effect."

Right and above: Concept art that helped create the atmosphere and lighting of the final battle atop the tower, high above what remains of San Francisco. James Chinlund: "I think it's natural that the apes would move to the high ground, and get the lay of the land. It's a place that the apes would feel at home: a giant tree."

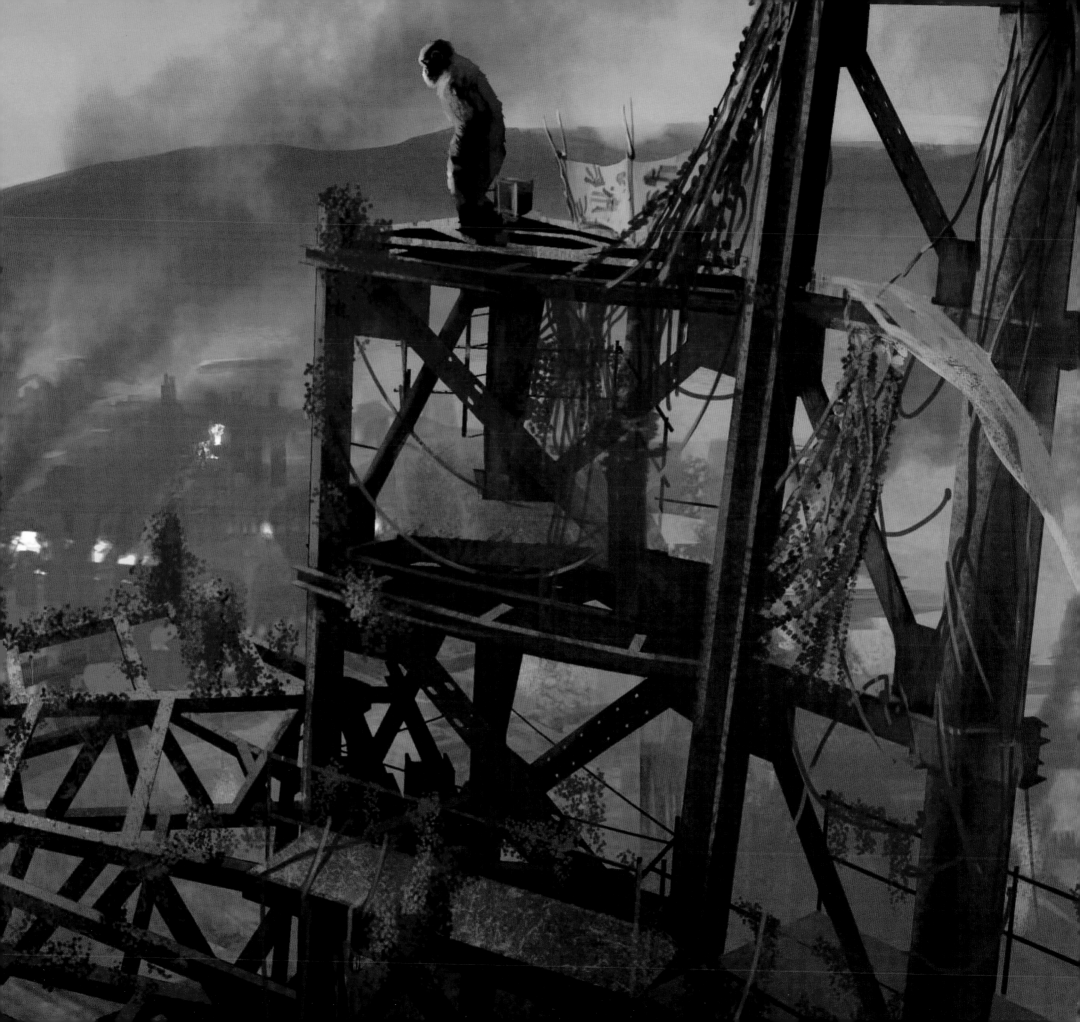

FINAL BATTLE

In terms of the aesthetic, I want that tower to feel as real and as tangible as the 80% that we shot on location," says Matt Reeves of the climactic sequence, the only one to be shot on a volume stage and then set in an all-CG environment. "Whenever I'm doing a scene, I want it to be driven by the characters and the actors. You stage a scene based on what feels right when you're shooting it. If you storyboard everything and the actors are just walking through their paces, then you don't get that feeling of reality."

"What we were trying to do was find a set piece for the stand-off that would only be able to be navigated by apes," explains writer Mark Bomback. "If two humans were up there, they would have died in about two seconds. You can't walk around those beams, 70 stories up, and not expect to fall."

"That was one of those scenes where the details of that fight sequence were still being worked out when we finished in New Orleans," recalls visual effects supervisor Dan Lemmon. Reeves brought in stunt coordinator Gary Powell to help develop the scene. "We worked out a fight sequence that could happen up in that tower," Lemmon continues. "Gary did a lot of planning in terms of stunt rigs and things that we could do in the performance capture volume to best get the movements out of that sequence. Then we went back and shot that later in Los Angeles."

The scene required a lot from the actors, not only from an emotional standpoint but also physically.

"There was one fall in the movie that was done by a stunt person, but apart from that, it was all Toby and Andy," says Dan Lemmon. "Certainly the big pummeling and punching shots were those two. They're both very physical

guys, very comfortable doing those physical movements."

"It was incredibly challenging," Reeves says, recalling the "three-dimensional chess editing" the sequence required. The shoot on the volume stage captured the performances, but the details of the final camera angles would be only worked out later, in post-production. "You're looking at a shot that the performance capture cameras got [on the volume], which is just to show you, say, what Andy was doing. So you go, 'OK, well here's where the camera is, but actually, in the movie I want the camera to be over there.' But it's not there, so you're editing together footage imagining shots you could have, and then you have to go and talk to Weta about creating the shots that you don't have... so it's a very unusual process! What I'm hoping is that at the end of the day, it will look as if we did it the way we did every other scene."

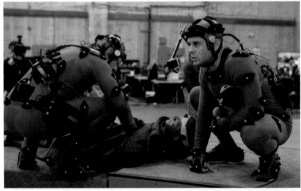

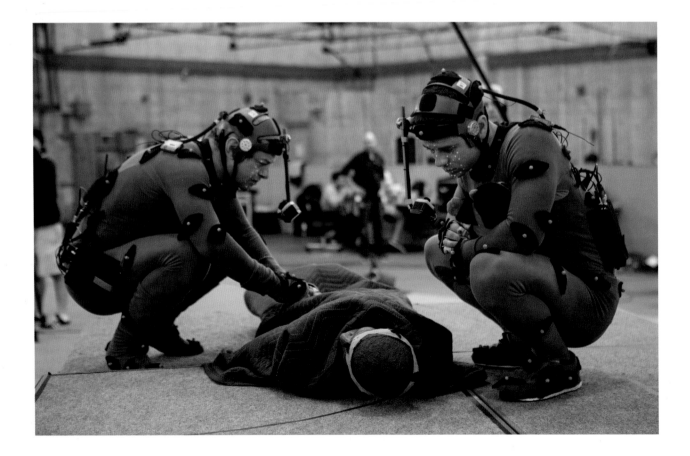

This spread: The ape actors, including Toby Kebbell and Andy Serkis, film the climactic showdown in a motion capture stage in Los Angeles.

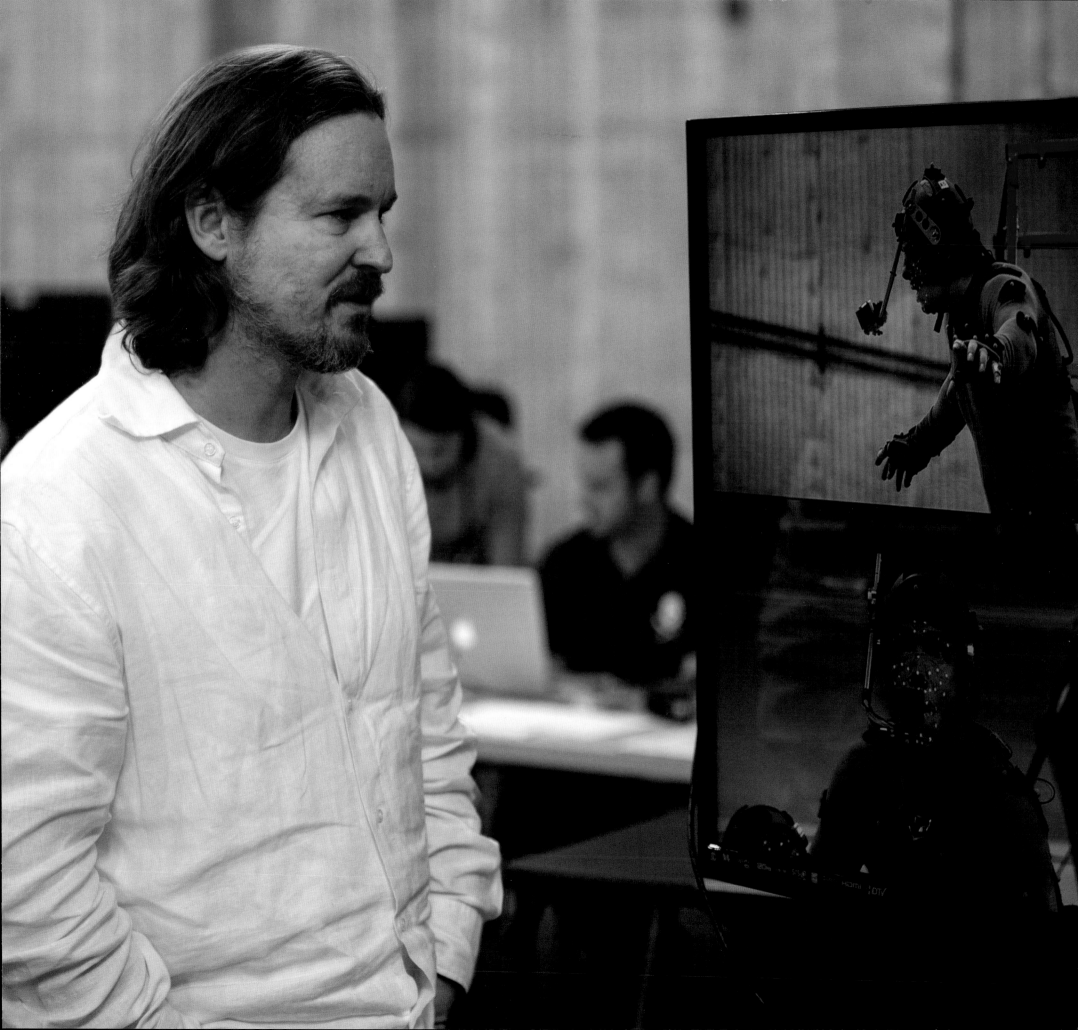

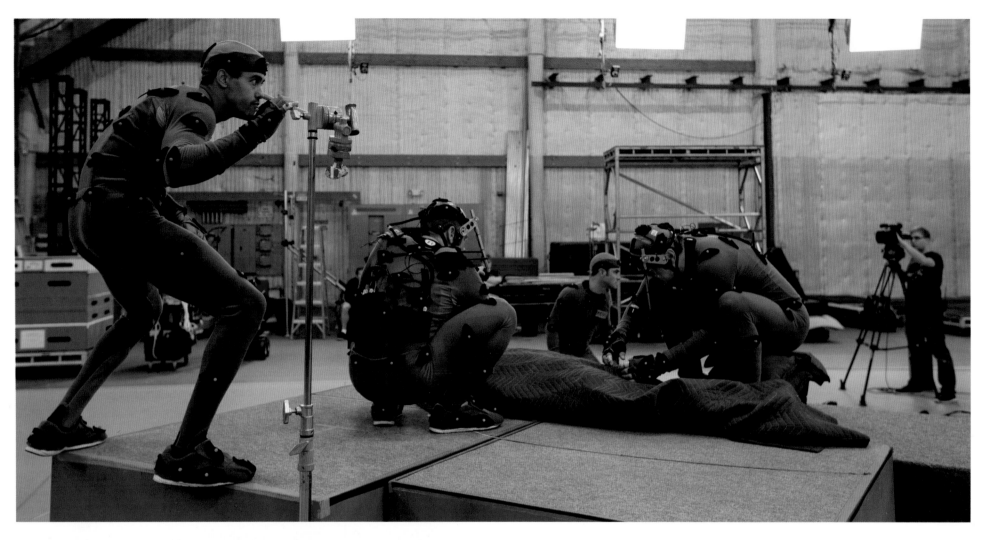

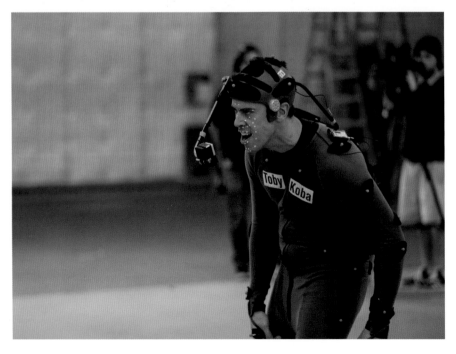

"To me, what was exciting about this film was this idea of world creation, the creation of ape civilization. Future movies are going to grow out of that. How will this character and this family be tested by challenges ahead of them – that's the path that I'll be interested in taking..."

Matt Reeves

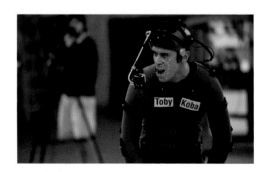

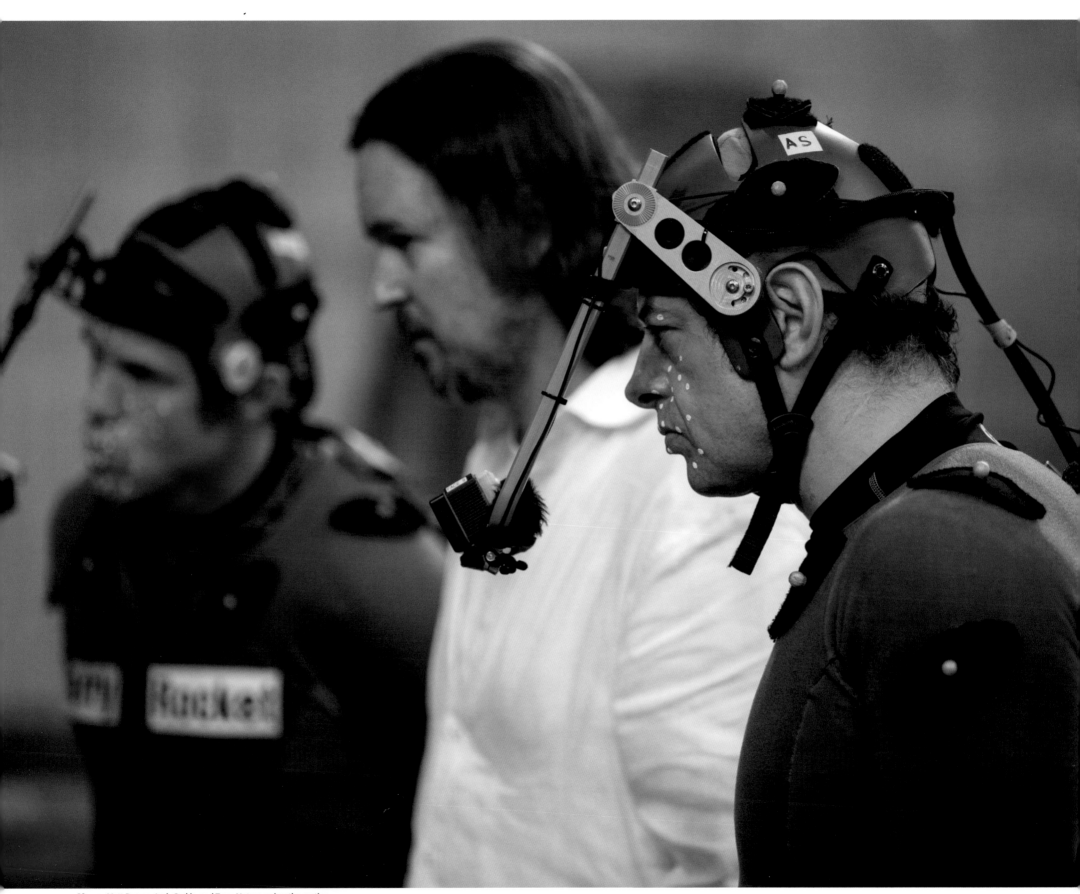

Above: Matt Reeves, Andy Serkis, and Terry Notary review the motion capture footage.

ACKNOWLEDGMENTS

This book would not have been possible without the help of Peter Chernin, Matt Reeves, and Dylan Clark.

Titan Books would like to thank all the cast and crew for their invaluable input. We would also like to thank Joshua Izzo, Lauren Winarski, Verneece Robinson, and Anthony Ripo at Twentieth Century Fox for their support.